D1294464

Vision of Harmony

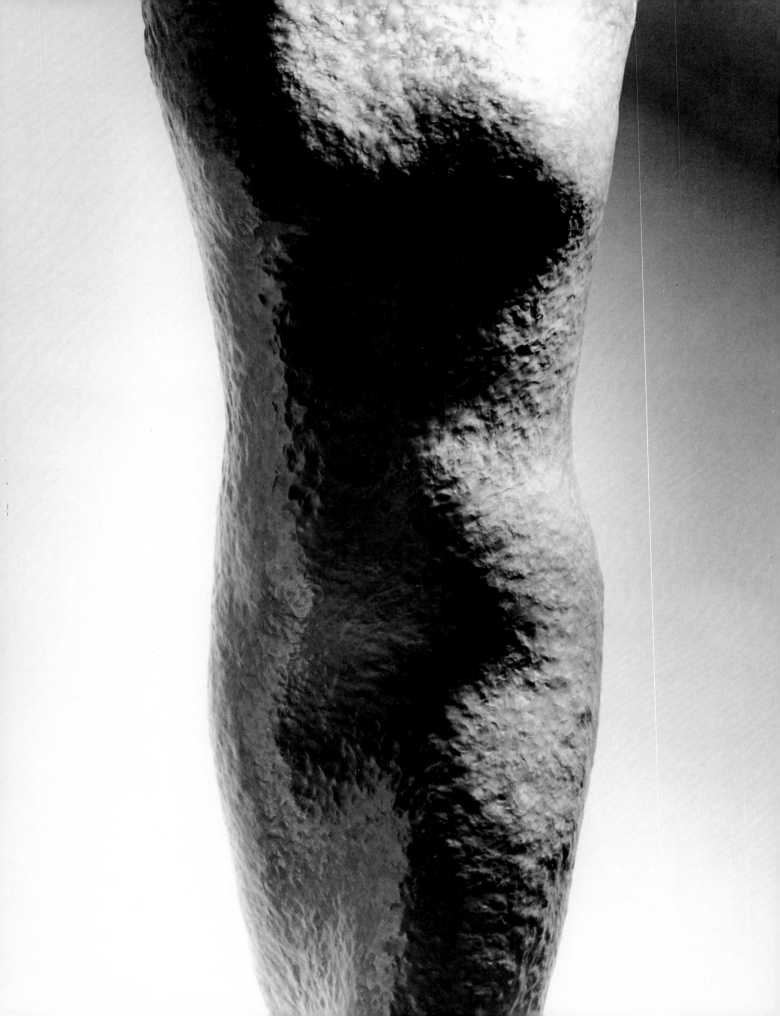

Vision
of Harmony

The Sculpture
of Saul Baizerman

photographs by
David Finn

text by
Melissa Dabakis

Black Swan Books

NB
237
.B28
A4
1989

Acknowledgments for permission to include as Foreword to this
volume the introduction prepared by Thomas Messer for the
catalogue of the Baizerman exhibition held at the Institute of
Contemporary Art, Boston in 1958, and to include excerpts from
Hilton Kramer's essay "Saul Baizerman (1889–1951)" which ap-
peared in the Feb. 9, 1963 issue of *The Nation* (© 1963 The Nation
Company, Inc.), and from Julius Held's catalogue *Saul Baizerman,*
prepared for the Baizerman exhibition held at the Walker Art
Center (Minneapolis) from January 16 to March 1, 1953.

DESIGNER: ULRICH RUCHTI
ASSOCIATE DESIGNER: MICHAEL SCHUBERT

Published by
Black Swan Books Ltd.
P.O. Box 327
Redding Ridge, CT 06876
U.S.A.
ISBN 0-933806-53-1
LC Card: 88-16665

CONTENTS

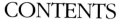

FOREWORD

Saul Baizerman was 67 when he died of cancer and it was then, in the year of his death [1957], that I saw him for the first and last time.

Baizerman lived with his young and attractive wife on the third floor of an old building on the Avenue of the Americas. I was greeted by a friendly, slight, and quick-moving man. As I entered there were warnings about the sharp and exposed edges of hammered metal as Baizerman led me to view his work. He was gracious and intent; serious but entirely without pretensions; quiet and polite, but radiating authority. There was no sign of illness, but every sign of a pervading, controlled and calm energy. As he talked he moved from corner to corner, yanking expertly the recalcitrant materials into full and unobstructed view.

This was difficult, for the large hollow reliefs were placed on every square foot of the three small rooms of his apartment. The largest reached from floor to ceiling and loomed ominously. Baizerman described his working method which, very simply, consists of hammering cold copper sheets from both sides until they assume the desired shape. As he spoke and moved, I could not free myself from the oppressive sensation that this little man was doomed to create with Michel-angelesque fervor—create giants that somehow would devour him. And so in a way they did, even during his lifetime. In the soldering process the copper fumes attacked his lungs; the relentless deafening noise of the hammer blows reduced his hearing; and his creatures virtually deplaced him as they claimed more and more floor space, leaving for the human inhabitants a corner for a last stand.

Viewed in the crowded studio these were not benevolent deities, but they were so remarkably alive, and when isolated, so inexpressibly beautiful.

What made them so?

First, the artist's ability to translate himself into his art. Baizerman himself expressed this in the following sentences which we quote from a catalogue published by the Walker Art Center, "When the piece has taken away from me everything I have to give; when it has become stronger than myself; when I become the empty one and it becomes the full one; when I am weak and it is strong, the work is finished."

6

Then, there is the artist's inventiveness, a quality which throughout art history is almost synonymous with beauty. It is inconceivable that Baizerman's work would speak to us with equal strength had he not *realized* the hollow hammered shape, fashioned freely and without the use of a molding. Had he not been the first to comprehend this new potential, the metal would have resisted and his arm would have lacked the strength that is required of those who force spirit upon matter. With Baizerman as with others, valid invention, technical and stylistic, *is* beauty. And what could be more inventive, more avant-garde than a new concept which in one master stroke combines the hitherto separate categories of relief and sculpture in the round, while at the same abolishing the time-honored commonplace that sculpture is either the result of addition or subtraction. The hammered copper sheet is a most ingenious synthesis of two mid-positions and the power of Baizerman's work revealed in this double concept stands witness to an inventive moment of considerable consequence.

There are other things, of course: The poetic inspiration which ranges freely and knowingly over pagan, biblical and other sources. The phenomenal skill which breaks the hard surfaces into planes as manifold and differentiated as an impressionist canvas—surfaces that invite the play of light. There is the artist's fullest comprehension of the sculptural limitation in general and of the range of his unique technique in particular.

These and other qualities will reward the attentive viewer. The images Baizerman has fashioned, the creatures that drained his strength, now turn their serene countenances toward us.

To honor Saul Baizerman means to re-absorb the living substance which he has hammered into copper and bronze.

Thomas M. Messer

CHRONOLOGY

1889	Born December 25 in the city of Vitebsk, Russia. Although this year is generally acknowledged as his birthdate, the United States Immigration and Naturalization Service lists 1887.
1906	Jailed for revolutionary activities in Russia until his escape in 1908.
1910	Arrived in Boston on February 5; shortly thereafter moved to New York City.
1911	Attended National Academy of Design in New York for one year.
1916	Attended Beaux-Art Institute of Design in New York for four years. Studied with Solon Borglum (1868–1922). Won several honors as a student, among them a commission for a monument (never erected) to stand before the Grant Memorial on Riverside Drive in New York.
1920	Met his future wife, Eugenie Silverman Baizerman (1899–1949). Attended art classes at the Educational Alliance, a settlement house on the Lower East Side of Manhattan, where he met Moses and Raphael Soyer, Chaim Gross. Began his first independent work, *The City and the People* (1920–1954), a sculptural series of sixty small-scale hammered bronze and plaster statuettes depicting the activities of New York's working-class inhabitants.
1923	First trip to Europe, visiting London and Paris for three months.
1924	Second trip to Europe, remaining for two years. First solo show at the Dorien Leigh Galleries, London. Extended visits to Russia, Italy, and France.
1926	Returned to New York and settled in Greenwich Village. In October, their daughter, Ugesie (Karen) Baizerman was born. Began to hammer sheets of copper into monumental figural forms.
1931	On January 29, his studio in the Lincoln Arcade Building on 64th Street and Broadway caught fire, destroying most of his monumental copper sculptures of the past five years.

1933 Resumed work on hammered copper sculpture. First solo showing in New York of *The City and the People* series at the Eighth Street Gallery. Exhibited in many group shows, such as the annual exhibitions at the Pennsylvania Academy of the Fine Arts and the Whitney Museum of American Art.

1938 First solo showing of hammered copper sculptures at the Artists' Gallery, New York. Begins to exhibit with the Sculptors' Guild and continues to show in group exhibitions, such as at the Whitney Museum, Pennsylvania Academy, the Philadelphia Museum of Art, and the New York World's Fair.

1948 Joint exhibition of paintings by Eugenie and sculptures by Saul Baizerman at the Artists' Gallery.

1949 Won an Honorable Mention at the Pennsylvania Academy of the Fine Arts annual for the hammered copper bust, *Silence,* 1936 (John Rood Sculpture Collection, University Gallery, University of Minnesota, Minneapolis). The Whitney Museum purchased *Slumber,* 1940–1948, the first hammered copper in a museum collection. Solo show at the Philadelphia Art Alliance. Eugenie Baizerman died on December 30 of a respiratory ailment from which she suffered her entire life.

1950 Won a $1,000 grant from the National Institute for Arts and Letters for the hammered copper sculpture *Ugesie* [1933–1940] (Pennsylvania Academy of the Fine Arts, Philadelphia). Continued to show in several national and international competitions.

1952 Received a John Simon Guggenheim fellowship. Won the Alfred B. Steel Memorial Prize at the Pennsylvania Academy of the Fine Arts for *Ugesie,* which the Pennsylvania Academy purchased shortly thereafter. Showed *Crescendo (The Fifth Sculptural Symphony)* [1940–1950] (Hirshhorn Museum and Sculpture Garden, Smithsonian Institution) at the New Gallery, New York.

1953 Retrospective exhibition at the Walker Art Gallery, Minneapolis curated by Julius Held.

1954 Solo showing of *The City and the People* at the New Gallery.

1955 Married Joan Hay Baizerman (1911–1984).

1957 Joseph Hirshhorn purchased five hammered coppers and three hammered bronzes for his collection. Died of lymphoma on September 1.

INTRODUCTION

"Saul Baizerman (1889–1957) was one of the most gifted and powerful artists who ever graced the American art scene," wrote Hilton Kramer in 1967, yet he remains virtually unknown today. Active in New York from 1920 to his death in 1957, he contributed a unique body of work which synthesized traditional and contemporary approaches to sculptural expression. Through his study of Michelangelo and Rodin, he revitalized the figurative tradition, while investigating process, materials and surface expression as well. Exhibiting extensively throughout the 1930s, 1940s, and 1950s, Baizerman received numerous prizes and awards. Nonetheless, late in his life, his career was eclipsed by a generation of younger and more successful abstract sculptors. Going against the grain, cutting across the artistic trends of his time, Baizerman pursued his own artistic goals. From this stems the tragedy of his current neglect.

Saul Baizerman was born in Vitebsk, Russia, on December 25, 1889, the oldest of five children. In this Russian town which also nurtured Marc Chagall (1887–1983) and El Lissitzky (1890–1941), Baizerman at the young age of thirteen resolved to become a sculptor. He was encouraged in this endeavor by his father, a talented harness maker who hammered leather hides into intricate equestrian gear, and by his mother, an educated and cultured woman. Thus, it was no coincidence that as a mature artist, he chose the hammer as his primary sculptural tool, at first to hammer the surfaces of cast bronze sculpture, then later to hammer copper sheets into monumental figural forms. After moving to Odessa with his family, he was enveloped by the fury of the 1905 revolution. Jailed at sixteen for revolutionary activity, he escaped from prison after a year and a half, and fled to the United States. In 1910, at the age of twenty-two, Baizerman settled permanently in New York City.

In New York, he continued his artistic training, studying at the National Academy of Design, the Beaux-Arts Institute of Design, and the Educational Alliance Art School. Like many artists at the time, Baizerman traveled to Europe on several occasions. It was in London in 1924 that he found his first opportunity to exhibit his "Labor Series" (*The City and the People*) and in Paris in 1925 that he was first

introduced to direct-metal sculpture. In Paris, Baizerman became aware of the work of Pablo Gargallo (1881–1934) and Julio Gonzalez (1876–1942), contemporary sculptors who worked directly with their materials by hammering, cutting and soldering metal.

Upon his return from Europe in 1926, Baizerman adopted a technique of working directly with metals and became completely absorbed in hammering sheets of copper into monumental figurative forms. An arduous and difficult technique, the physical act of hammering became central to his sculptural expression. He transformed the sociological concerns of *The City and the People* into a more personal statement, no longer documenting the lives of others who toiled but exposing the intensive labor of his own sculptural process.

Baizerman worked with a focused intensity on his hammered copper sculpture throughout his career. Despite the tragedy of a devastating studio fire of 1931 which destroyed all his new copper sculpture—pieces which had taken several years to complete—he persisted in his artistic production and showed in numerous group exhibitions in the 1930s and 1940s. He held solo shows of his hammered coppers in 1938 and 1948, gradually gaining a reputation as a well-respected sculptor. But in 1949, tragedy hit again. Eugenie Baizerman died. From the emotional stress of his wife's death and the physical strain of the hammering, Baizerman's health began to deteriorate.

Baizerman received his highest honors during the years 1949 to 1954. He won awards from the Pennsylvania Academy of the Fine Arts, the National Institute for Arts and Letters, and the John Simon Guggenheim Foundation. Moreover, the Whitney Museum of American Art and the Pennsylvania Academy each purchased a hammered copper sculpture. In 1953, the Walker Art Center organized Baizerman's first retrospective. The prominent art historian Julius Held curated the exhibition. In his essay, Held wrote the first important assessment of Baizerman's work and challenged the art world to accept the sculptor's high standards.

The art critic or historian rarely is affected so powerfully by an aesthetic experience as to forget acquired habits of critical reaction and to respond in an essentially emotional manner. Since it is so rare, such an event is likely to be remembered—and possibly even treasured—all the more. Thus I shall probably never forget my first meeting with one of Saul Baizerman's sculptures. I had been making my way conscientiously along the walls of a large exhibition, moving from piece to piece with the slightly smug assurance of the professional gallery-goer, when I came to Baizerman's work. There was no sudden break in my routine. Nothing stopped me with a "blow between the

eyes." I looked at the hammered head before me as I had looked at so many other works, checking it off in the catalogue, examining its forms impartially, and associating them with previous impressions. Since my reaction was favorable, I noted the artist's as yet unfamiliar name. Then something unexpected happened. I did not move on. I took a few dutiful steps to the next item but returned. Again and again my eyes were moved over the lovely surfaces that rose and receded as if they were part of a living, breathing organism. Gradually I became aware that in that whole show nothing could possibly be of greater concern to me than this piece of copper beaten into the likeness of a face. It was as if an enchanting melody had been weaving its magic circles around me so that the rest of the world, and the purpose of my visit, were forgotten. All I was conscious of was a delicious sensation of sheer happiness.

It would be presumptuous to say that Baizerman is a great artist because his work affected one person so deeply. The experience, however, proved to me again that art can have strange powers; indeed, these rare moments of artistic revelation can give meaning and worth to years of reflection and study.

I do think, of course, that Baizerman is one of the major sculptors of our time, and I am confident that this opinion will eventually be shared by many. His works . . . do not conquer by shock-methods but by a slow, if irresistible, infiltration. They have great force but they do not show it blatantly. Their voice is not that of "great winds, earthquakes and fires," they ingratiate themselves in a subtler way. Baizerman himself is a quiet man with a soft way of speaking and mild manners. I have never heard him raise his voice. Yet, he is possessed by a fierce belief in himself and in the mission of his art, a belief that has sustained him in many a trying situation. He looks frail, but he works on a monumental scale and in a technique that requires enormous physical endurance. His subjects are limited to the possibilities of the human body but he has explored them as have only the greatest sculptors before him. The Greeks, Michelangelo, and Rodin come to mind, and it is indeed to this illustrious ancestry that Baizerman himself feels related, and indebted.

The response which is evoked in sensitive beholders by his works may recall different kinds of experience. They may suggest many things, just as Baizerman thinks of many things when he works on them. One fact is clear: his sculptures do not mirror or duplicate reality. They give the impression of weight and solidity, although they are hollow and made of thin metal. Some look like fully rounded pieces until we become aware that this is only due to the skill with which the edges have been dissimulated. Yet, even the views

that expose these edges add to the formal interest. Baizerman's handling of anatomy and proportion is never literal or standardized; he takes any liberties with reality which will give to his figures more animation or which will sustain the chosen rhythm. For what counts in the end is not the poetic association, or the technical tour-de-force, but the wealth of purely sculptural imagination. This indeed is the test by which Baizerman's stature in modern art will be measured. It is here that the critical observer will make the most rewarding discoveries.

A noble and moving tribute, the exhibition won much praise from artists and critics alike and provided Baizerman with one of the most gratifying moments in his life.

Over the next three years, Baizerman withdrew from exhibiting and worked independently on his last sculpture. In 1955, he married a long-time friend, Joan Hay Baizerman (1911–1984), a strikingly beautiful and cultured woman, whose poetic temperament offered Baizerman the inspiration he required. His health was continually failing and he no longer had the energy to challenge the radical artistic innovations of abstraction which had begun to capture the imaginations of critics, curators, and younger sculptors. In May of 1957 he was hospitalized, suffering from lymphoma. On Sunday, September 1, 1957, Baizerman died at the age of 67. A man of small build (5'6″ tall, 134 pounds), he left a studio full of monumental sculptures. He remained true to his artistic vision through his life—the integrity of his work being his greatest sculptural legacy.

Baizerman did not live to see his last works exhibited in his second major retrospective, organized in 1958 by Thomas Messer, then Director of the Institute of Contemporary Art, Boston. Nevertheless, he died knowing that a dedicated group of critics and patrons had supported his work, among them, the art critic Emily Genauer, Hugh Stix of the Artists' Gallery and Philip Bruno of the World House Galleries, and the collector, Joseph Hirshhorn. More recently, Hilton Kramer, Carl Goldstein, and Virginia Zabriskie have continued to keep Baizerman's work before the art public. For nearly a decade, from 1963 to 1972, Kramer's critical voice had consistently supported Baizerman's sculpture. He deplored the obscurity into which Baizerman's reputation had fallen and wished to bring attention to the sculpture which he felt was of the highest calibre. In 1963, he wrote:

> The exhibition of sculpture by the late Saul Baizerman, currently installed at the World House Galleries, presents from a body of work that is one of the most important ever produced by a sculptor in this country, but one that followed this familiar course of neglect at the hand of the critics and custodians

of both American art and modern sculpture. A look at the present exhibition will confirm for anybody with an interest in sculpture Baizerman's right to be considered one of the most powerful artists at work here, or anywhere, in the quarter-century from the early thirties to 1957, the year of his death.

The titles of several major pieces (*March of the Innocents, Aphrodite, Song of the Earth,* etc.), evoking as they do the grandeur of the great classical themes, suggest the universe of thought and feeling in which the work was conceived; but Baizerman's originality—the crux of his achievement, really—lay in his ability to embody these themes in a completely contemporary mode of expression. Which is to say, in a style that conferred on the physical medium and the method of execution an expressive importance equal to that of the subjects portrayed. By subjecting the heroic nude to the rigours of the hammered metal medium, Baizerman succeeded in revitalizing one of the greatest sculptural motifs and making it truly modern. His masterly technique in modeling (with a hammer!) an unbroken metal surface so that it forms a seamless continuum of image and matter, and his ability to inflect every contour of this metal skin with the pressure of his own sensibility in a way that seems at the same time to liberate the natural expressiveness of the material itself—these and other characteristics of his style more than satisfy the demands we have come to make on the relation of art to its medium. Where Rodin's academic progeny isolated the nude from the medium in which it was conceived and sentimentalized it beyond the reach of art, Baizerman committed the nude irrevocably to the physical quiddity of his sculptural method and thus preserved its artistic viability for our time. It was a courageous and unique achievement.

Kramer had understood that Baizerman's hammered copper technique provided modern sculpture with a profoundly new vision of three-dimensional form. In his hollow-shelled sculpture, he redefined the understanding of sculptural form by abolishing mass without sacrificing surface unity. In never dissecting or abstracting the human form, he reformulated the sculptural qualities of mass, surface, and void through the vocabulary of the heroic nude. In this, Baizerman linked formal exploration with sculptural tradition.

Baizerman intended his copper works as sculpture in the round, despite their affinity with traditional relief sculpture. In hammering the copper, he treated the concave and convex surfaces with equal importance, refusing to ascribe a "front" or "back" to any piece. In describing his working technique, Baizerman remarked: "The metal is beaten from front and back. For me there is really no front or back.

If such sculpture is placed toward the wall, we miss the enjoyment of beauty within concavities." Baizerman restated the accepted notions of convex and concave by opposing mass, as defined by the copper shell, with the space it enclosed. What appears solid to the eye is in reality a void, and what appears three-dimensional is the product of a two-dimensional surface. Though not simultaneously apparent (as in cubist-inspired works), Baizerman opposes solid and void in a format which maintains the integrity of the figure, utilizing space as an essential element of sculptural design, while never abandoning the classical human form.

His sculpture served as a link between two artistic attitudes normally considered irreconcilable. A sculptor either carved wood or stone into a figurative monolithic form or assembled or constructed sculpture in an abstract manner with space as an active agent. Baizerman synthesized these opposing elements in his hammered coppers. He borrowed from Brancusi the sculptural touch and craftsmanlike approach to materials, from Rodin the expressive potential of the partial figure with its active modeling, and from a cubist/constructivist aesthetic a denial of the monolithic form (in molding his copper into concave forms, he activated space as a pulsating force). Fitting no specific category or style, his sculpture stood independent of current artistic taste. In his synthesis of past and present, his work is best viewed within the continuum of sculptural tradition. Baizerman's work is strong, powerful, and moving; it speaks firmly of human passion, sentiment, and experience. Requiring an empathetic response—a surrender to the language of figurative form—it continues to challenge the contemporary viewer.

Melissa Dabakis

BAIZERMAN'S TECHNIQUE

To realize his sculptural vision, Saul Baizerman engaged in an exacting physical struggle with his material. In every aspect of his technique, strength and endurance were demanded, and he immersed himself unstintingly in the process. Baizerman reflected a craft ideal which had its roots in his native Russia and, more intimately, in his father's work, the hammering of leather into intricate harnesses. In his sculpture, Baizerman ever remained the craftsman, working directly with his material from start to finish. He sought in his material the most obdurate and resistant qualities that metal could provide. Requiring a resiliency that could withstand the pressure of his pounding, he ordered specially made copper sheets—the largest of which measured ten-by-eight feet—which had been cold-rolled several times, adding both strength to the copper and a bright, smooth finish to the surface.

The more he worked the surfaces of his sculpture, the more resistant they became to his hammer blows: the copper not only grew thinner as it was stretched, but also became harder, more steel-like, as the crystal structure of the molecules was transformed by the stress of the constant beating. Baizerman pushed his material to its limits, often breaking through the metal surface with his hammer, and was then forced to repair the copper by soldering the interior surface with lead.

The hammer was Baizerman's primary tool. He used rubber and wooden mallets for laying out the initial forms but a double-headed metal hammer for the bulk of the work. Due to the vibrations caused by the pounding, these tools were constantly in need of repair. Taping each wooden handle in a criss-cross fashion to prevent splintering from the continuous impact with the metal, Baizerman perfected his hammering technique—his "dead blow," the exacting stroke he applied to the copper's surface—by minimizing, but never eliminating, the vibrations.

For each sculpture, Baizerman stretched a sheet of copper over a wooden frame which he suspended vertically by a series of ropes and pulleys from a ceiling support. He hammered the principal volumes of the sculpture from behind; then, in the finishing stages, he worked both sides of the sculpture at once, responding to the subtle give and take of the metal. Working in this fashion,

Baizerman would occasionally be knocked to the ground by the rebound of the hammer blow. Eschewing a cushion, Baizerman's body itself absorbed the shock of these strokes. The sculptor rejected the use of materials which would absorb the vibration or ease the strain of the pounding. Likewise, he also rejected the *repoussé* technique where wood, pitch or tar would be placed behind the copper sheet to serve as a mold into which the sculptor would pound his metal, on the grounds that such accessories would impede free movement around the work and deny access to essential portions of it. Baizerman imposed his force of will directly upon the copper, consumed by the desire to pound vitality into the inert substance.

In doing so, Baizerman was able to establish a direct relationship with his material. Describing this process, Baizerman compared it to the relationship of a painter with his canvas and spoke of a need to find "a material which will respond directly to the sculptor's emotions, as canvas and paint respond to the artist-painter." Working simply and directly, he used no intermediaries to thwart his sensitivity to the material. With the exception of two works (*March of the Innocents* and *Exuberance*), Baizerman never used sketches or models when sculpting. Rather, he hammered the copper directly, assured at the very start of the final form. In correspondence, Baizerman wrote:

> Working in the hammered metal, I must be completely certain of direction, visual appearance and the character of its form harmonies before commencing the actual work. In my mind it is finished before the first strokes of the hammer.

Baizerman required little preparation in commencing. As he began hammering the copper, he would first "spot" the surface, establishing where the mass of his design would be placed. Once this initial decision was made, the progress of the work then depended upon the acuteness of his sensitivity to the material.

For Baizerman, hammering copper took on a significance which rivalled all else in his life. He immersed himself in the sculptural process to the point that it greatly contributed to the ruin of his health. The vibrations from the incessant hammering not only damaged the fine motor control of his hands but also affected his heart; the constantly loud noise of the banging partially impaired his hearing, and the poisonous oxides from soldering the brittle and cracked copper led to his fatal cancer. Baizerman poignantly remarked:

> On the whole it is a tough job. No other method of sculpture can equal its problems. It is a nerve-shattering work, affecting the heart rhythm. For the vibrations speed it up and more so as a sculpture reaches completion. For the

copper then becomes very springy and rings as a bell with the vibration, easily to be heard from three blocks away. That the vibration is so intense can be seen from the shredded hammer handles that used to happen every couple of weeks, until a method of crisscross taping was developed. But I have not been able to discover some method of preventing the vibrations from entering the body through the arms.

The arduousness of this technique was an essential part of his total physical and emotional participation in the creative process. The intense labor of his hammering was necessary, indeed essential, to his personal expression:

> How do I know when a work is finished? When the piece has taken away from me everything I have to give, when it has become stronger than myself; when I become the empty one and it becomes the full one; when I am weak and it is strong, the work is finished.

While often thoroughly worn out by this process, the labor of hammering served as a life-giving force. As he sacrificed his energy for his sculpture, so was he revitalized each time he returned to creating. Contact with his work recharged his vitality: "My cheek touched the cool metal, a familiar feeling. Strength seemed to flow into my body."

Baizerman transformed the very essence of his material, creating plastic form out of a flat surface. He pushed the metal to grow and swell and eventually develop into a defined form. Like the growth of an embryo or the budding of a plant, the worked-on copper simulated a process of organic growth. Baizerman's method seems thus to resemble the hand of God, infusing nature with energy: "To express the incomprehensible elements of life, the sculptor's emotional power breathes living elements into dead material. That is magic indeed."

Along with the Greeks and such contemporary exponents of the direct carving method as Henri Gaudier-Brzeska, Jacob Epstein, Constantin Brancusi, Jean Arp, Barbara Hepworth and Henry Moore, Baizerman looked to two other sculptors: Michelangelo and Rodin. He was particularly moved by Michelangelo's intense commitment to the sculptural process and the emotive power of his forms. Likewise he was also attracted to Rodin's agitated and dynamic modeling, as well as to the expressive potential revealed by his use of fragmented figures.

Despite the difference in expression—Michelangelo conveying a violent and eruptive passion and Baizerman, a delightful and harmonious order—both artists sought to free an energizing force from the confines of sculptural matter while sharing the arduous struggle of imposing their artistic will upon resistant material.

As Michelangelo, he believed that direct participation in the sculptural process was essential to expression. In a letter to him, his wife Eugenie drew his attention to a passage from a biography of Michelangelo which she had been reading:

> To the end one remains with the impression: work, work, work, this is what his life was, everything leading to that, his life's joy was expressed in that. . . . Working makes him healthy, he would say when he was around eighty.

Interpreting this in very personal terms, both he and Eugenie envisioned Michelangelo's labor as the activity which brought fulfillment to his life—an activity which served precisely that function in their own existence.

In technique, Baizerman's was one of slow, painstaking direct carving. In form, however, his sculptures differed substantially from works in wood or stone. In place of the simplified volumes and solid masses emphasized by the carvers, Baizerman manipulated his copper to create actively modeled surfaces and dynamic effects of light and shadow (akin to Rodin) which instilled a quality of animation and movement—metaphors for the endlessly moving sensations of life.

Baizerman looked to Rodin for inspiration in bringing his sculptures to life, adopting his formal means of achieving animation. In conversation, Rodin stated:

> Art does not exist without life. When a sculptor wants to interpret joy, pain, any passion, he cannot move us unless he first knows how to make his figures come to life. For what is the joy or pain of an inert object, a block of stone to us? Now the illusion of life is obtained in our art by good modeling and by movement. These two qualities are like the blood and breath of all beautiful works.

With modeling, Rodin produced an actively flickering surface, responsive to the transient effects of light. For Baizerman, these qualities assumed great importance. However, in assimilating the lessons of Rodin, he synthesized them into his own personal vision, at first in hammered bronze statuettes and later in hammered copper sculpture.

It was only through his hammered copper technique that Baizerman was able to realize fully his goal of plastic animation within the partial figure. Baizerman explained the significance of conveying movement in sculpture thus:

> The sculptor's task is not to present the actual, as if he were taking a cast of a body in an action pose—this would result in an immobile and petrified appearance—but to create an illusion, an illusion of mood, movement, life.

When Baizerman speaks of an "illusion," he speaks of that mystery of life that Rodin described as "the gradual unfolding of a movement" in time. Whereas a

photograph or a cast of a figure in motion was a frozen, static image—life depicted in a single instant—a sculpture imbued with life-force simulated movement in duration, so capturing life's essence as change:

> As decorative sculpture is static in expression, it clashed with my dreams of endless movement. . . . All around me I sense an endless movement which varies in intensity and in the character of its rhythms, but never arrives at a dead end. . . . I still judge sculpture from this point of view. I feel sad when I am not able to give an illusion of endless movement in my forms.

Baizerman's sculpture often conveys a sensuality suggesting an inner life force. In one of his sculptures (*Nana*), the female figure heaves as in the throes of orgasm. Her breast rises upward, as in response to the vital energy flowing within. Baizerman often utilized a warm, earthy patina which softens the metal's texture, creating a golden glow by scumbling brown and gold paint on the copper and then applying a soft wax shine to the surface.

In many instances, Baizerman also communicates the sensation of movement through the sheeting at the periphery of the sculpture. This copper sheet functions as an active surface which gives impetus to the rising form. Slightly fluted at the edges, the copper plane embellishes the sculptures:

> I have wanted to eliminate the stops or edges of the form and suggest continuing motion, because the borderline was the element that registered the stops and thereby created the static state.

Baizerman's sculptures are supported on wrought iron armatures. Often suspending his figures above their bases, he attempts to deny their static quality by freely positioning them in space.

For Baizerman, the human figure was the vehicle through which he communicated the splendor of nature. With their gently rolling rhythms, his female figures serve as metaphors for the dynamic sensations experienced in the natural world:

> This figure must speak of contentment of a being who feels the value of its own beauty. The time is endless for her. . . . She is a reflection of nature and thus is endless in space and time. Death has no meaning to her, it is far away, as something not clear, a shadow falling so very slowly that only cools but not chills.

Like the natural formations of the earth, these figures appear to rise out of the soil, the embodiment of the life-pulse of nature in defiance of death. In a pamphlet which accompanied an exhibition of his sculpture in 1948, Baizerman wrote of the

importance of natural forms to his artistic expression:

> We sense in these pieces, although of human shape, movements of nature in rivers, in sloping mountains, in the flatness of fields and quiet brooks, or the turbulence of the sea. We are never conscious of design delineation—but a movement, in various tempos and rhythms. Though a beginning might be defined, the edges flow away, making a perpetual interplay. The pose or action is usually simple, but the inner movement is dynamic, until through its vibratory speed it appears static.

Throughout his work, the condensed essence of life's forces is manifest, suggesting the dynamics of nature; in this, the sculptural process emulates the creation of life itself.

Melissa Dabakis

SELECTED BIBLIOGRAPHY

"Artists for Art's Sake" [Saul and Eugenie Baizerman]. *Newsweek* 32 (13 September 1948): 88.

Baizerman, Saul. "Thoughts About Sculpture." In *Seven Arts*. Edited by Fernando Puma, pp. 52–56. New York: Doubleday and Company, 1953.

_____. "The Journal, May 10, 1952." Edited by Carl Goldstein. *Tracks* I (Spring 1975): 8–23.

Dabakis, Melissa. "The Sculpture of Saul Baizerman, 1889–1957." Ph.D. dissertation, Boston University, 1987.

Goldstein, Carl. "The Sculpture of Saul Baizerman." *Arts Magazine* 51 (September 1976): 121–25.

Goodnough, Robert. "Baizerman Makes a Sculpture." *Art News* 51 (March 1952): 40–43 ff.

"Hammered Statues." *Life Magazine* 25 (4 October 1948): 157–58 ff.

Held, Julius. *Saul Baizerman*. Minneapolis: Walker Art Center, 1953.

Kramer, Hilton. "Saul Baizerman (1889–1957)." *The Nation* 196 (February 1963): 127–28.

_____. "A Lost World." *New York Times,* 26 November 1967, sec. 2, p. 23.

_____. "Show of Sculpture in the Heroic Style." *New York Times,* 22 January 1972, p. 25.

Lansford, Alonzo. "The Baizermans." *Art Digest* 22 (September 1948): 18.

"Man with a Hammer." *Time* 61 (2 March 1953): 62.

Preston, Stuart. "Extremes of Vision and Design." *New York Times,* 21 September 1958, sec. 2, p. 19.

Saltpeter, H. [H. S.] "The Man with the Hammer." *Coronet* 5 (January 1939): 135–40.

Saul Baizerman. Foreword by Thomas Messer. Boston: Institute of Contemporary Art, 1958.

"Saul Baizerman in Boston." *Arts* 32 (June 1958): 30.

ON PHOTOGRAPHING THE SCULPTURE OF SAUL BAIZERMAN

It was at the World House exhibition of 1963 that I first became acquainted with the sculpture of Saul Baizerman. This work seemed to me to have a spellbinding quality. My wife and I were thrilled at the possibility of acquiring a sculpture of Baizerman and we purchased *Astarte* for our own home. Since then it has stood in front of a window adjoining my bedroom. Exploring its endless beauty each morning and evening has proven a continual joy of discovery and the work grows more seductive the longer I live with it.

My enthusiasm for Baizerman's sculpture was further heightened when I saw the exhibition of his work at the Storm King Art Center in 1978. I was then able to acquire a second Baizerman work (*Elegy*) for our home, and that sculpture stands at the entranceway, adding its marvelous presence to our daily lives.

The idea of photographing Saul Baizerman's sculpture for a book grew as my love for these two works deepened. I wondered if I would ever be able to reveal through my camera's eye the remarkable inner beauty which I found so compelling. The lack of recognition he had received over the years was, if anything, a stimulus to find a way to show the greatness which has been ignored for so many years.

It would be difficult, I knew, to capture on photographic film Baizerman's sensitive reliefs with their gentle curves and swelling forms which the naked eye sees when it roams over his sculptures. The magic in the metal creates a surface that appears to be as soft and yielding as flesh itself, and one can almost feel the pulsing of a living body within the forms. But most of this would be invisible to the camera's eye, and the image on the film would probably do little more than delineate flat and formless shapes. The deep, rather monotonous, color of the metal would swallow up all the subtleties in the work.

When the opportunity finally arose to produce what is in effect a photographic essay of Baizerman's work, I knew that the problem of lighting it properly would be a major challenge. During my early years as a photographer of sculpture, I had valued the qualities of natural light, and in my books on Donatello, Michelangelo, Canova, Cellini, almost all of the photographs were taken without special lighting.

My theory was that either the artist himself or the one who had installed the work had the existing light in mind when placing the sculpture in its position, and I would do well to take advantage of that knowledgeable judgment. The same was true when photographing works by Henry Moore out of doors where the light from the sky brought out the forms the sculptor intended one to see. But Baizerman was different. Without special lighting, I felt that the extraordinary qualities of his work would be lost.

All of the sculptures in this book were photographed either in private homes or in museum storerooms. (The four works owned by The Metropolitan Museum of Art had been on display when the new twentieth century wing was opened in the Spring of 1987, but after that opening exhibition was over, they were banished again to the storerooms.) Although I would have been gratified to see his works on exhibit, having them to myself where I could have the freedom to control the lighting in relatively uncluttered places proved to be a distinct benefit. This was true even when the space was not ideal for photographing as was the case with the large *Infinity* in The Nelson Rockefeller Collection at Pocantico Hills, where the narrow gallery, worked out with Philip Johnson's help, presented a major photographic problem which took quite a bit of maneuvering to solve.

After considerable experimentation, I discovered how to use my lighting to bring out the form harmonies which were intrinsic in Baizerman's sculptures. Soft shadows were necessary to show the rhythm in the forms, but they had to be handled carefully so as to avoid creating sharp lines which would distort the shapes. In many instances I spent a good deal of time searching for the right lighting balance and re-adjusting the position of the lights to produce the desired effect as I turned the sculpture around to photograph it from different angles. I often took thirty or forty photographs of an individual sculpture and then worked in the darkroom to print those which I found most revealing.

The photographs that I found particularly satisfying were of surprising views in which I could express my own creative response to the work. These enabled me to make exciting discoveries of things the naked eye would not ordinarily see. I was especially amazed by the beauty of the outlines of the works. In the past, I had always loved the gentle surfaces of his sculpture, but I had not been aware that the edges of the metal were also sensitively shaped. It was not until I began to look at the contact prints of my negatives that I realized how beautiful those forms were. I also realized that the side and rear views, especially those in which one could simultaneously see part of the front and part of the back, were just as commanding as the straight-on views from the front. Not only were the shapes perfectly com-

posed, but the iron supports were twisted and turned to provide an organic skeleton which was an aesthetic counterpart to the concave forms of the interior of the reliefs. Moreover, the wood bases to which the metal supports were bolted proved to be architectural forms specifically designed to set off the unique qualities of each sculpture.

The works shown in this volume were not selected with the idea of giving a retrospective overview of Baizerman's work. Rather they were chosen as ideal subjects for a photographer's eye. The purpose was to probe in depth the remarkable sculptural qualities in the sculptor's unique way of working with his chosen material.

The book is intended as a photographic essay, with the sculptor's own words providing insights into his sensitivity and vision. Saul Baizerman was a fine writer as well as a superb sculptor and a typescript of his journals which run over 1,000 pages is an inexhaustible source of poetic thoughts about the creative process. By combining extracts from his diary with a photographic exploration of his work, it is our hope that readers will gain some idea of the greatness of Saul Baizerman's sculpture and that his position as one of the leading artists of our time will be more firmly secured.

David Finn

If we think of a body form as the
perfect instrument *with which to*
speak of our thoughts and sensa-
tions, of the visions of harmonies
unknown to humans before, of
the means to speak of joy and
happiness and sorrow and pain of
life, or of our reverence for a per-
fection beyond reality, of those
great musical harmonies that we
seem to hear at our best moments,
of our love for one whom we ele-
vate and place among the gods—
these are the illusions of art.

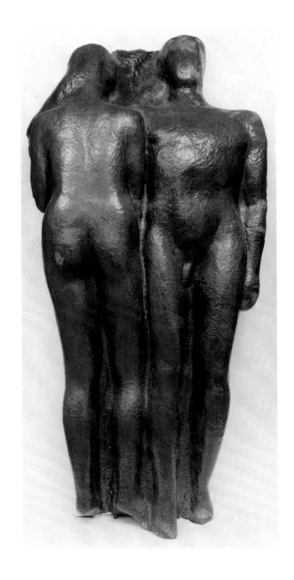

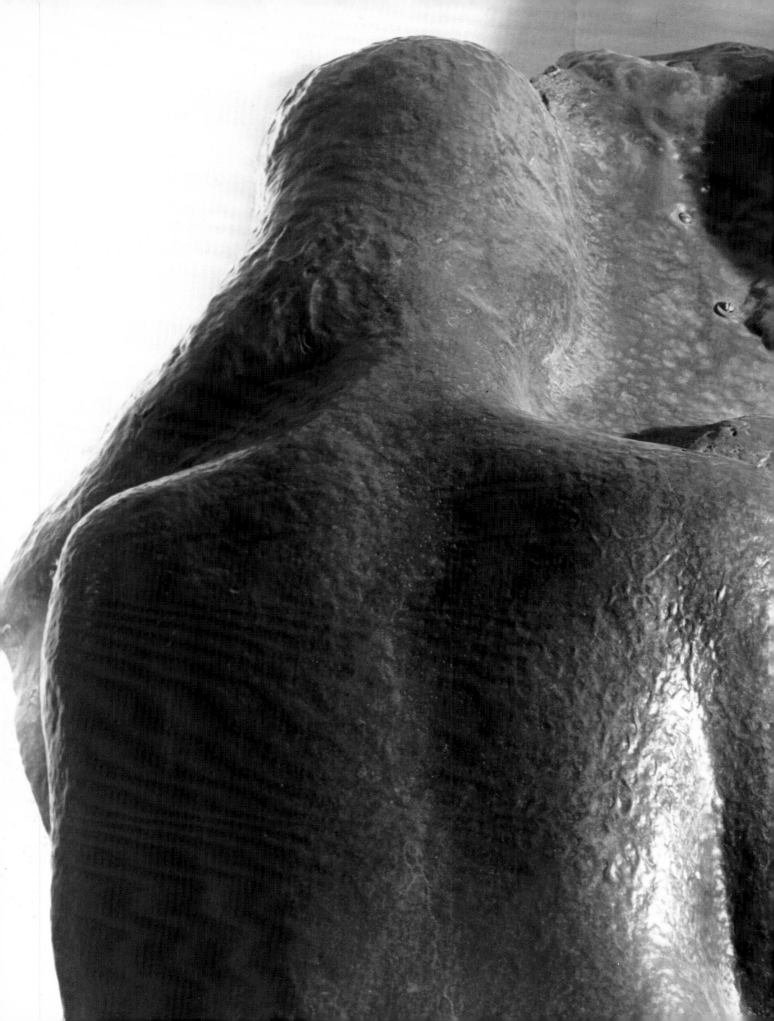

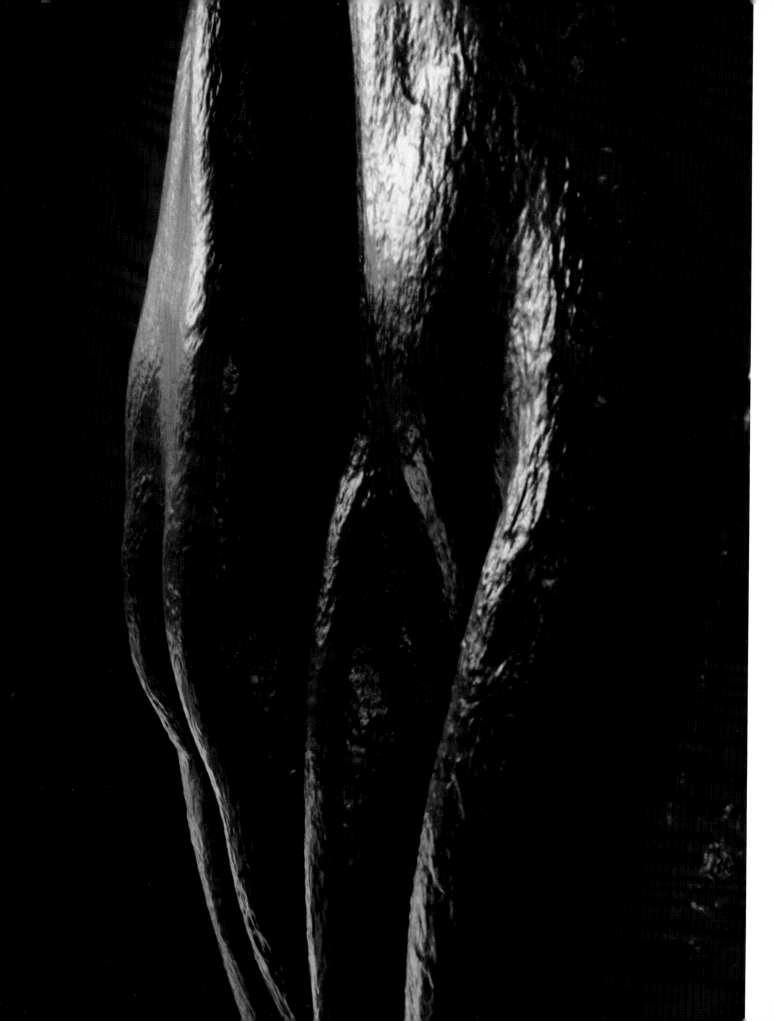

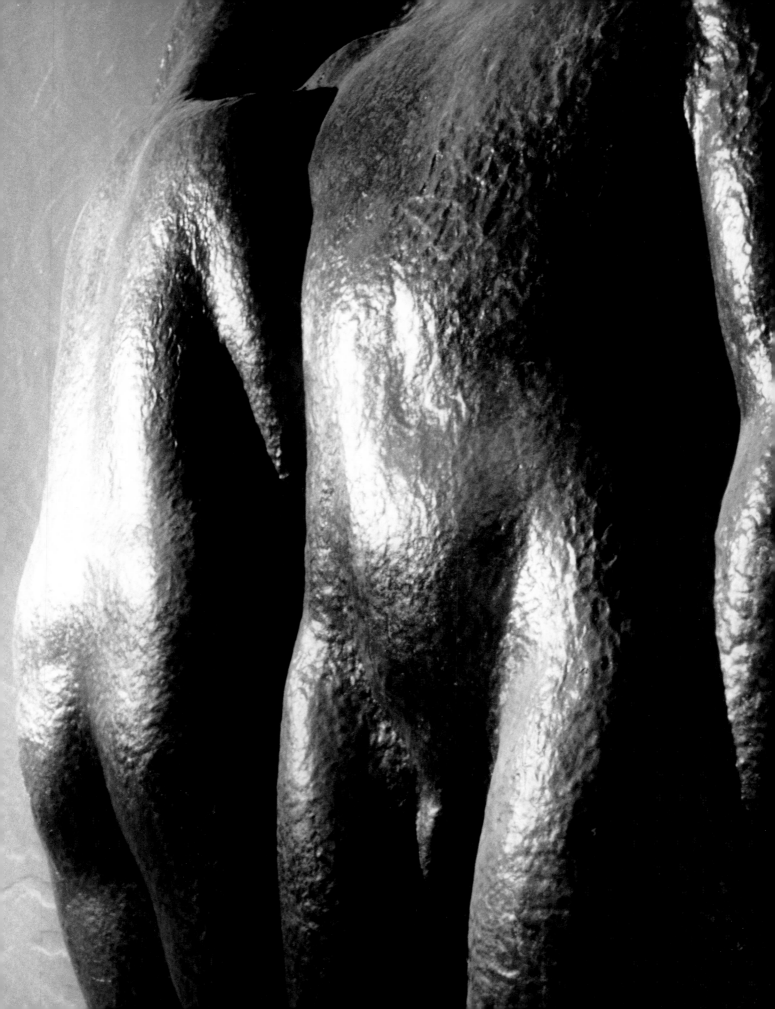

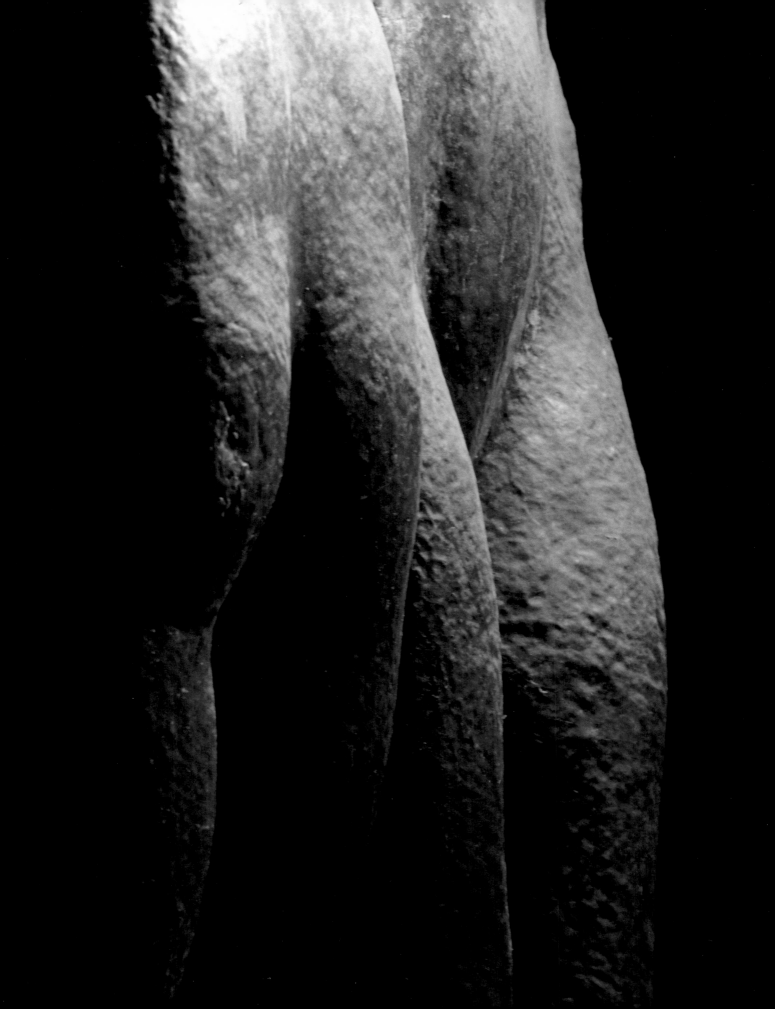

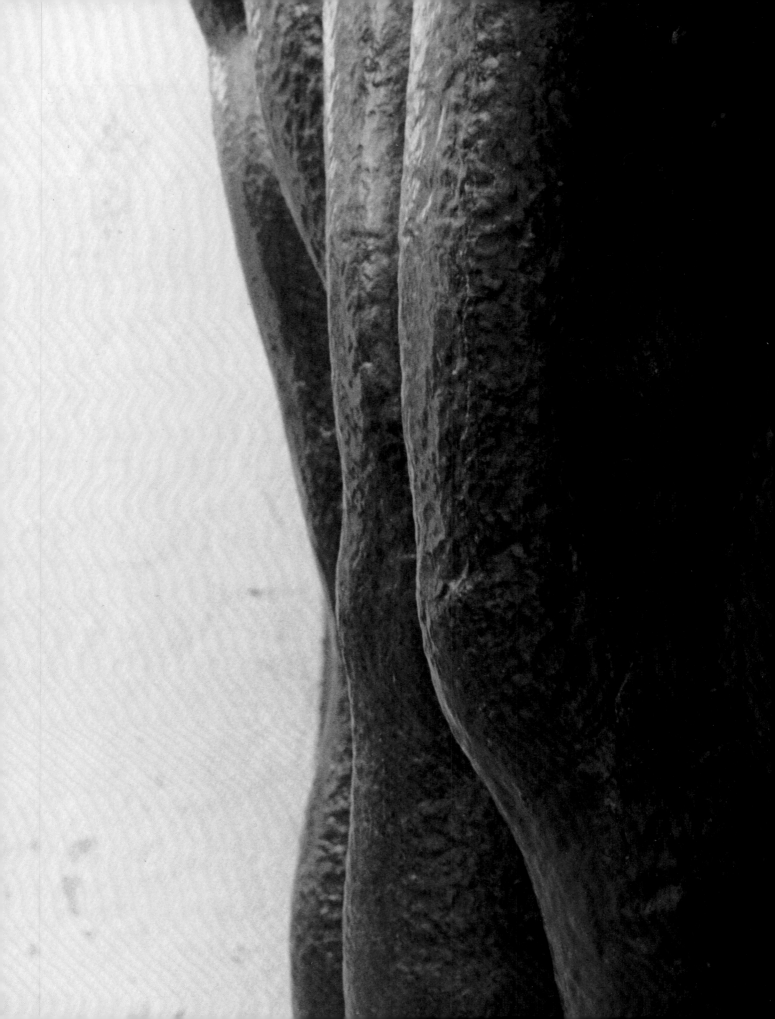

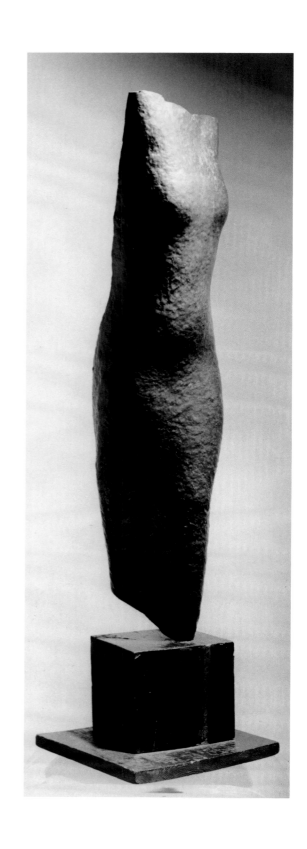

I plan the conception of a part to be a whole. . . . A frontal sculpture has no back, and a back in front has no front in back . . . the design of the open back was intentionally arranged (while appearing accidental). . . .

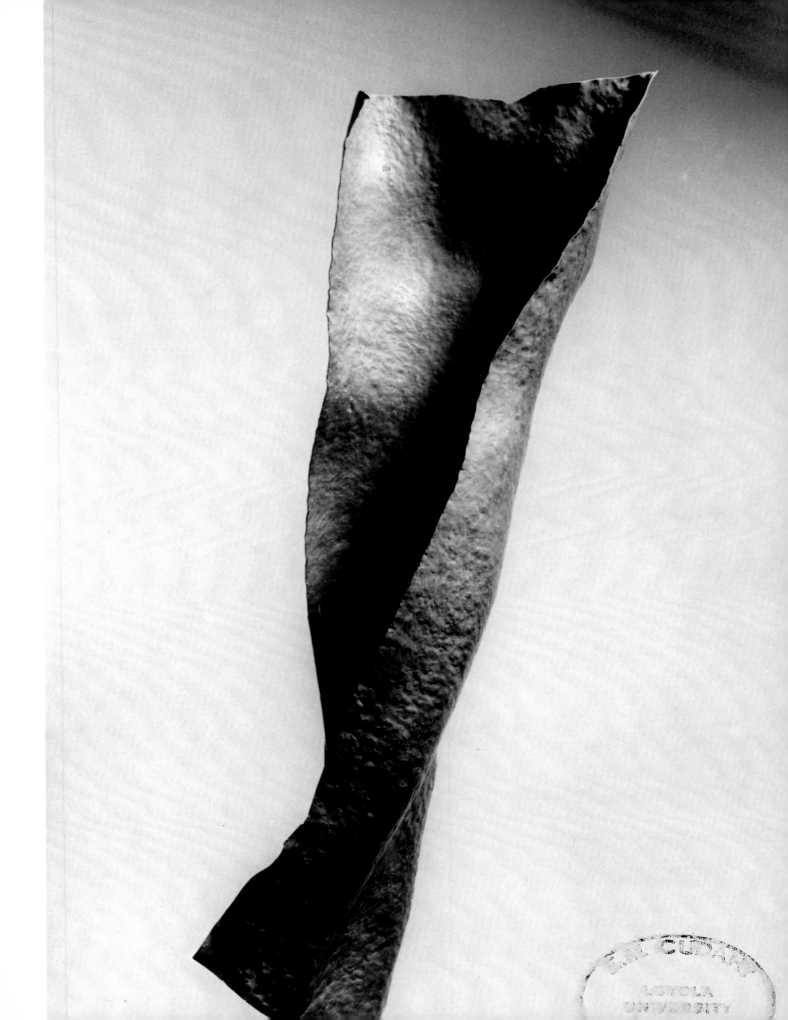

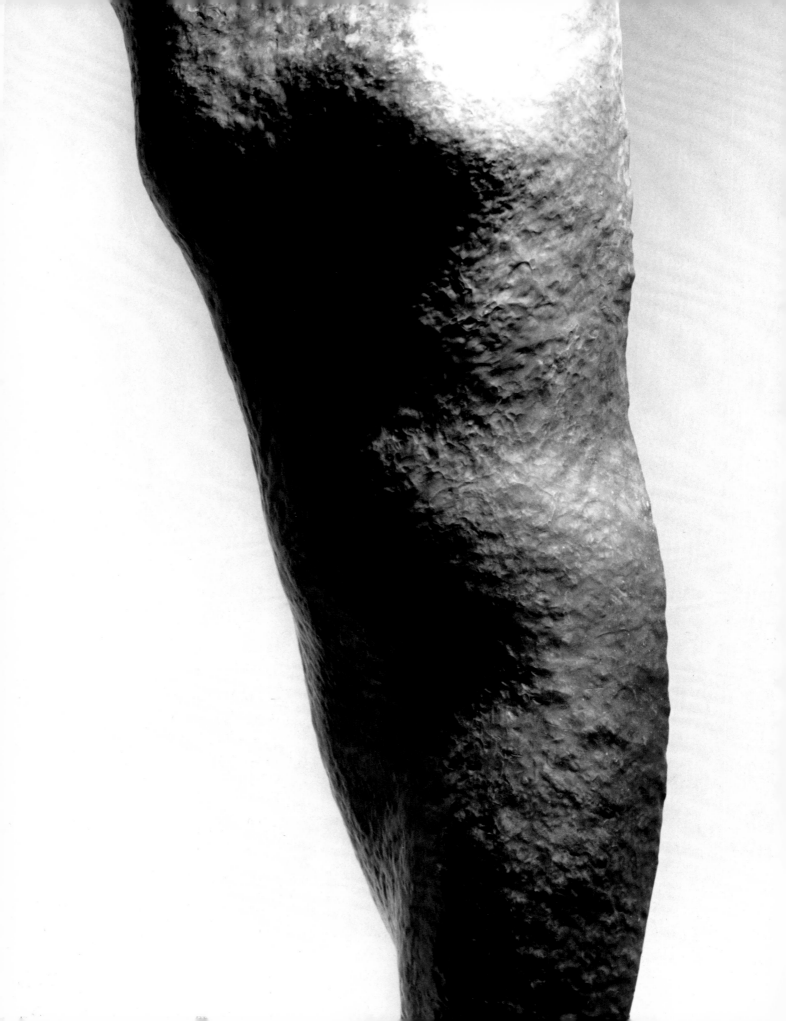

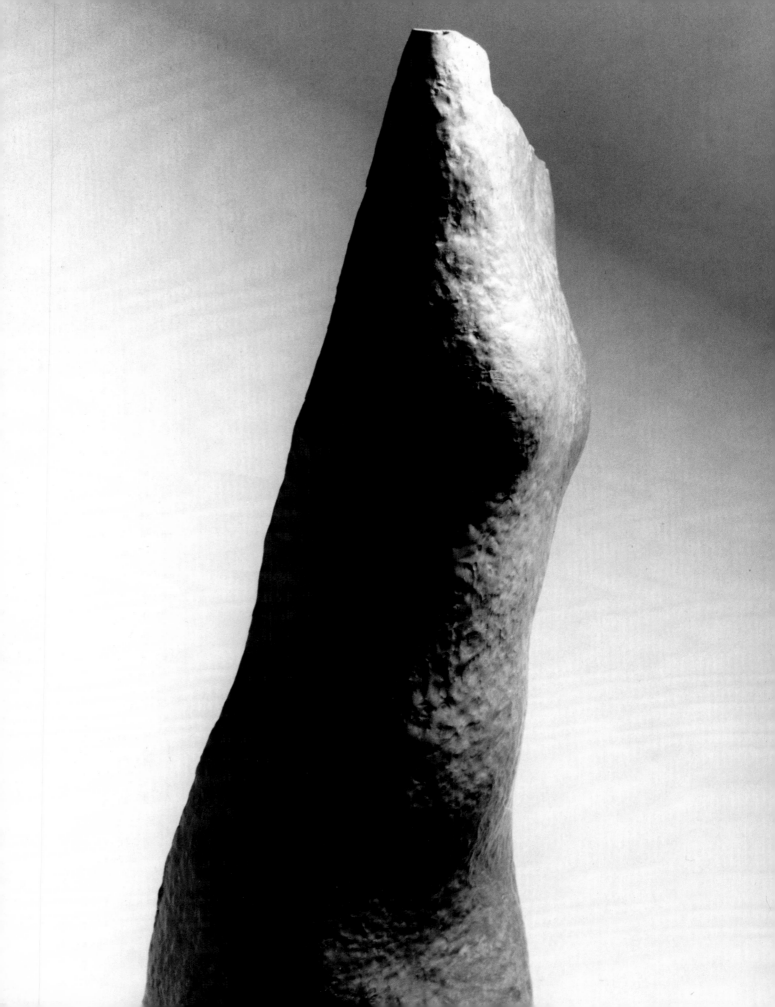

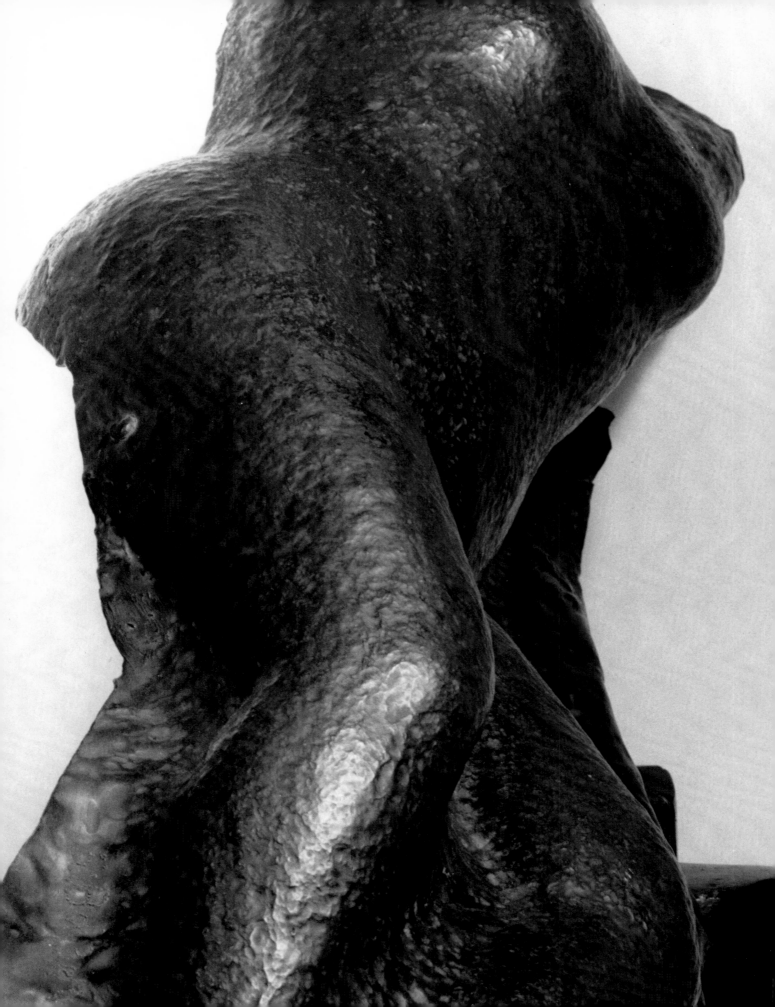

Art must possess the quality of
dreams, which lift a human being
as a child to finer aspirations. . . .
It must possess the suggestiveness
of living—for the dead material,
the dead forms, must breathe and
move and change—yet never seem
to leave the place they are in.

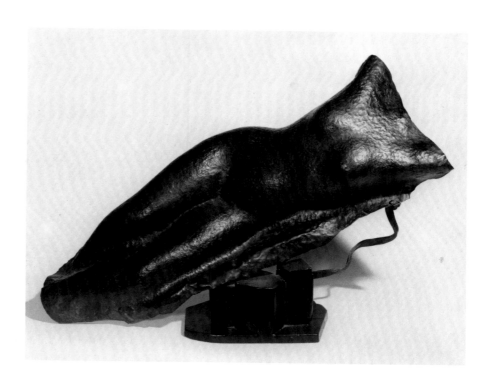

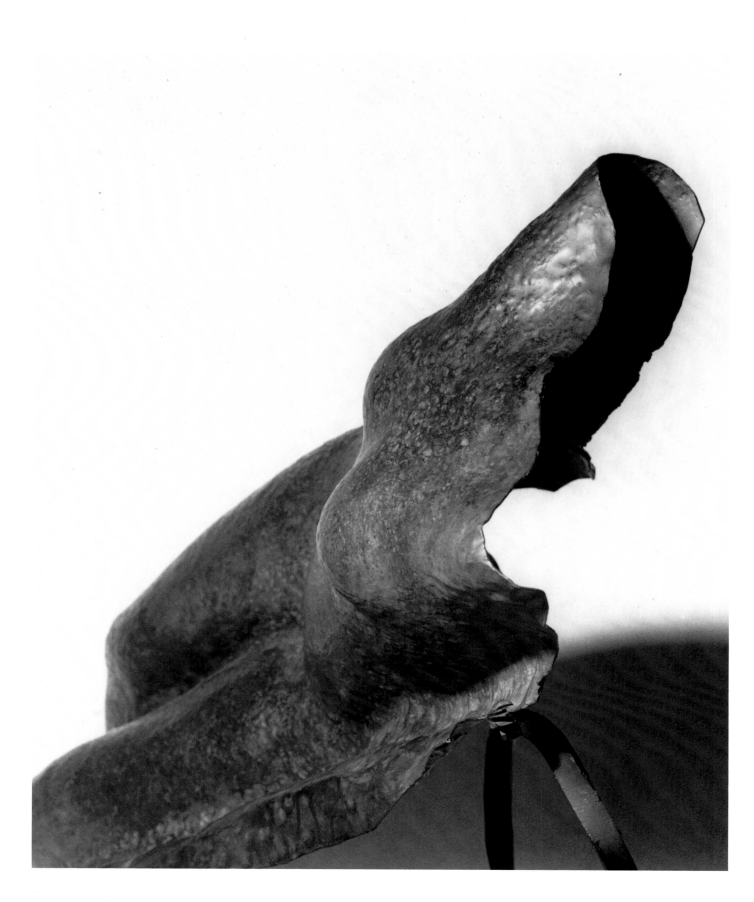

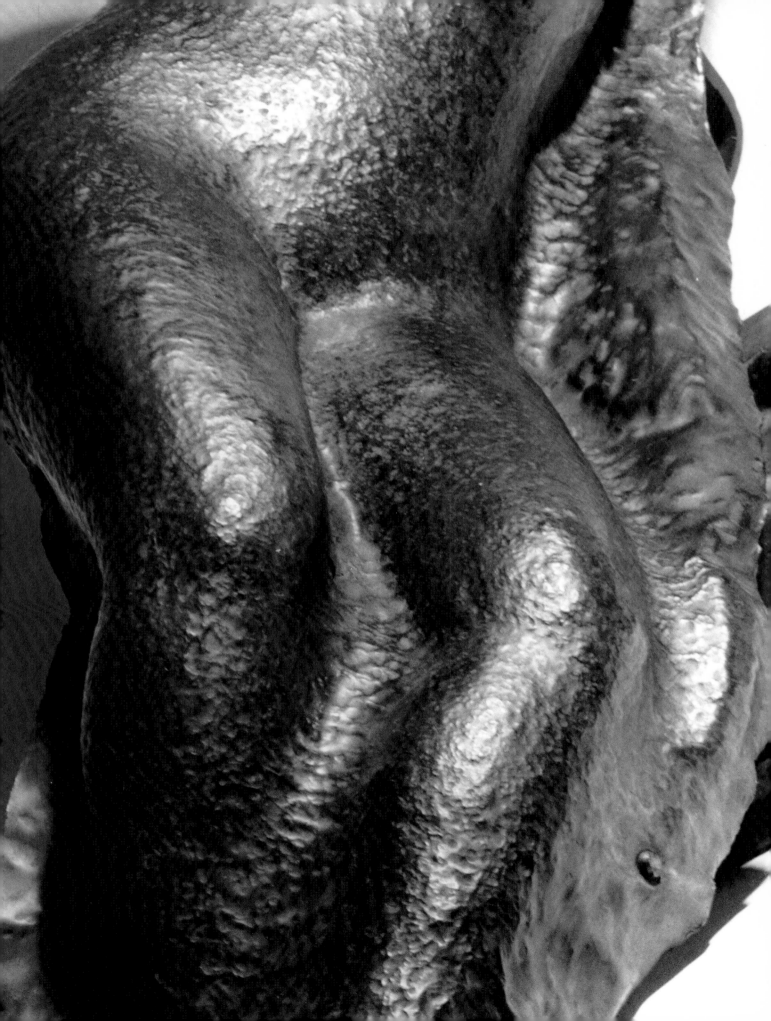

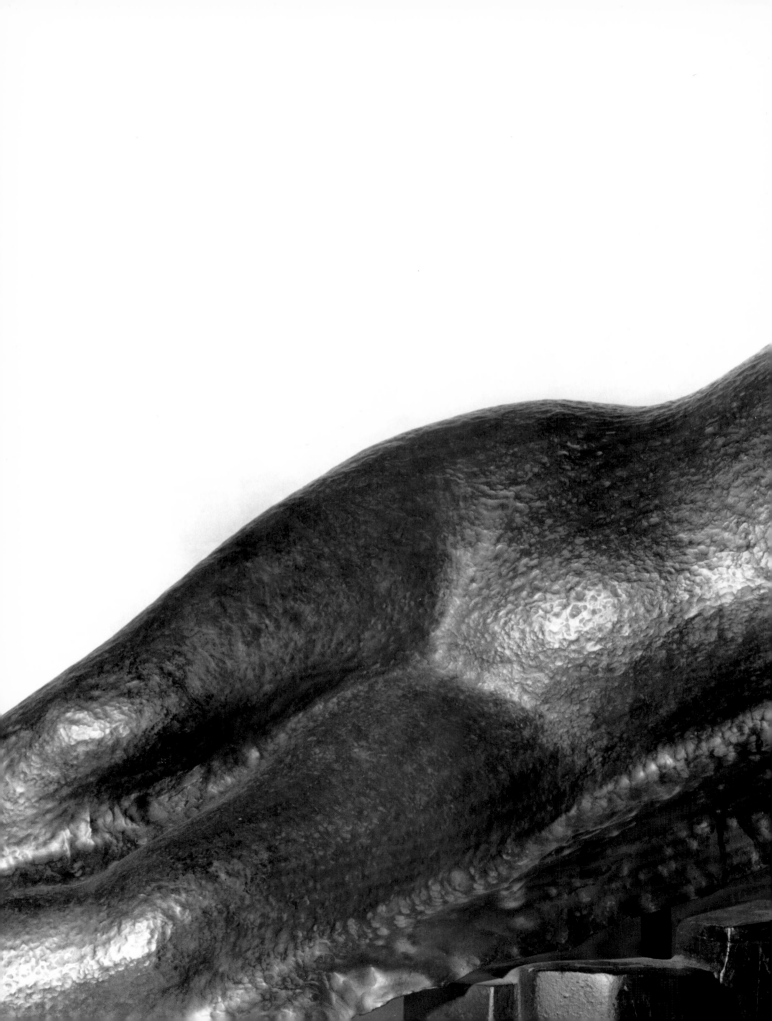

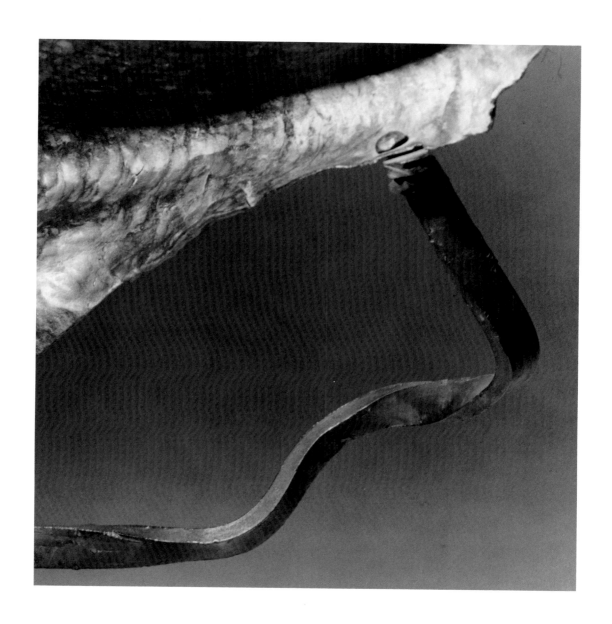

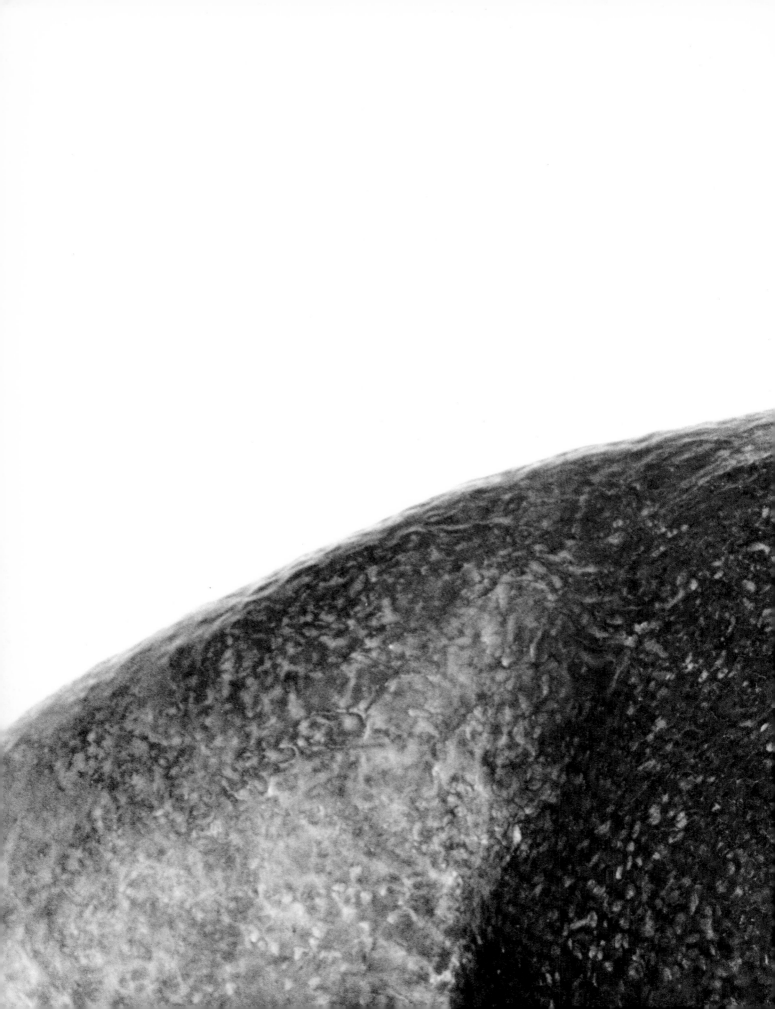

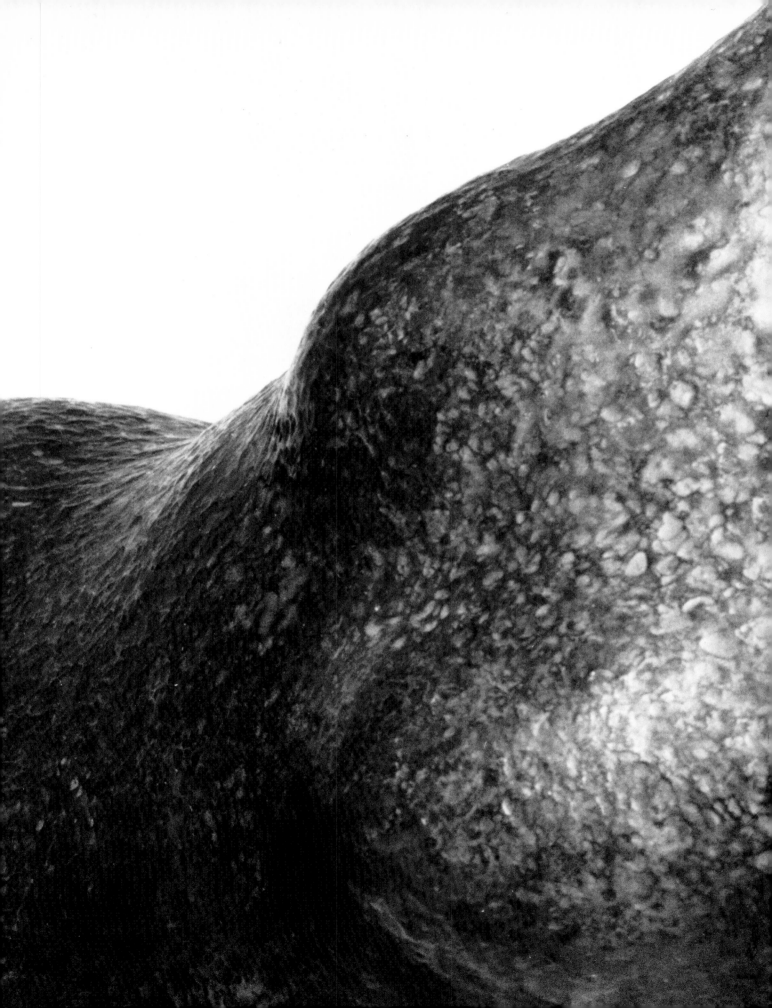

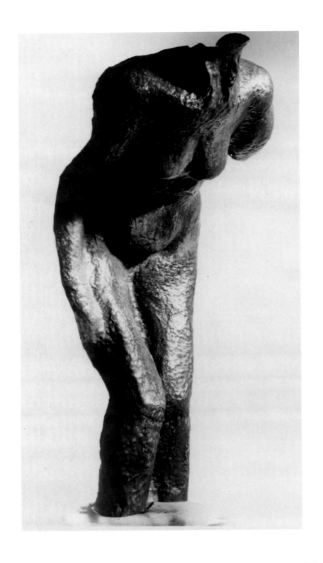

The copper sculpture has its limitations in the shaping of the curvatures. That means also a limitation in the arrangement of light and shadows. I have been successful in doing often what seems an impossibility.

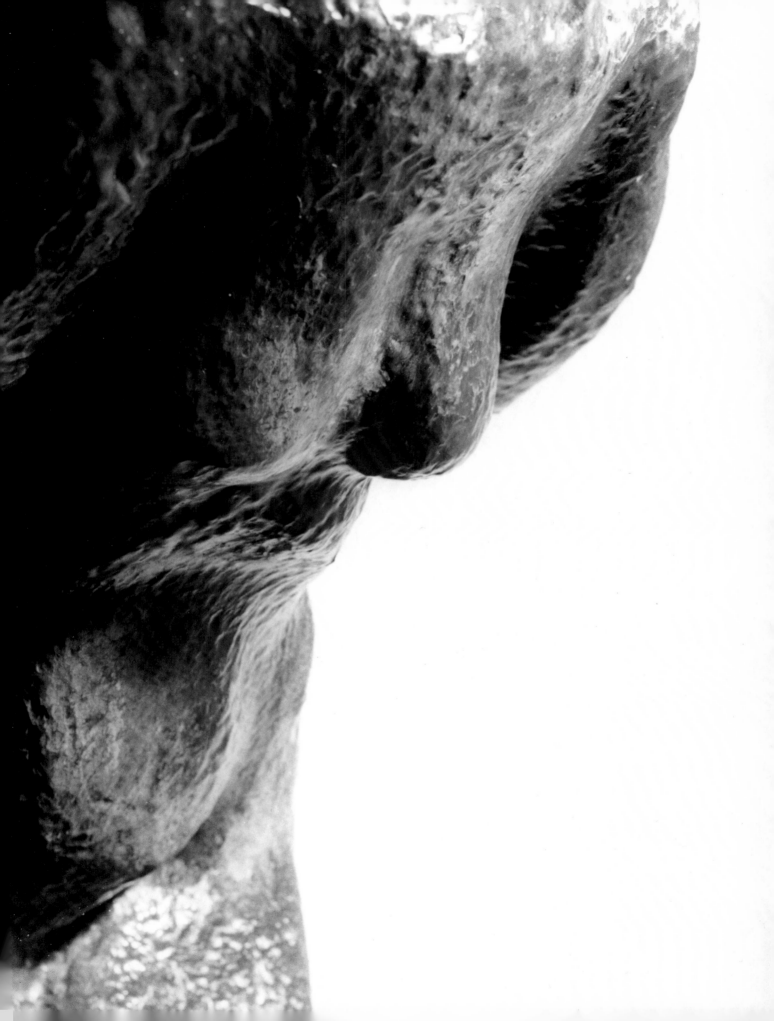

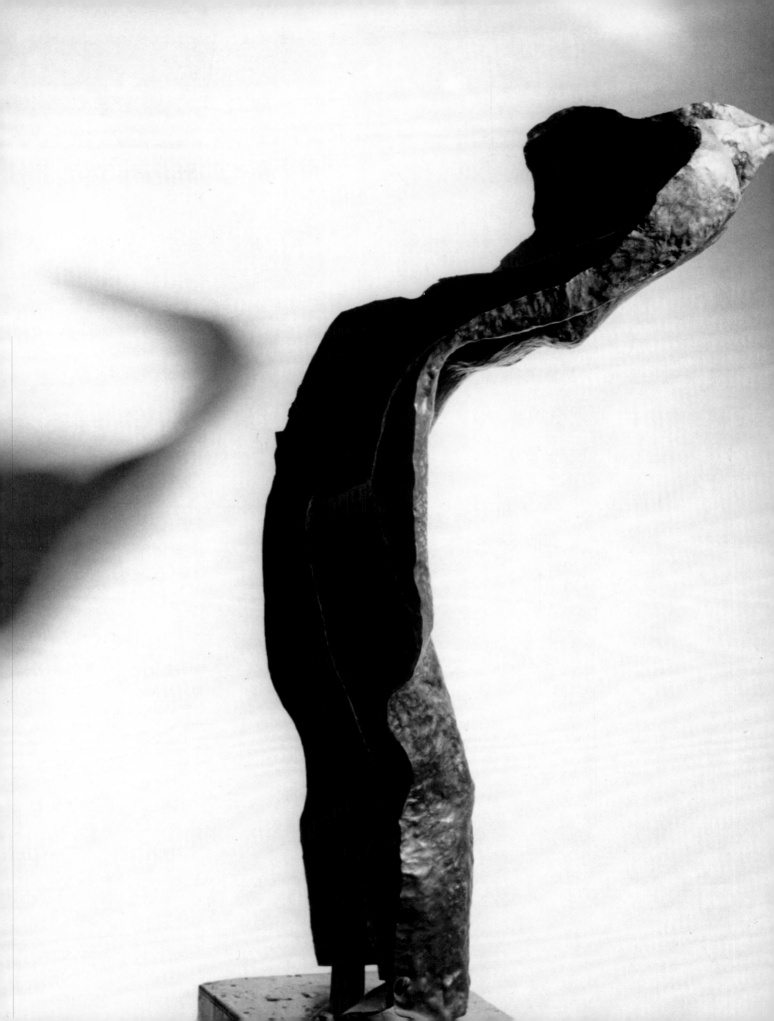

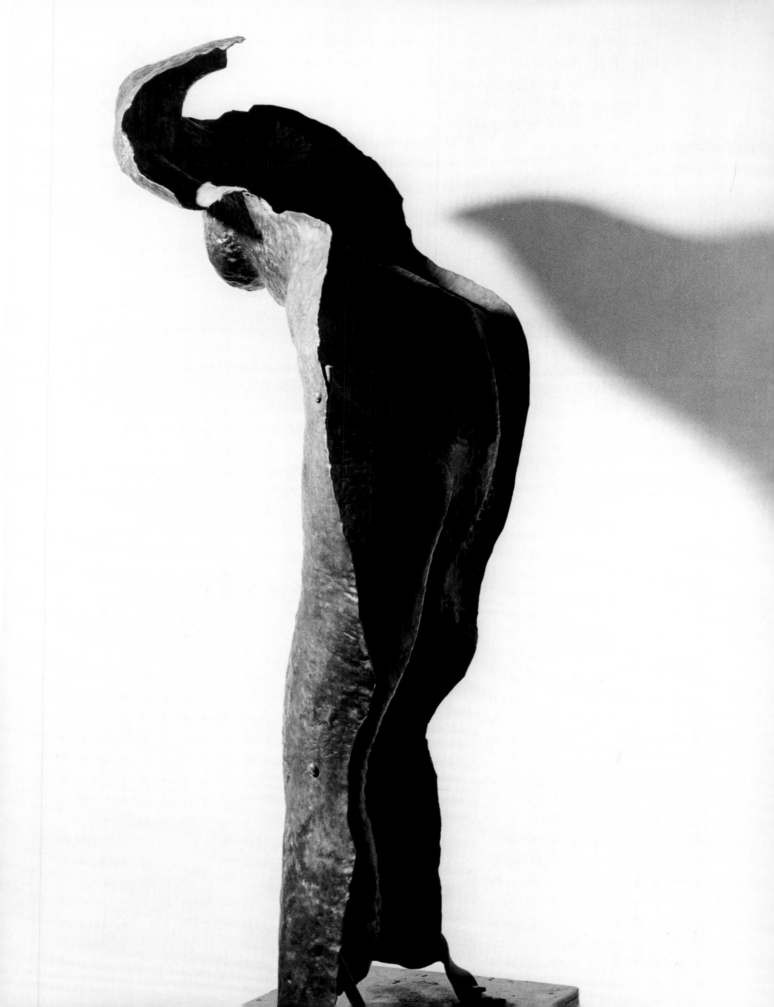

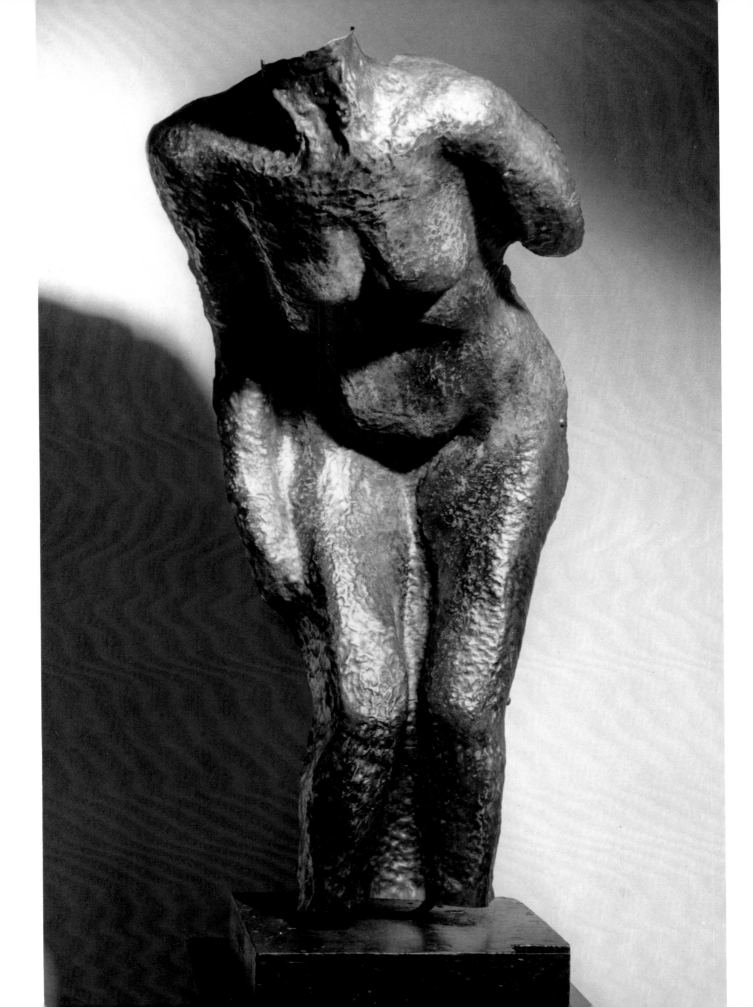

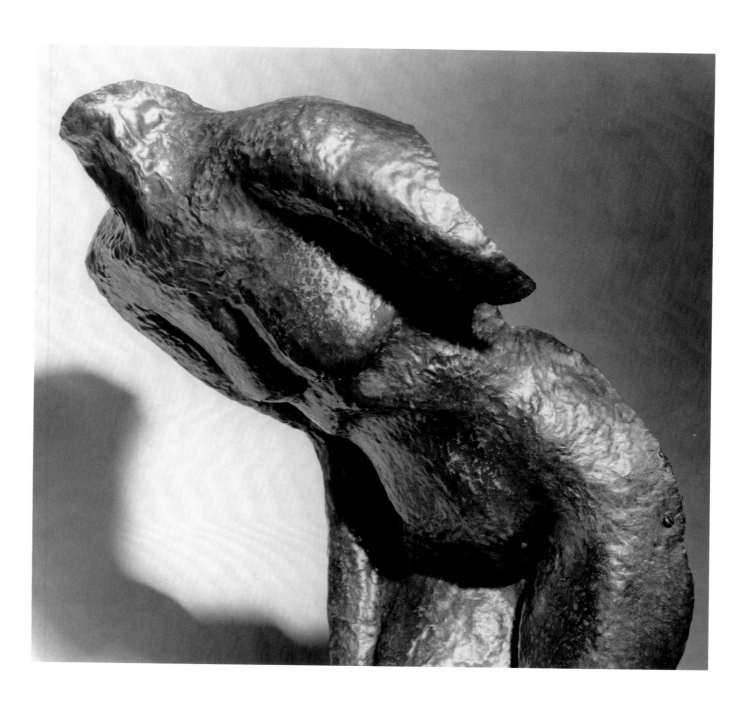

We may be affected by a tree, a mountain, a cloud, a light, a part of the body. . . . But when the human being becomes an artist, when he adds something individual to that collection of sensations, when they pass through his personality, those sensations are . . . organized into a homogeneous thing. . . .

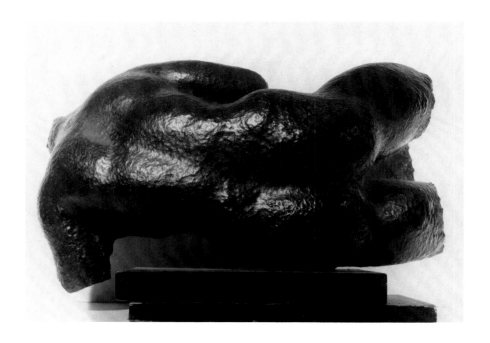

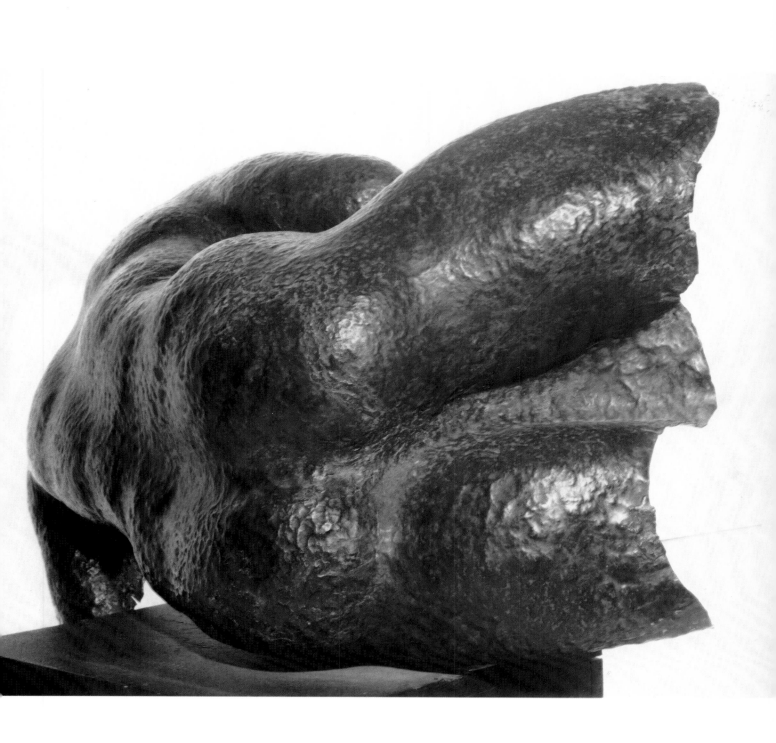

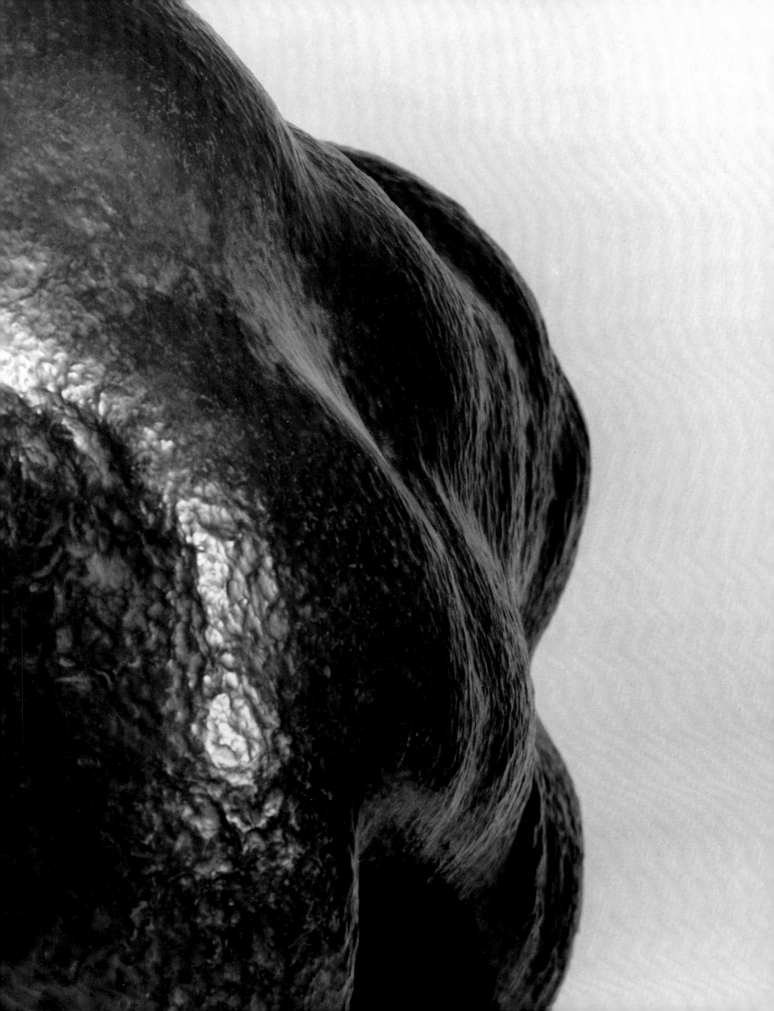

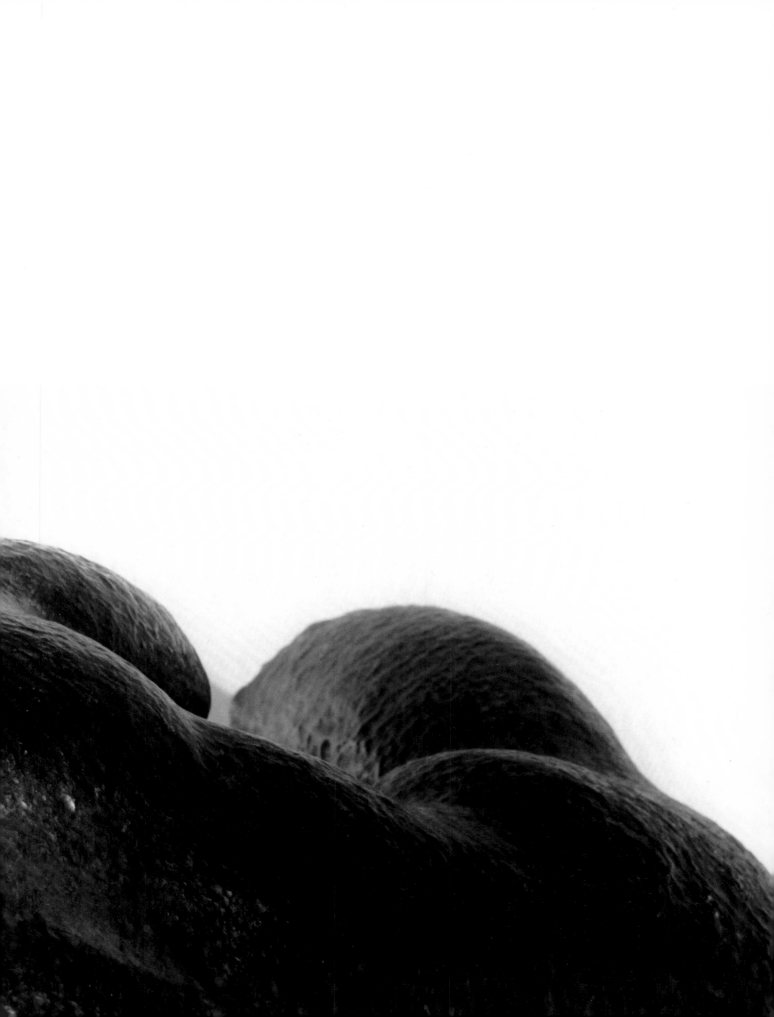

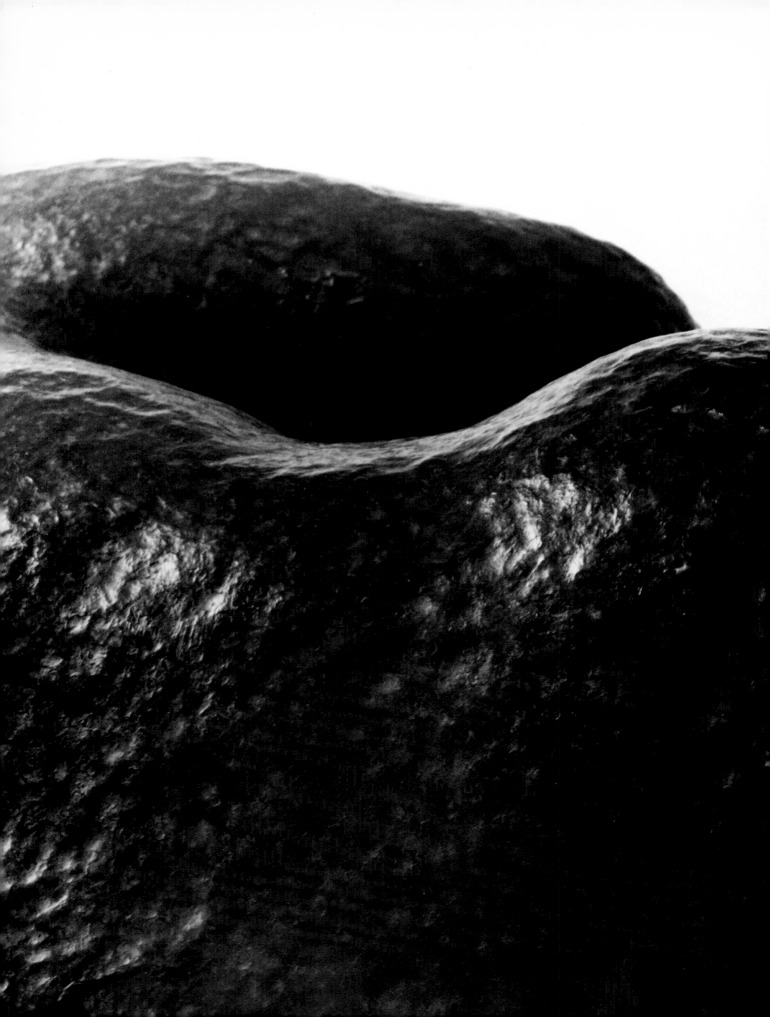

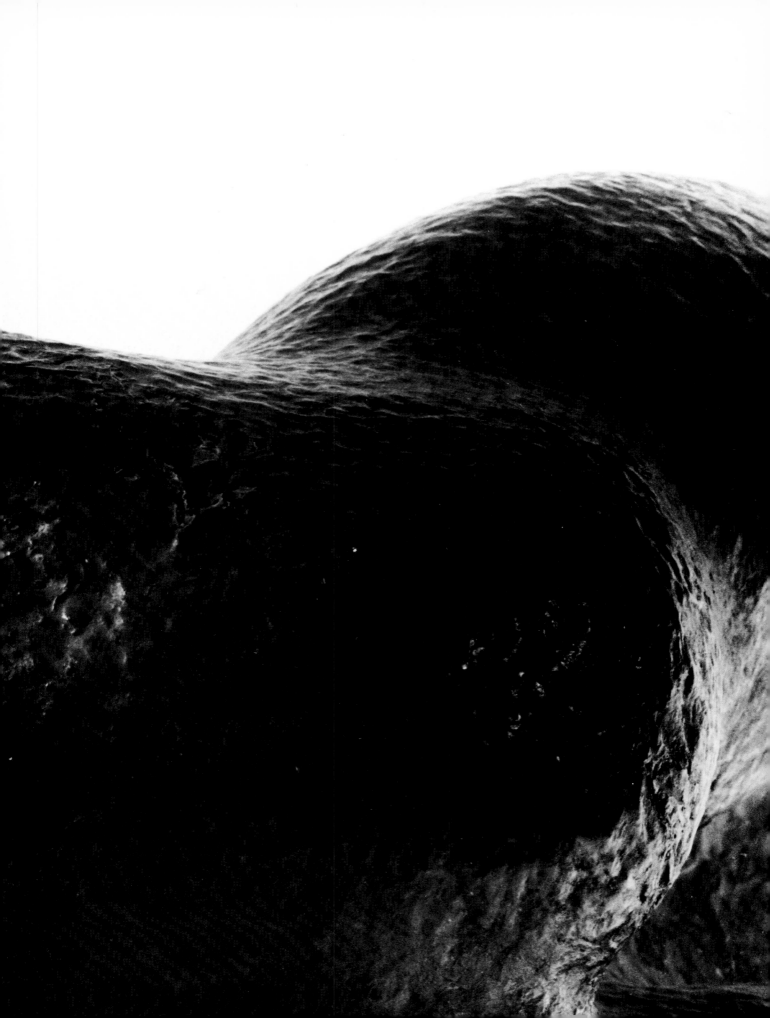

I touched the forms with my

hands, embracing the figures like

loved ones. . . . My cheek touched

the cool metal. . . . Strength seemed

to flow into my beaten body. . . .

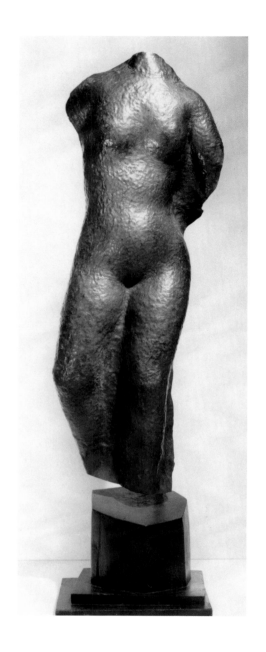

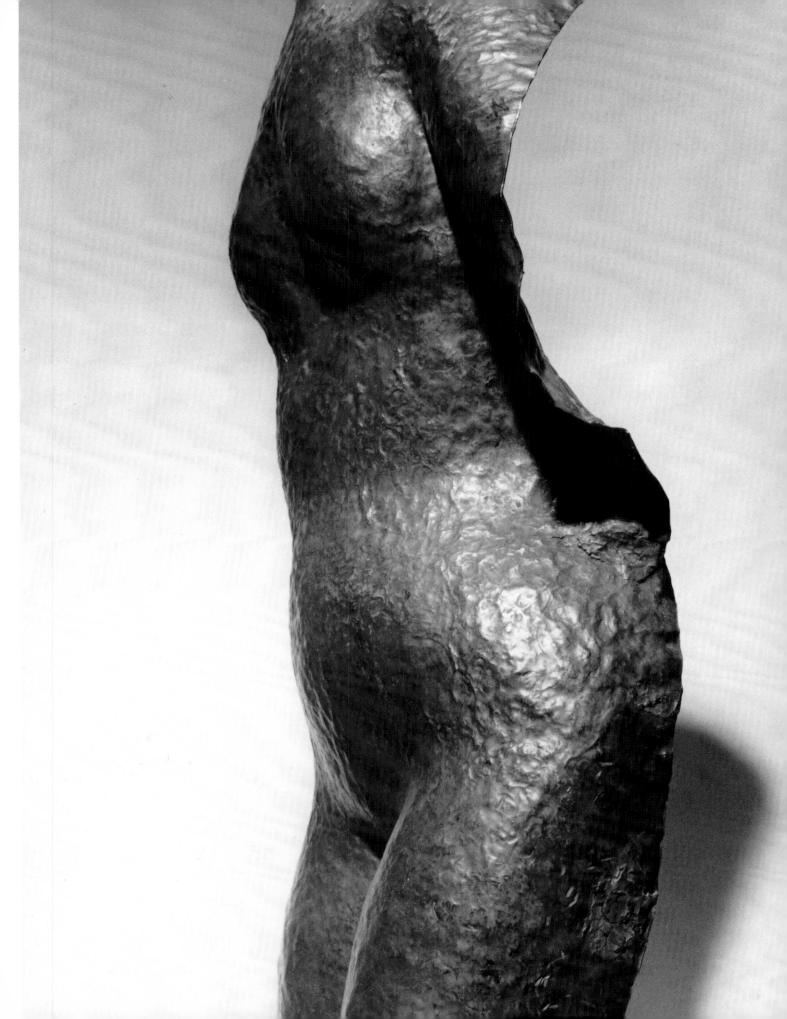

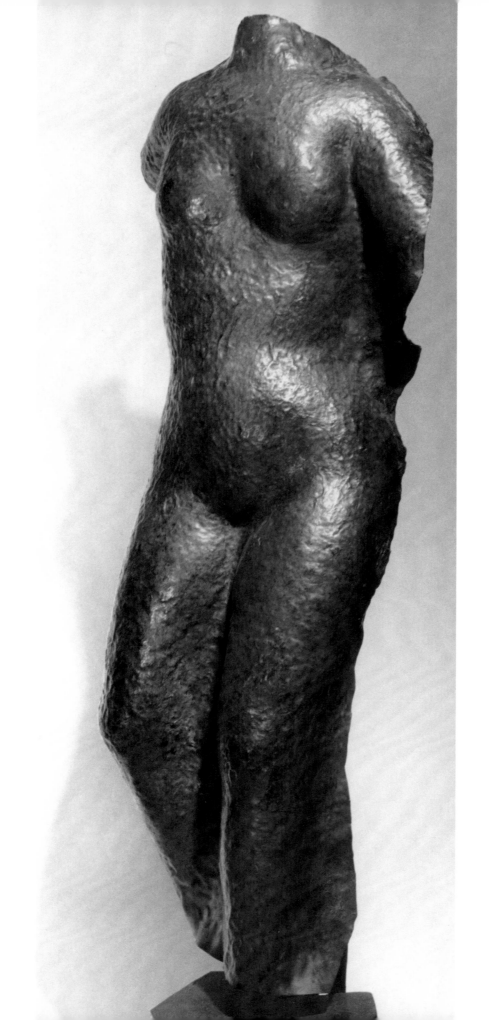

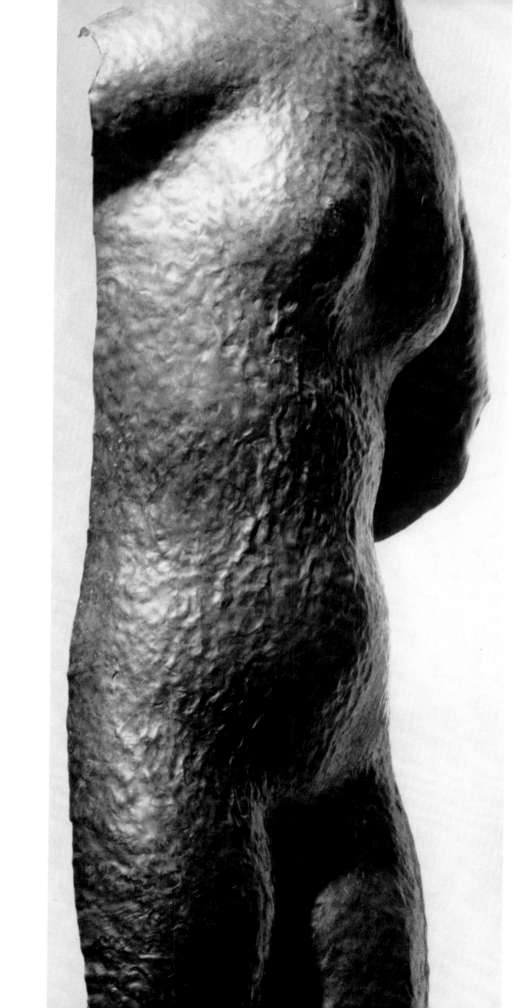

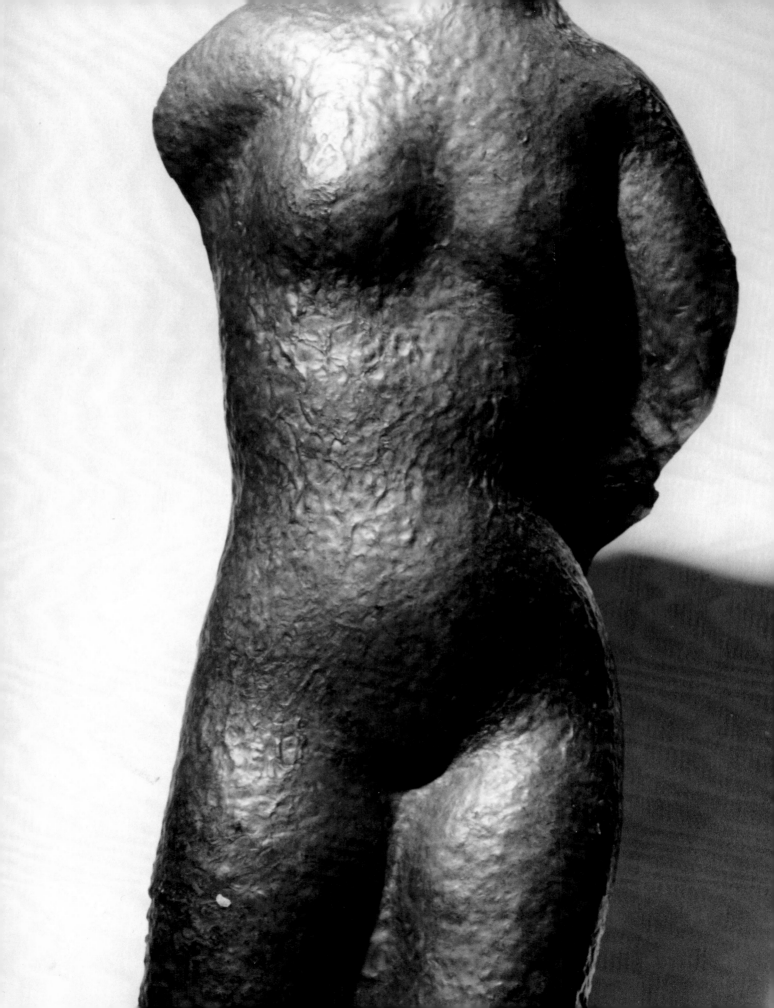

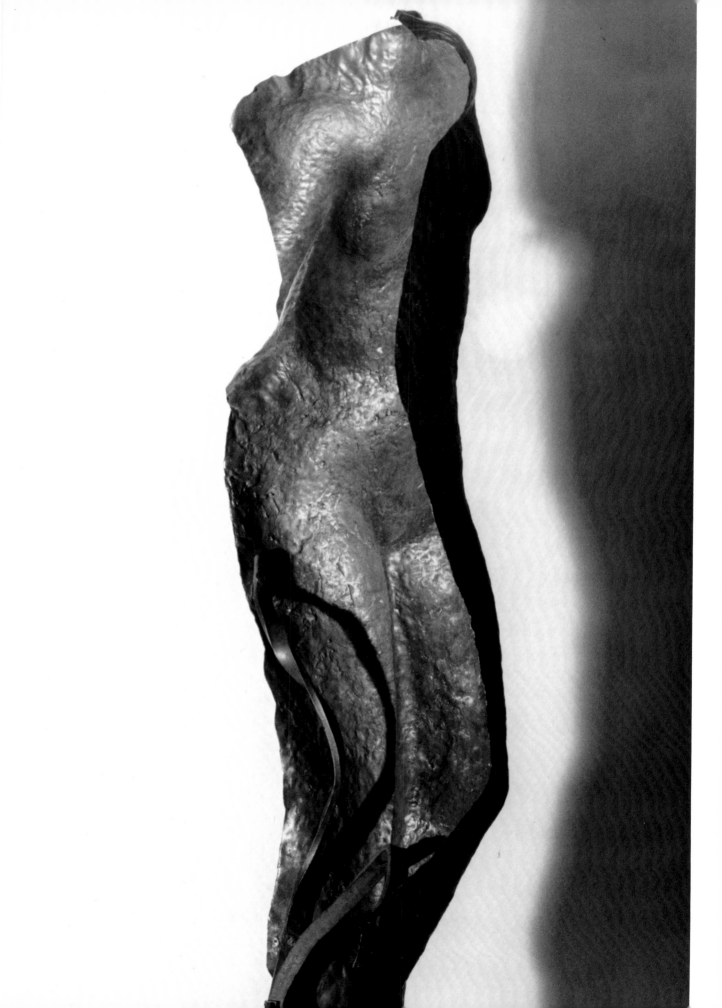

A new expression cannot be poured into old forms. Having a new tempo, *it demands different form relationships which, when perfectly organized, show a new movement of line. . . .*

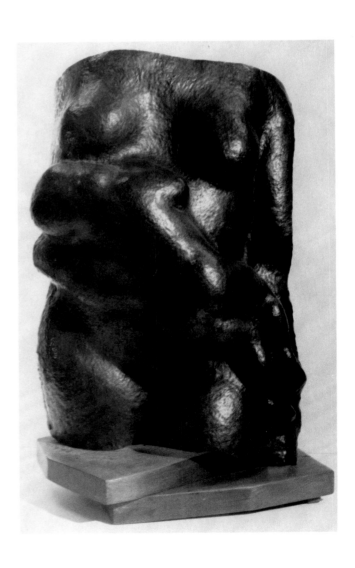

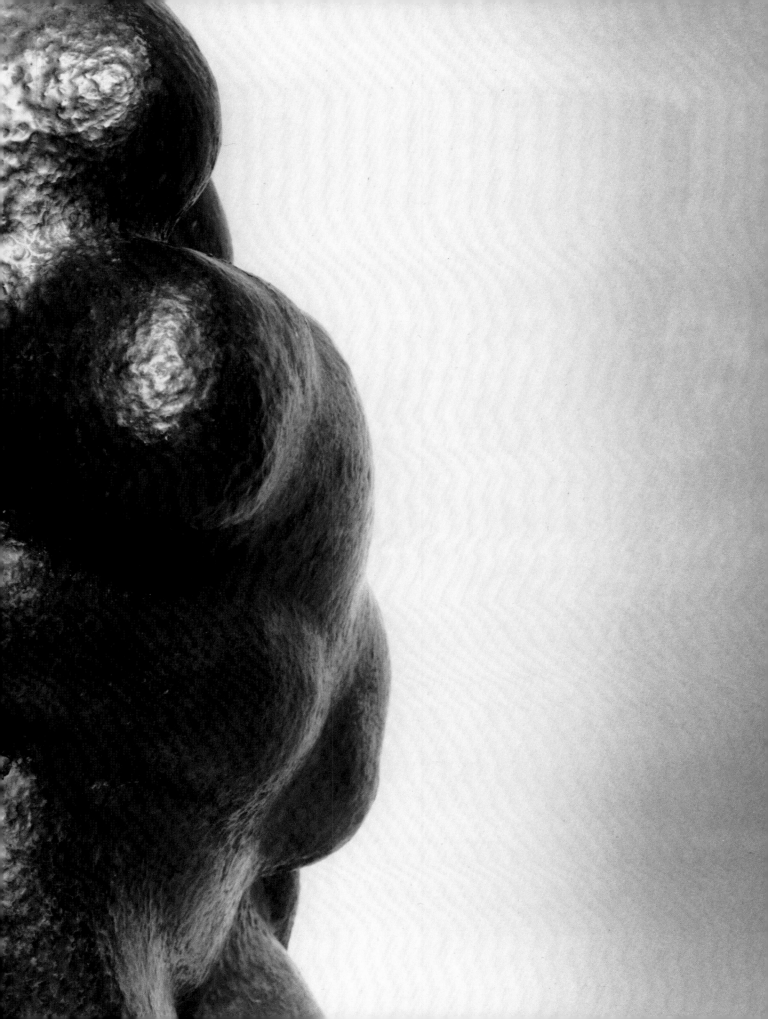

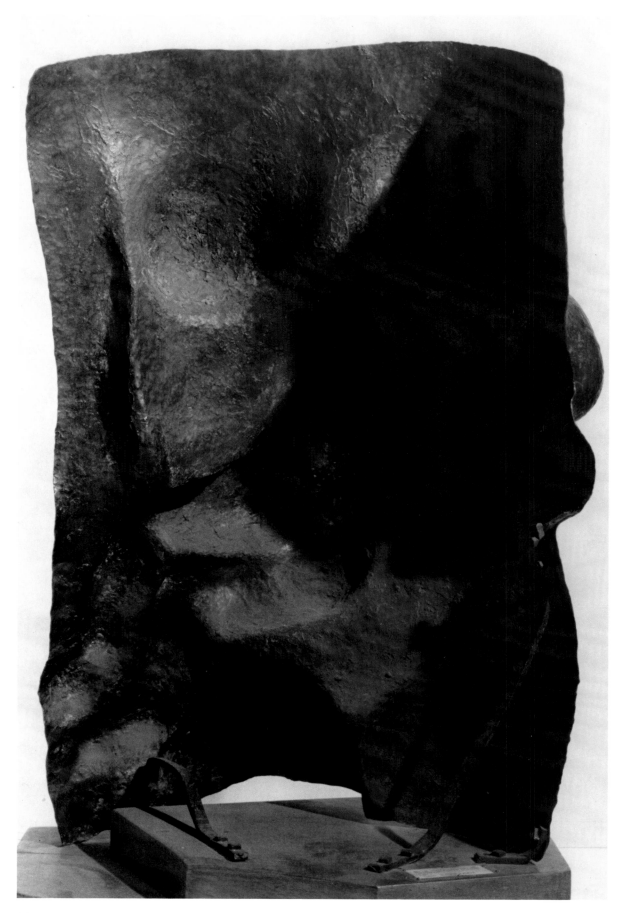

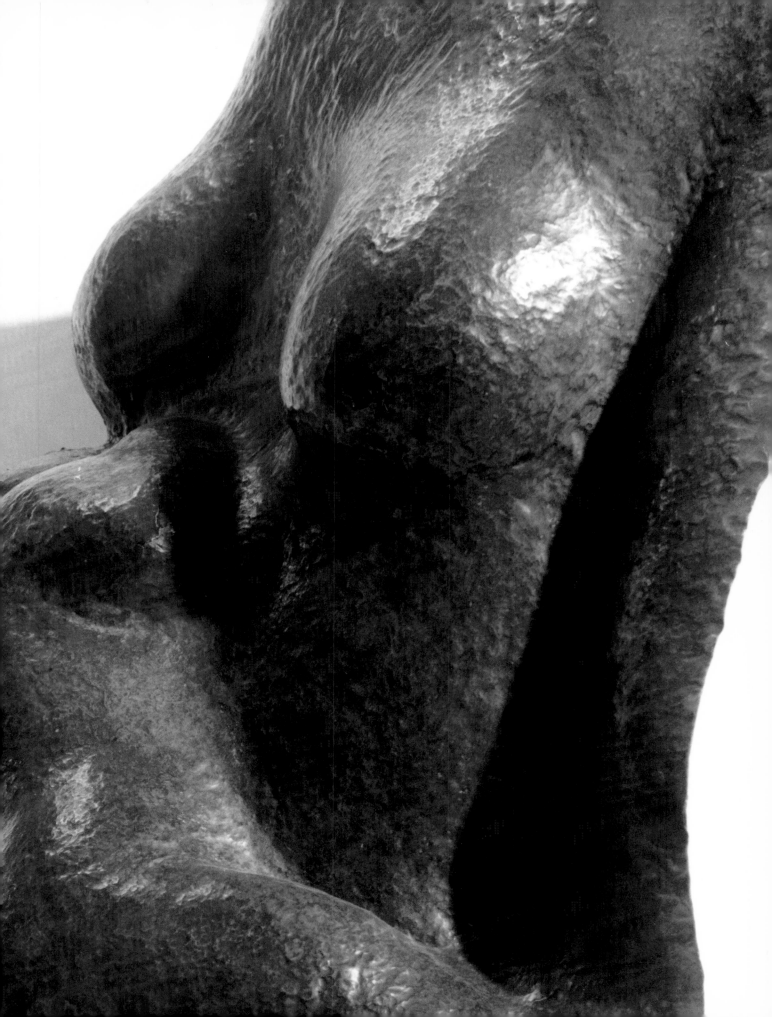

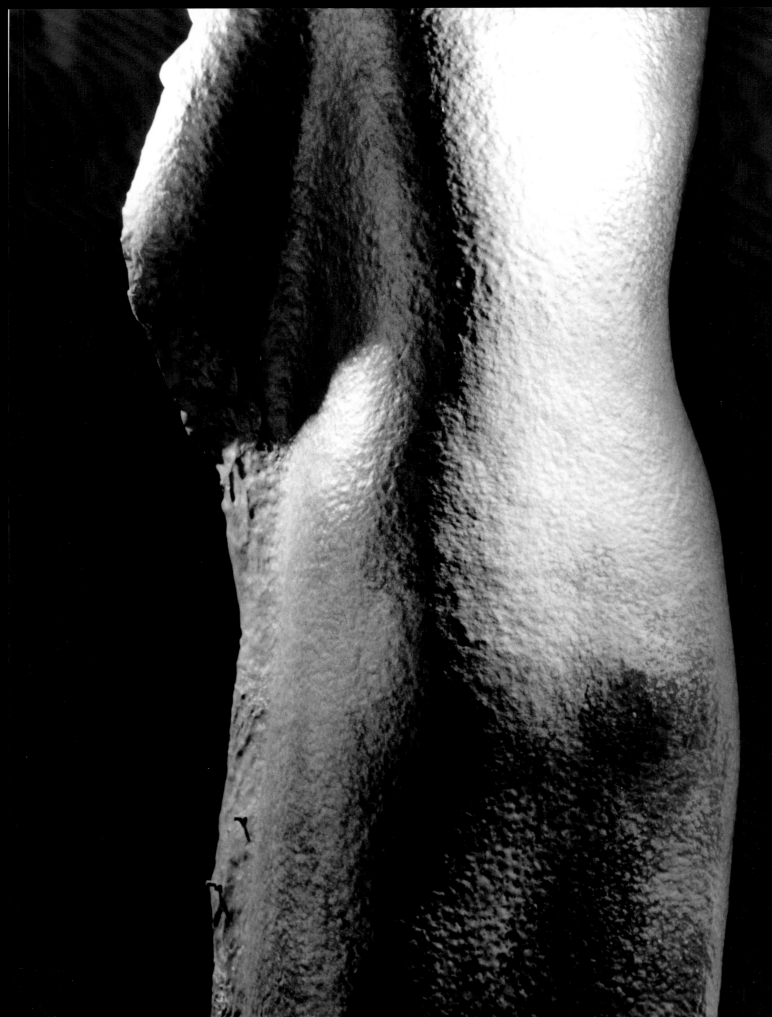

Art is an invention of the mind with which the human being attempts to express, make conscious to others, those fleeting ever appearing sensations of his own nature responding to impressions from other human beings and from nature herself, and the thoughts *thereof.*

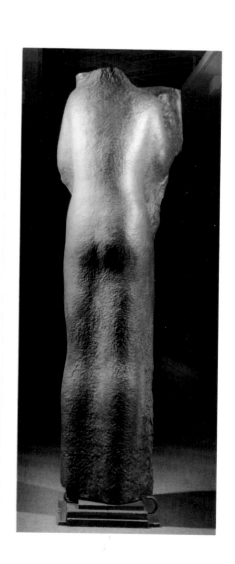

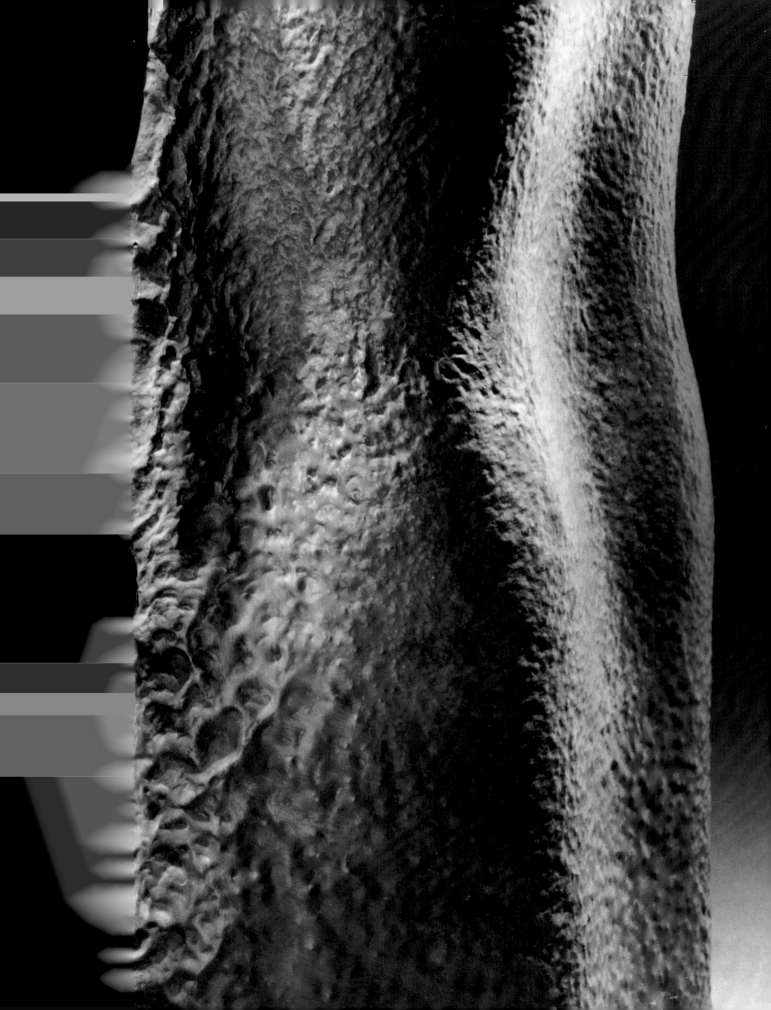

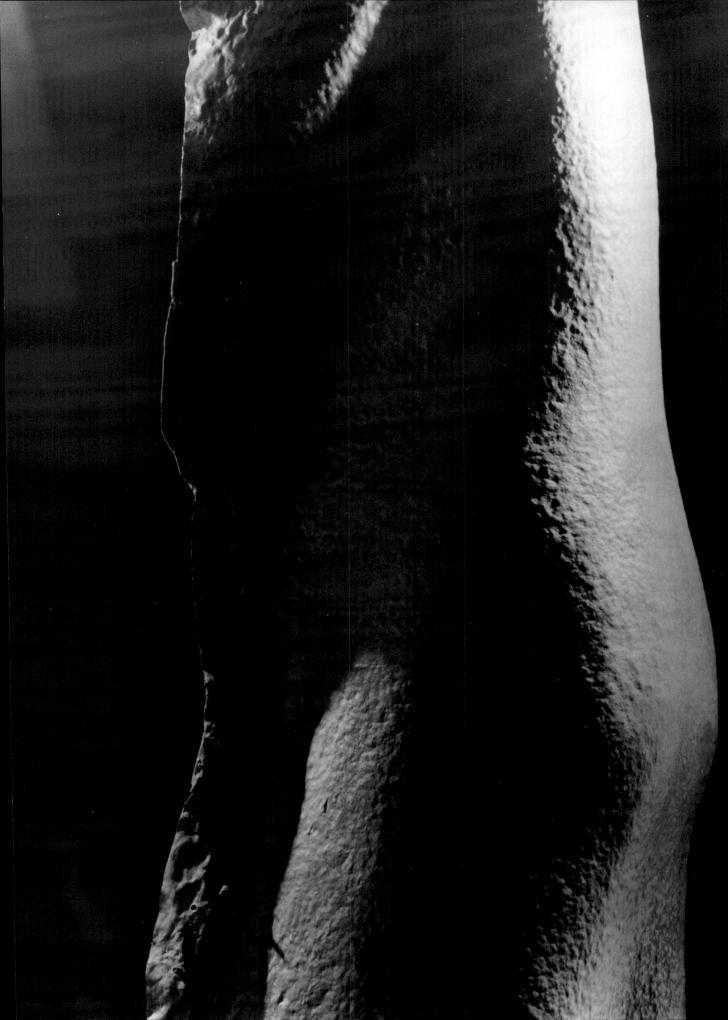

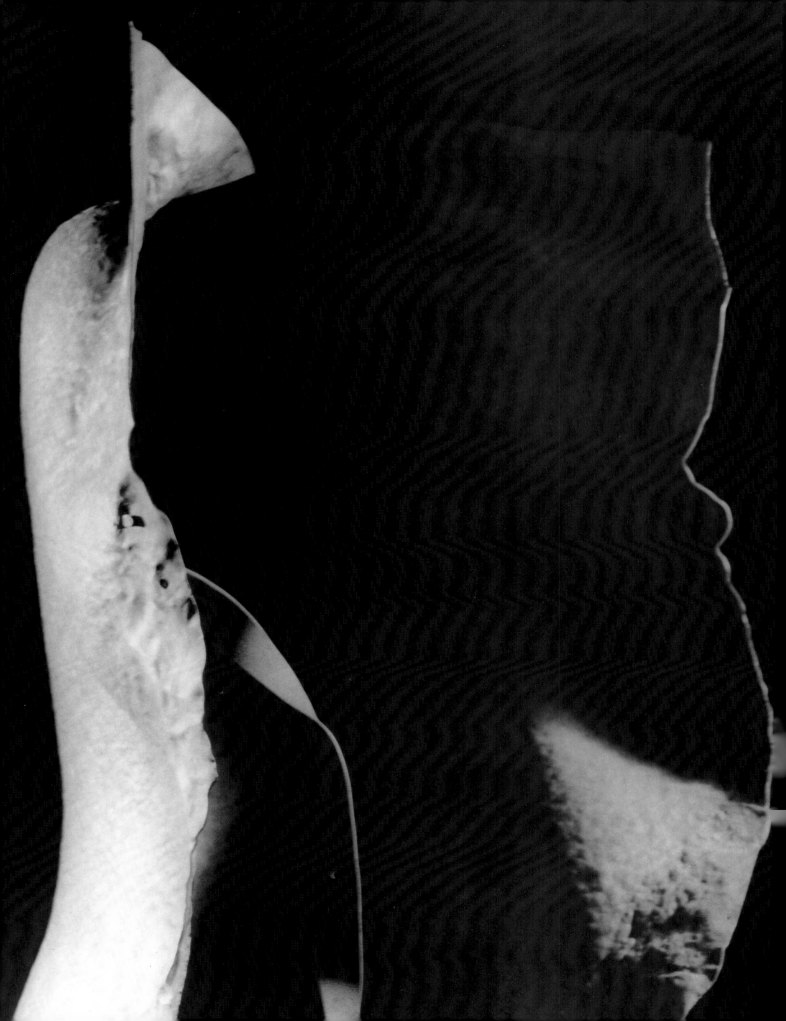

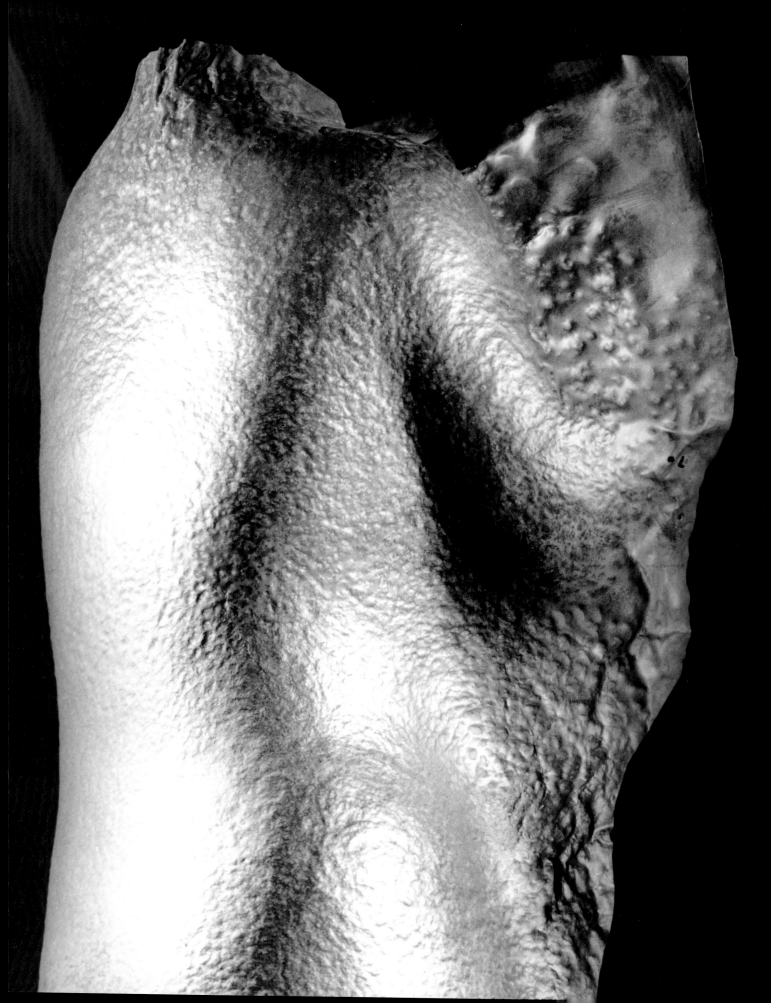

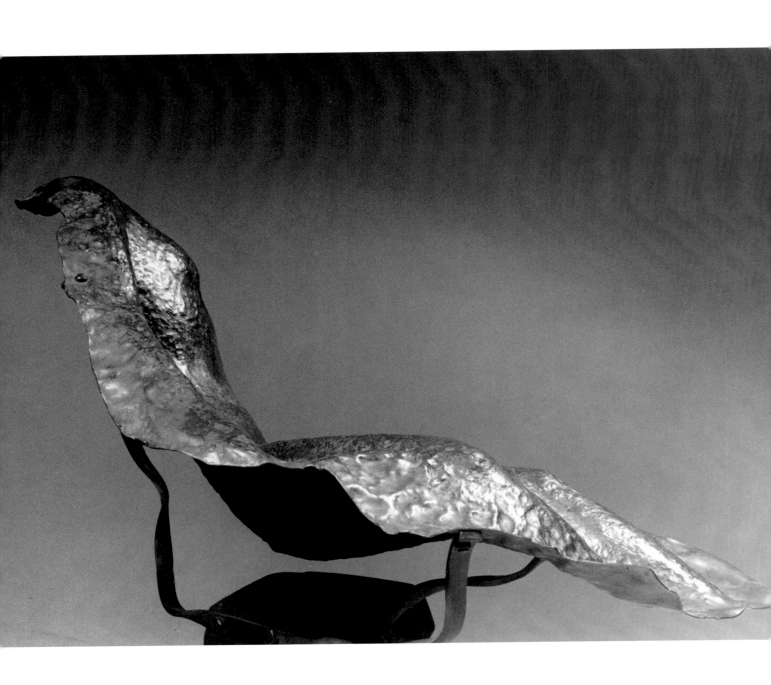

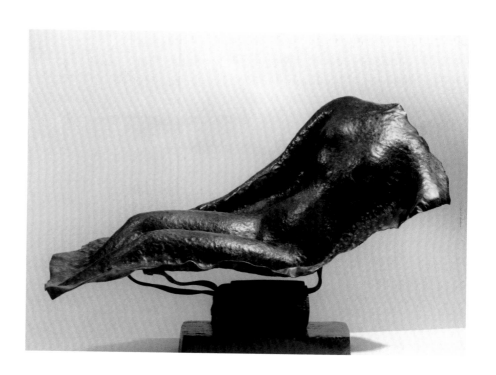

Throughout the sculpture the form tonalities are arranged to suggest a continuity of movement, radiating from the center to the rim and joining there with space.

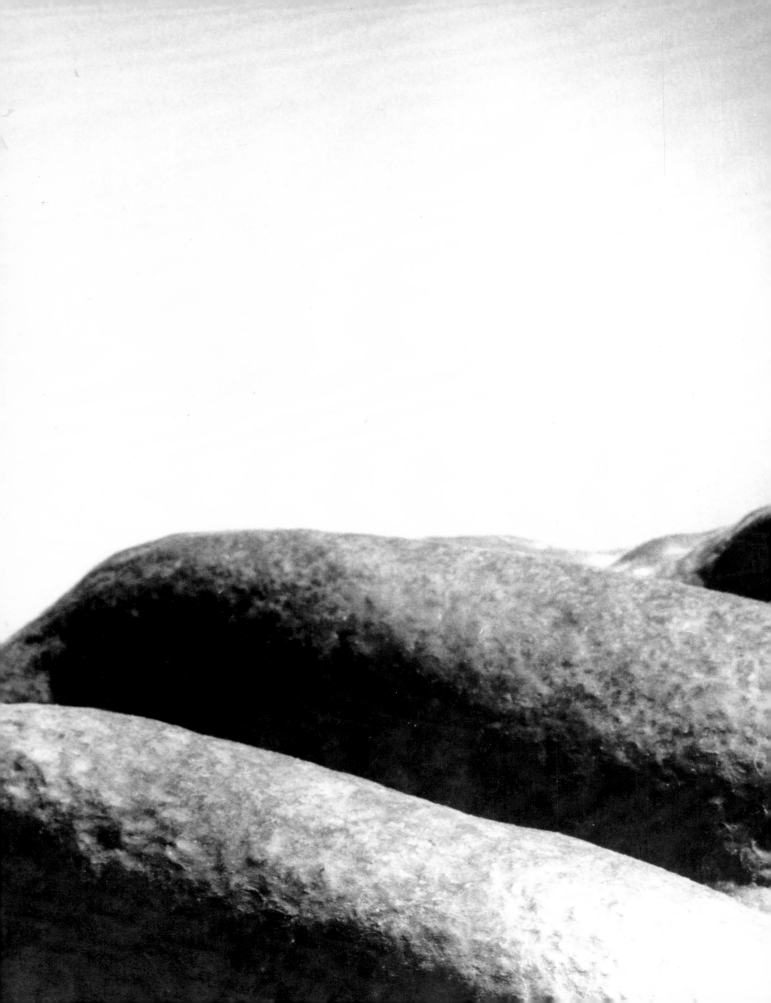

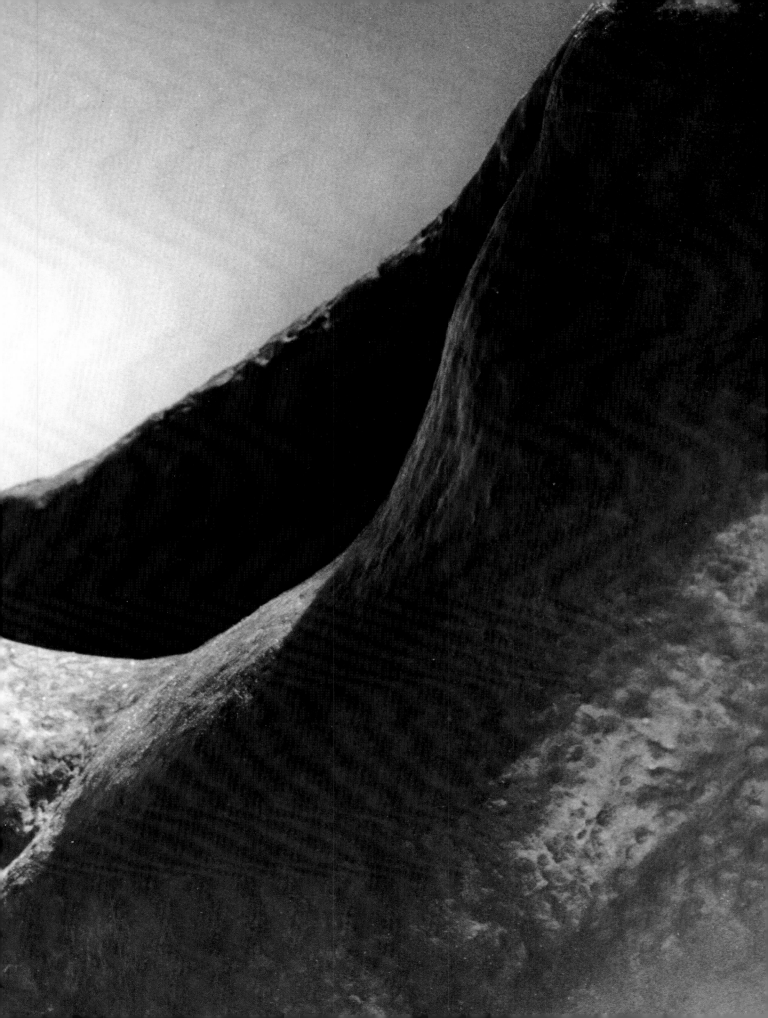

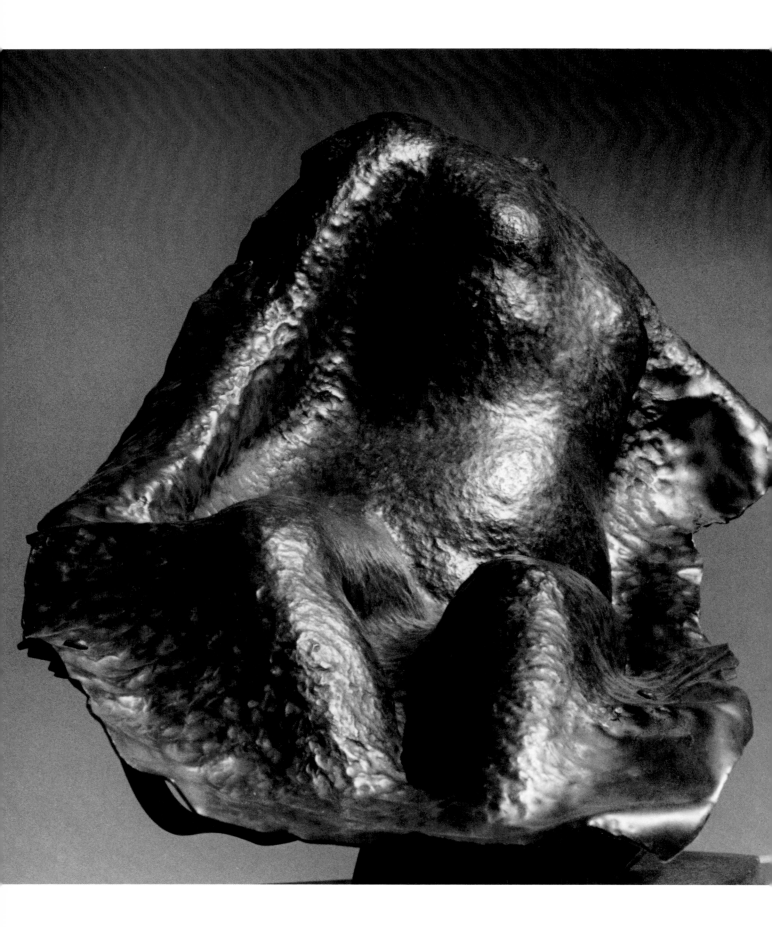

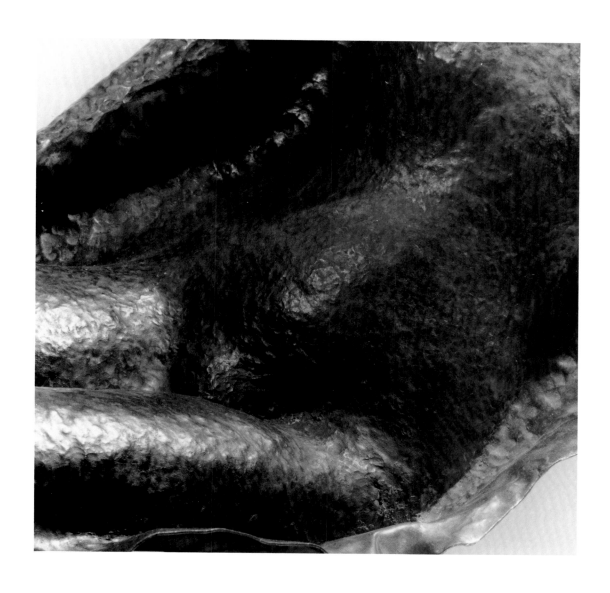

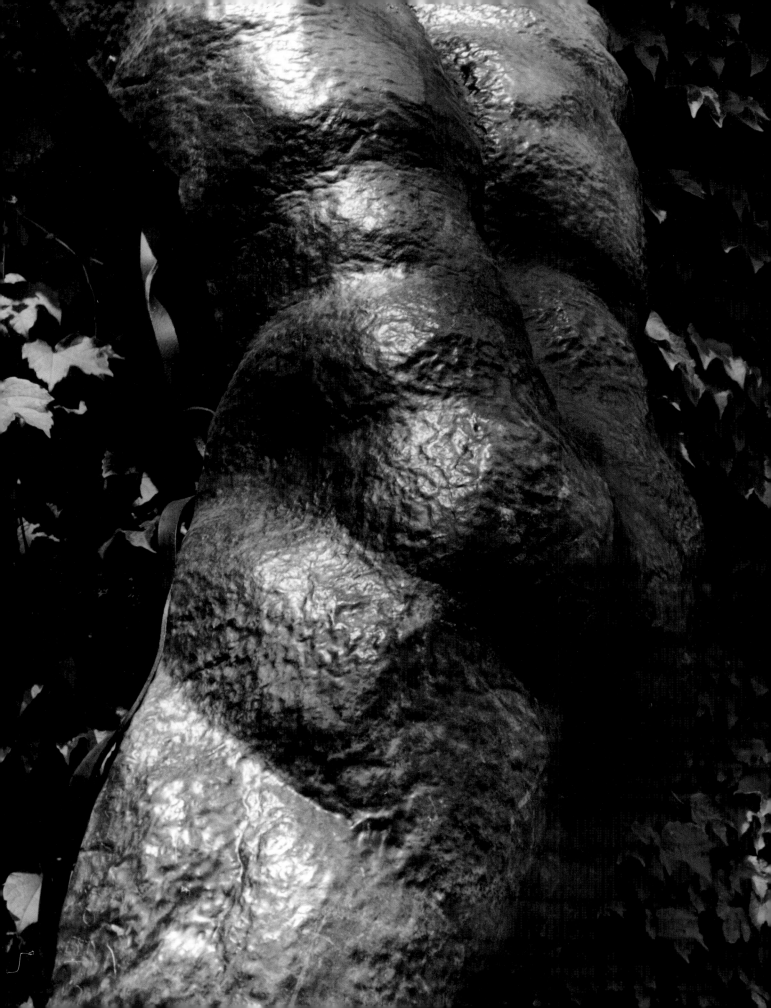

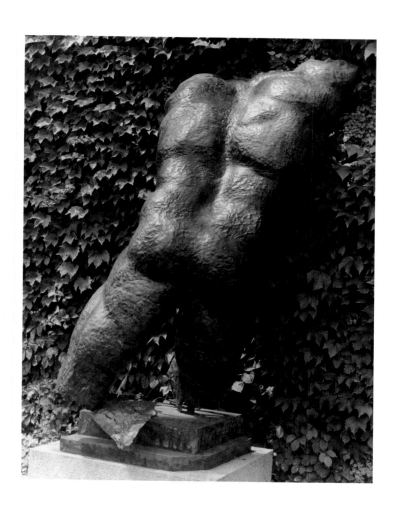

I wanted to say something that was undefined, something that I did not find in other sculpture, a certain feeling, a thought, a rhythm, a form-harmony, a group of sensations that did not fit into the old forms, which made me endlessly discontent, a seeming inability, a handicap, an uncertainty, doubts, unsteadiness in growth of knowledge and experience. . . .

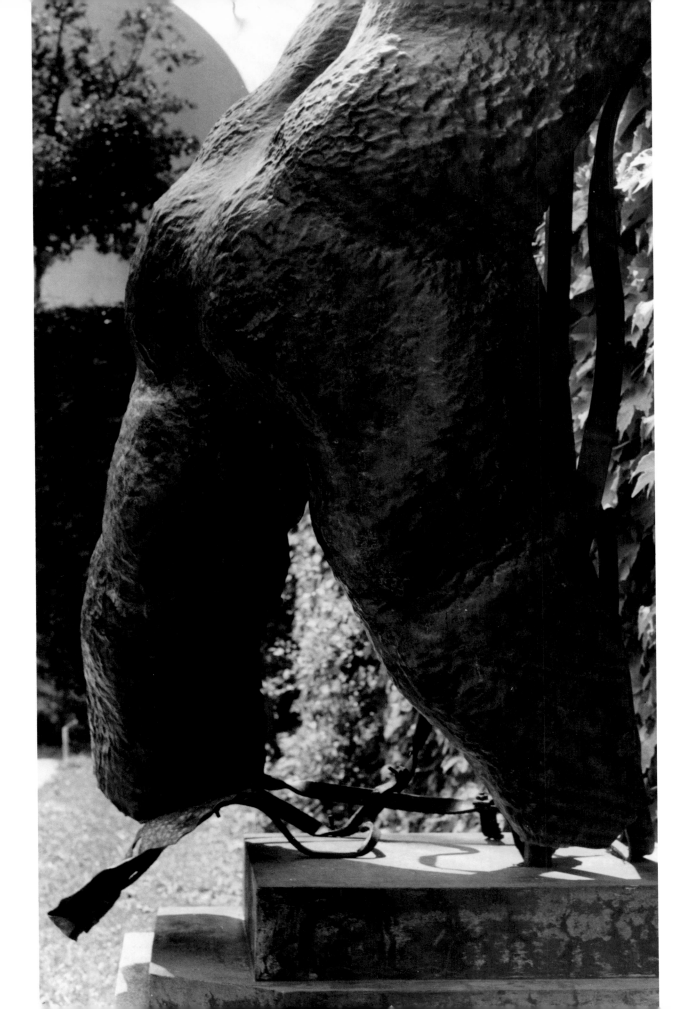

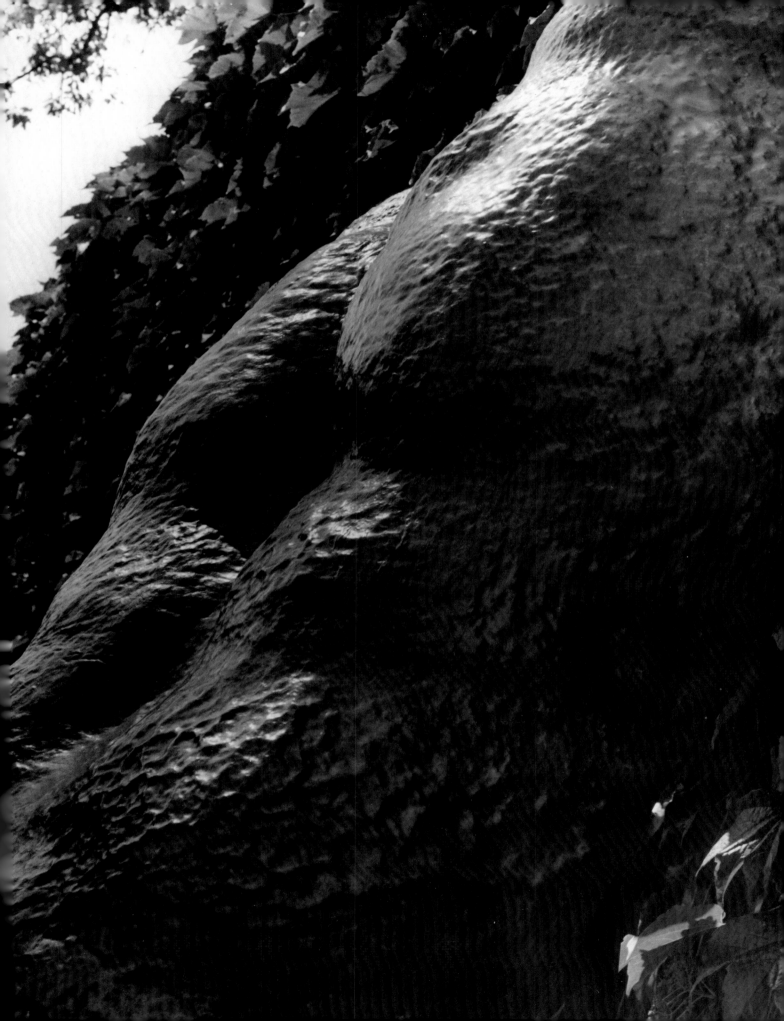

Working on sculpture, one must possess . . . peace within himself, an unchangeable, untroubled spirit. Sculpture is an art of time, not of moments. From the moment of conceiving the piece to its perfection pass many hours, which often crowd into years.

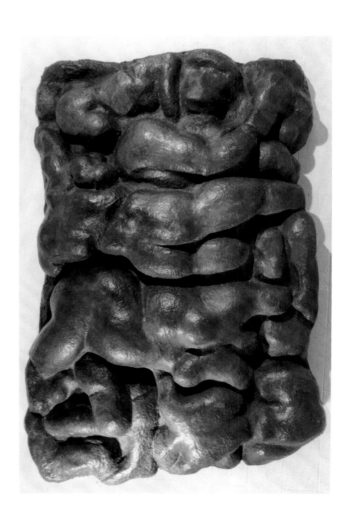

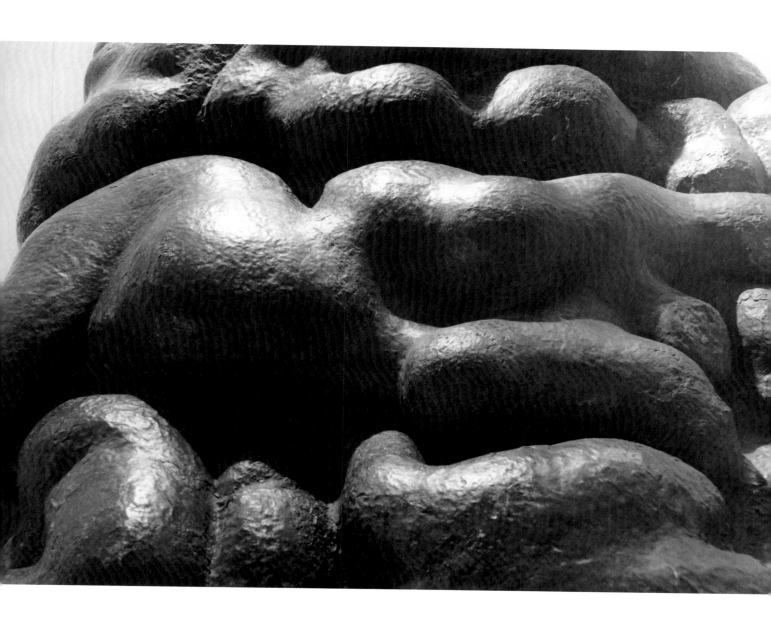

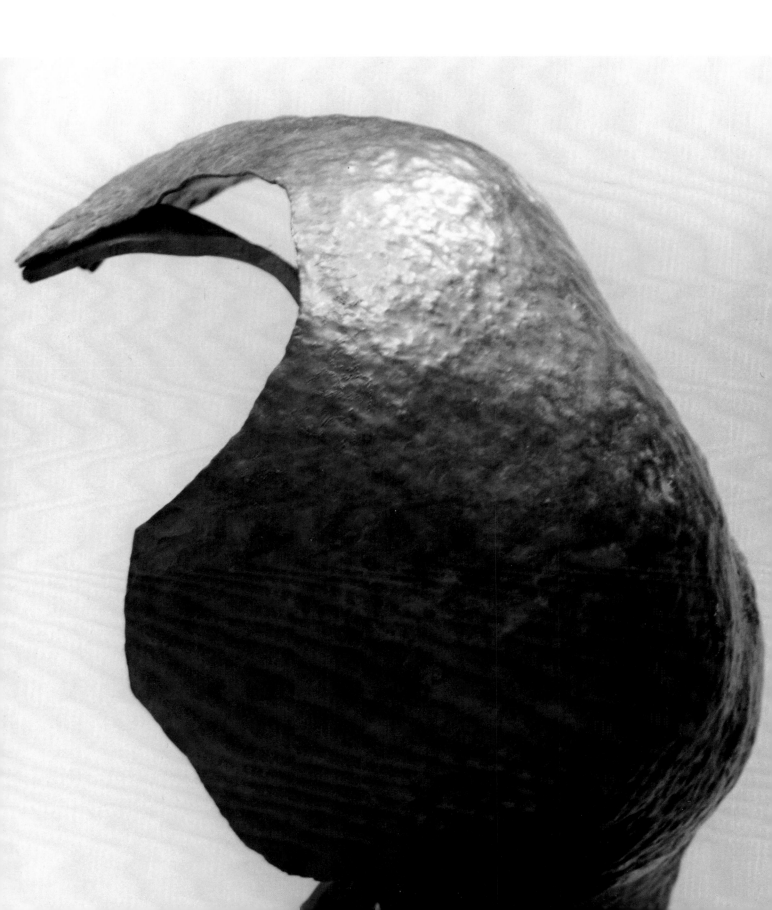

A body is the finest instrument for

a sculptor to create his harmony

with. . . .

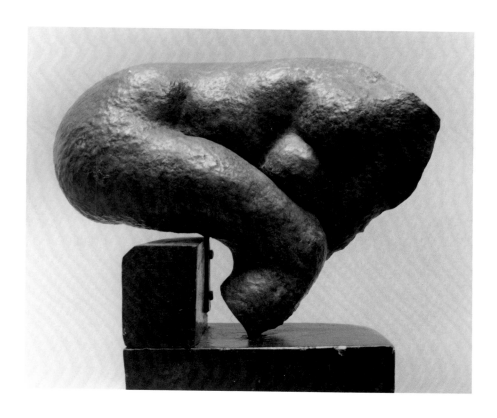

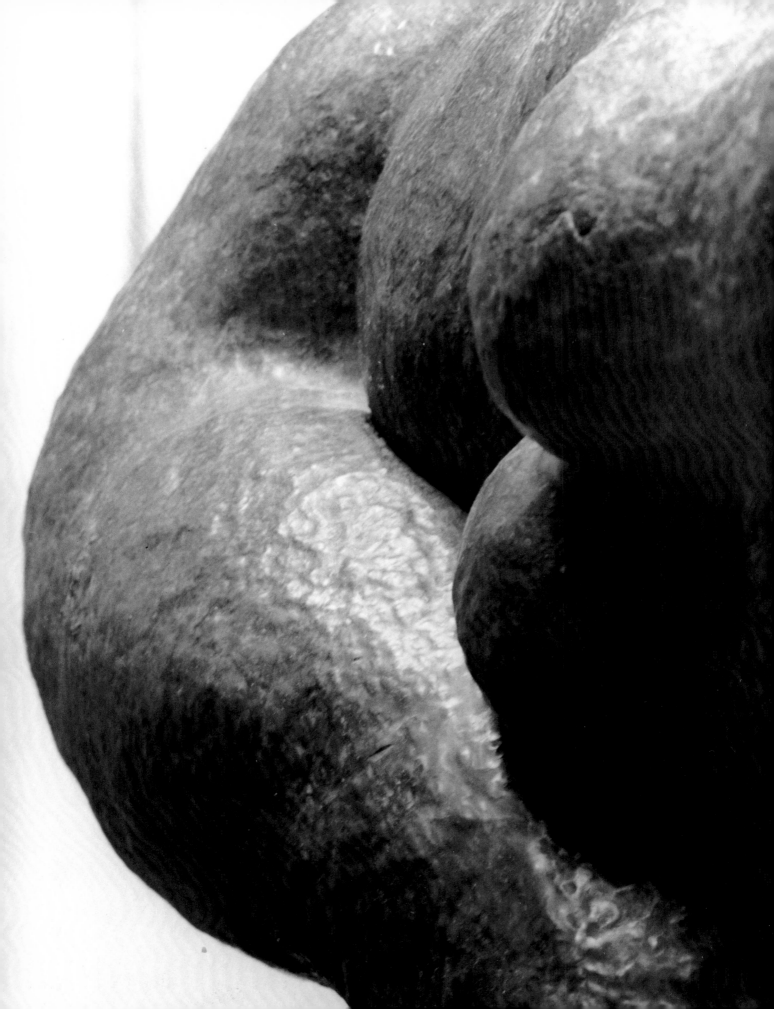

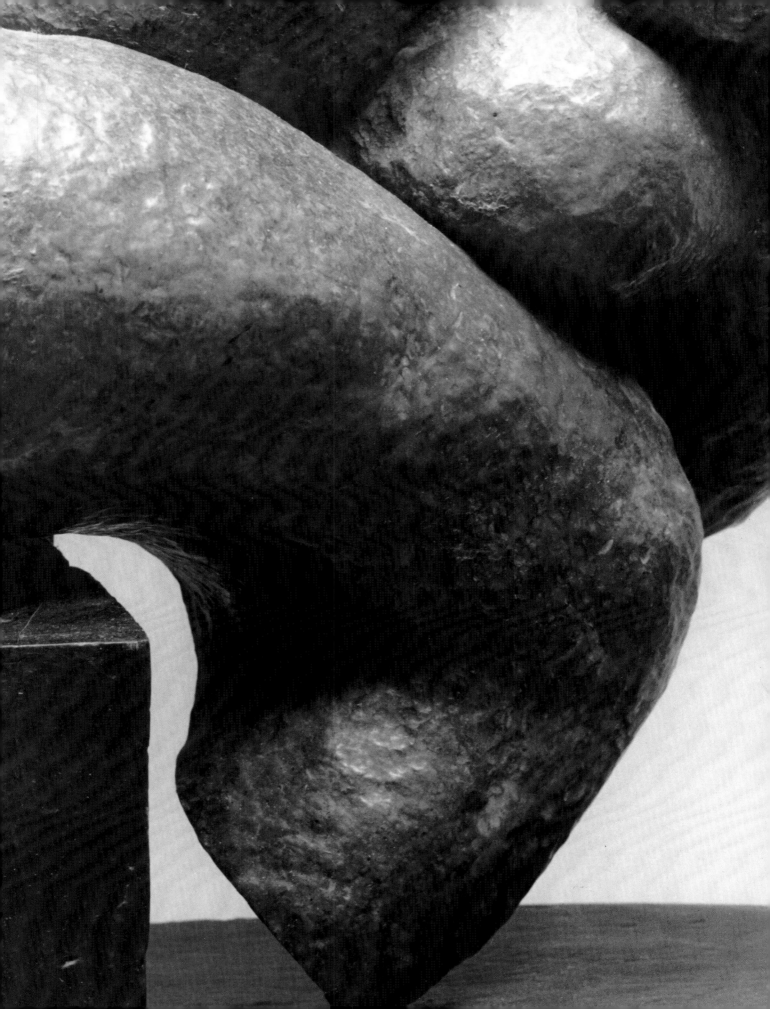

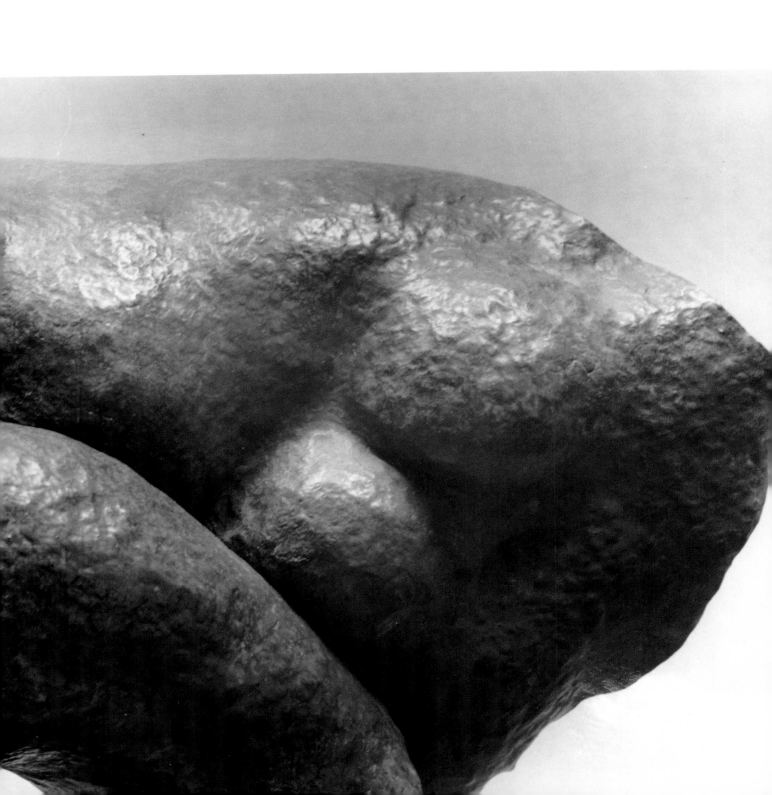

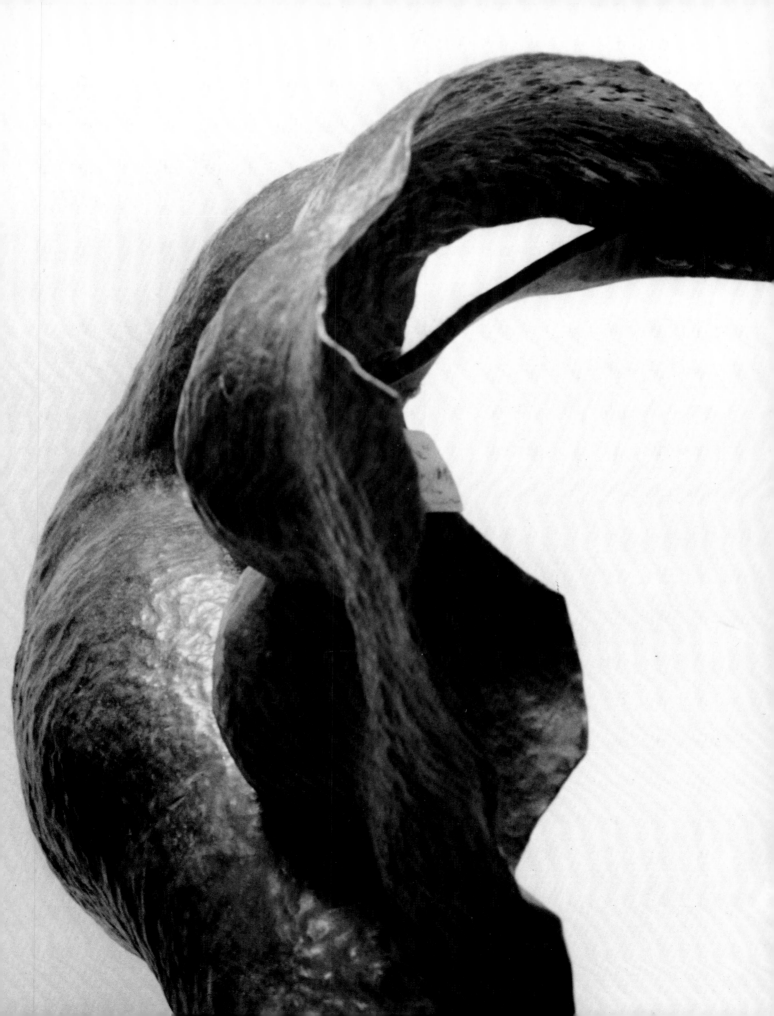

A living quality in art is rare and difficult to achieve. One can only try and try hard and, failing, try again. The work may receive the spark at the most unexpected moment. But it will never enter it without pain. . . .

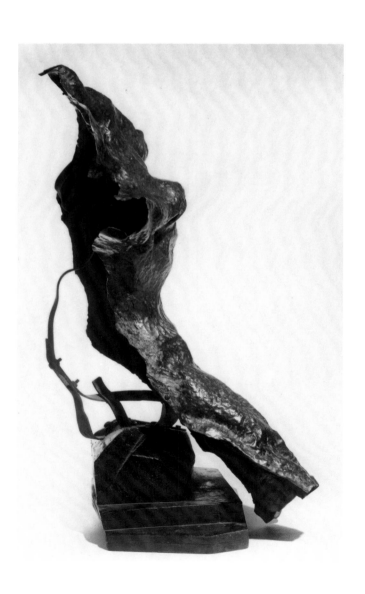

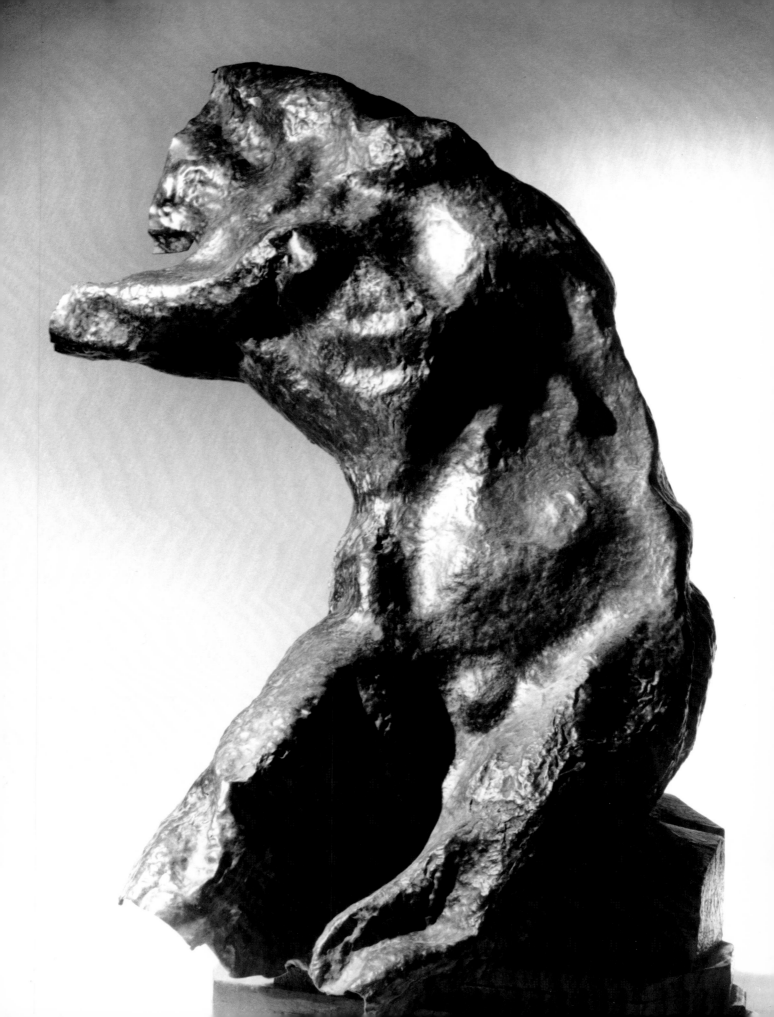

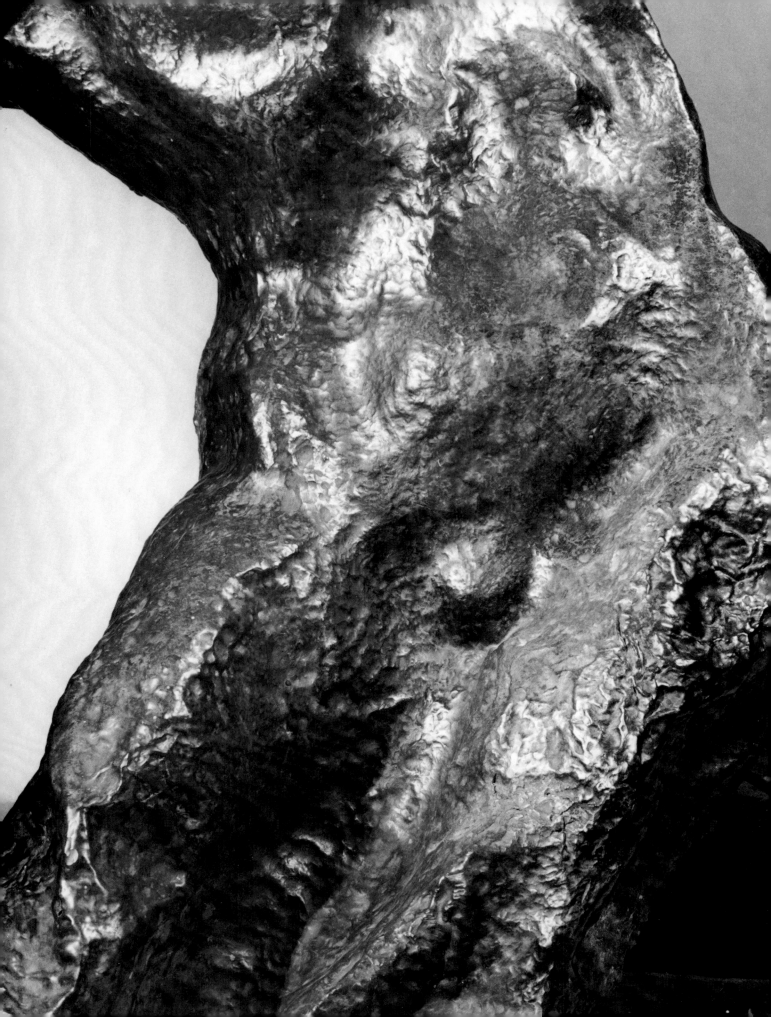

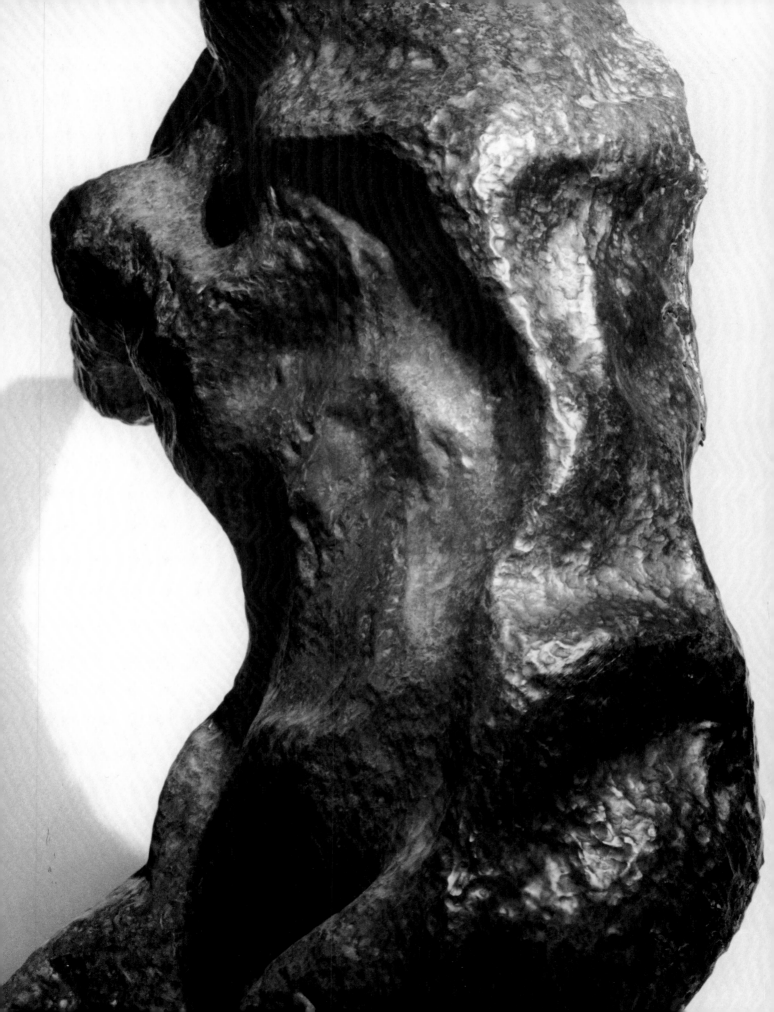

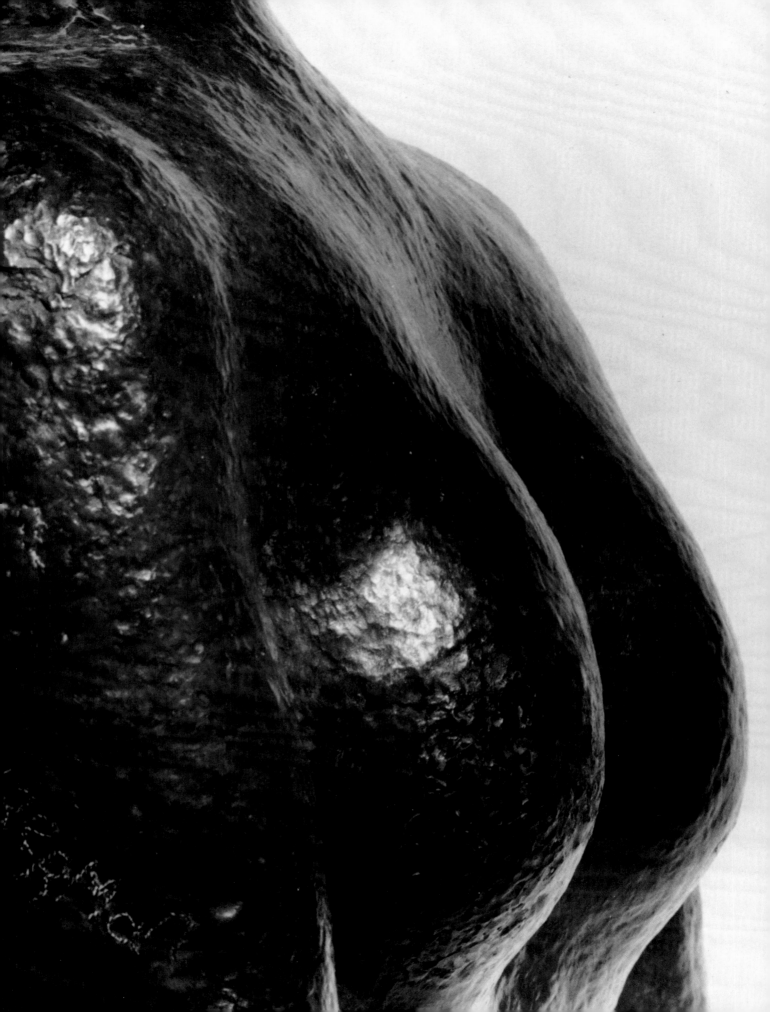

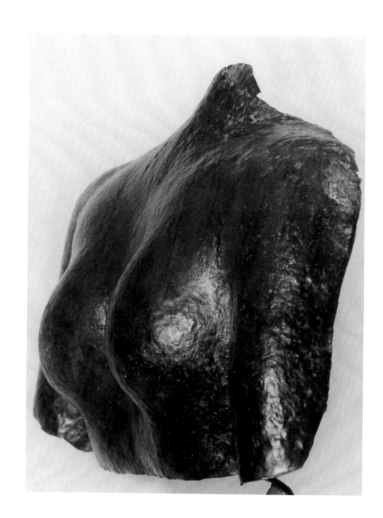

*The sculpture is separated by its
circle rim from being connected
to any other thing in reality. It is
an entity. The many sensations of
life are gathered, organized in a
whole to express such an entity.
The sculpture at the end must
suggest at its completion a living
entity, possessing a life, a power of
its own. . . .*

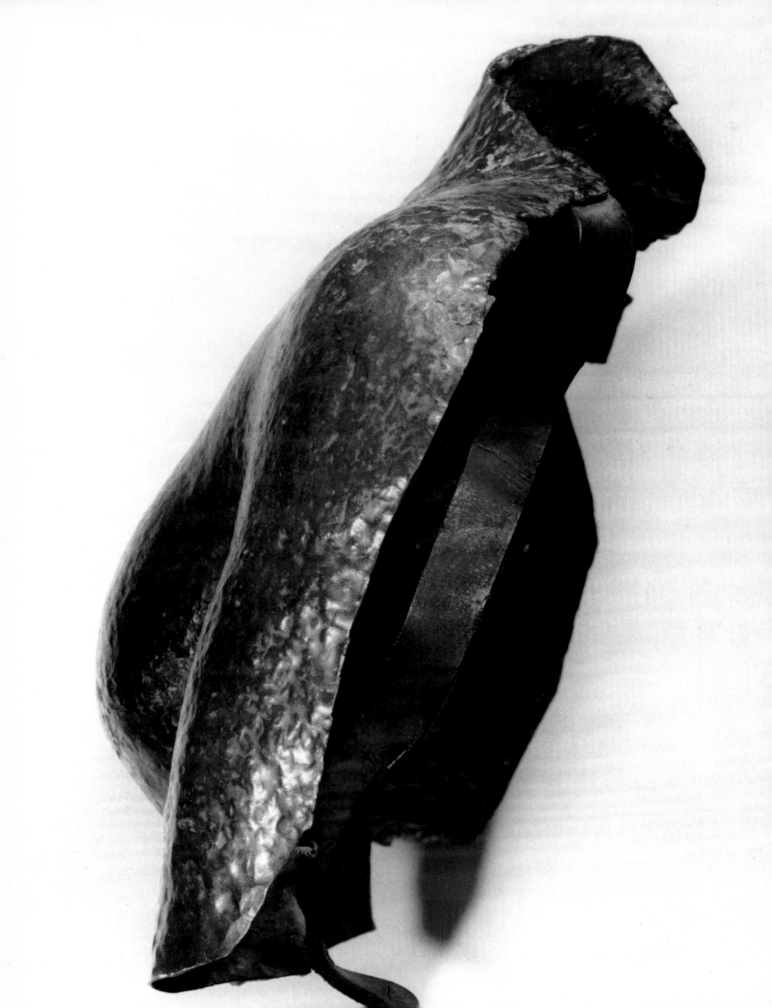

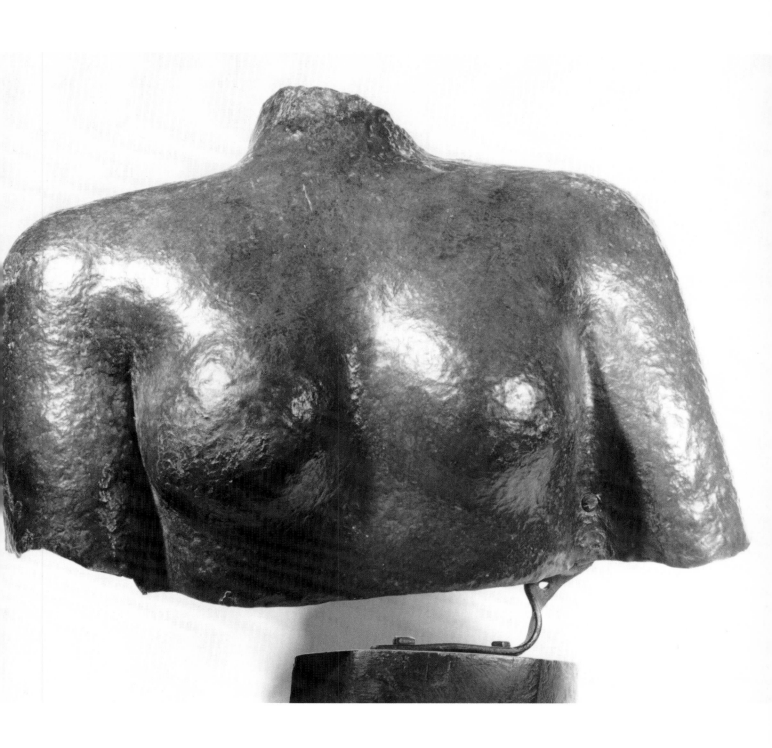

It is to express the various sensa-
tions and the rhythm of their life
that my sculpture aims. After each
completed piece, I still remain with
the thought that I have but
touched the many harmonies
abounding. That life is richer than
I can ever hope to express it. It has
never been my fortune to feel that
I have reached the fulfillment of
my vision.

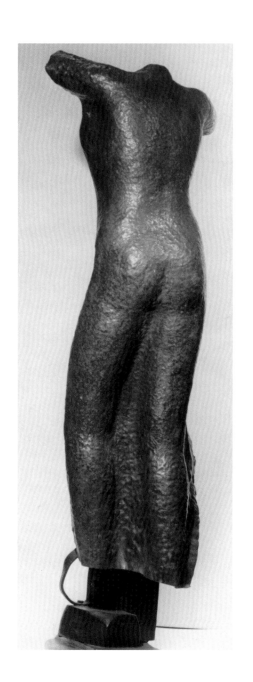

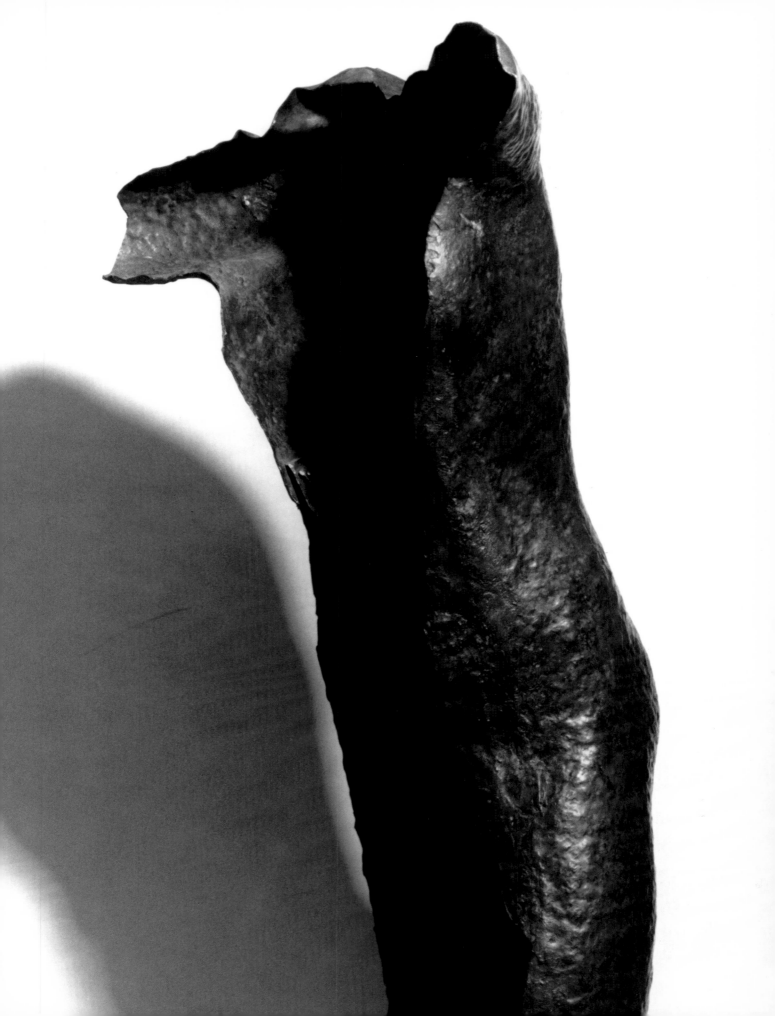

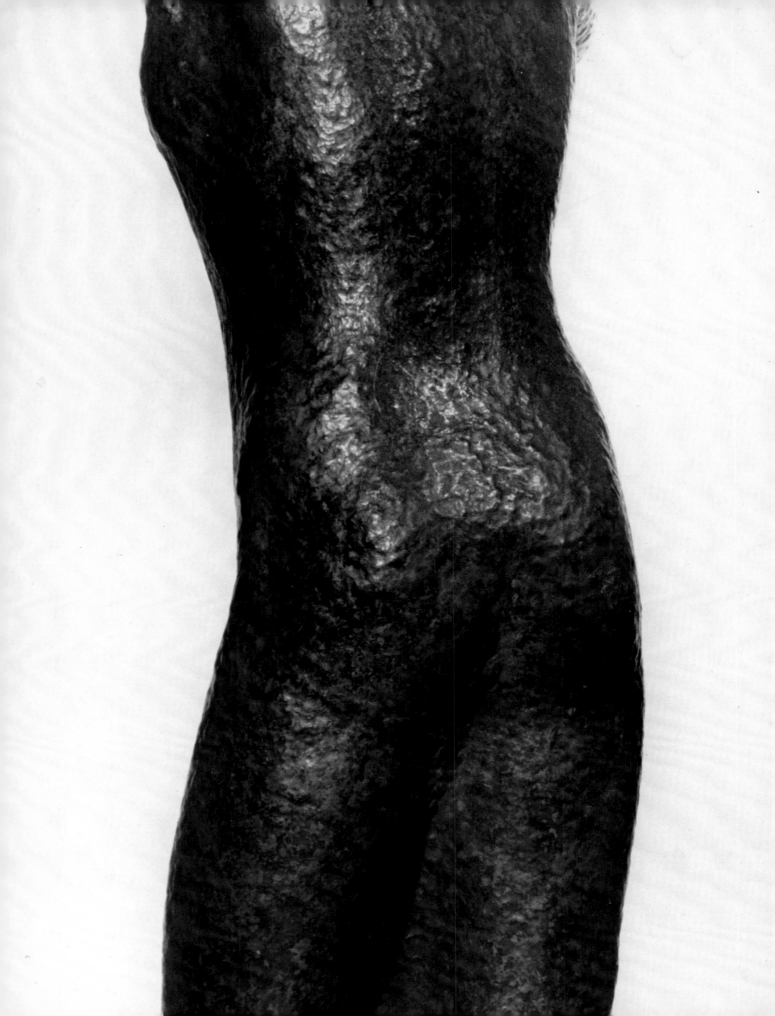

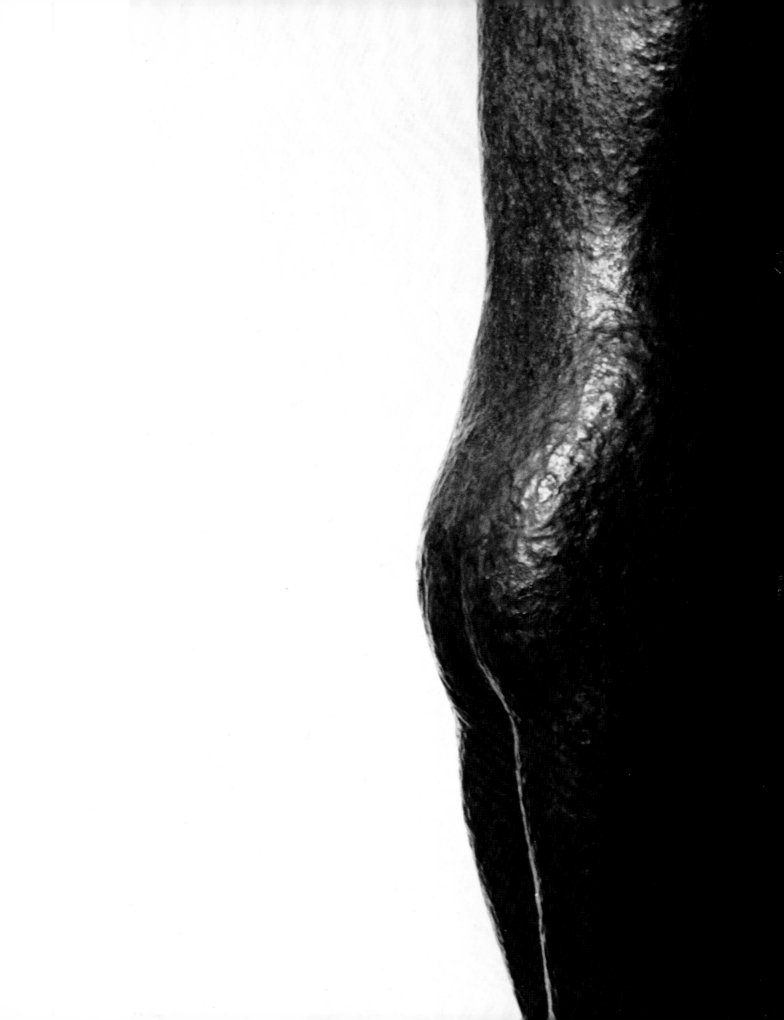

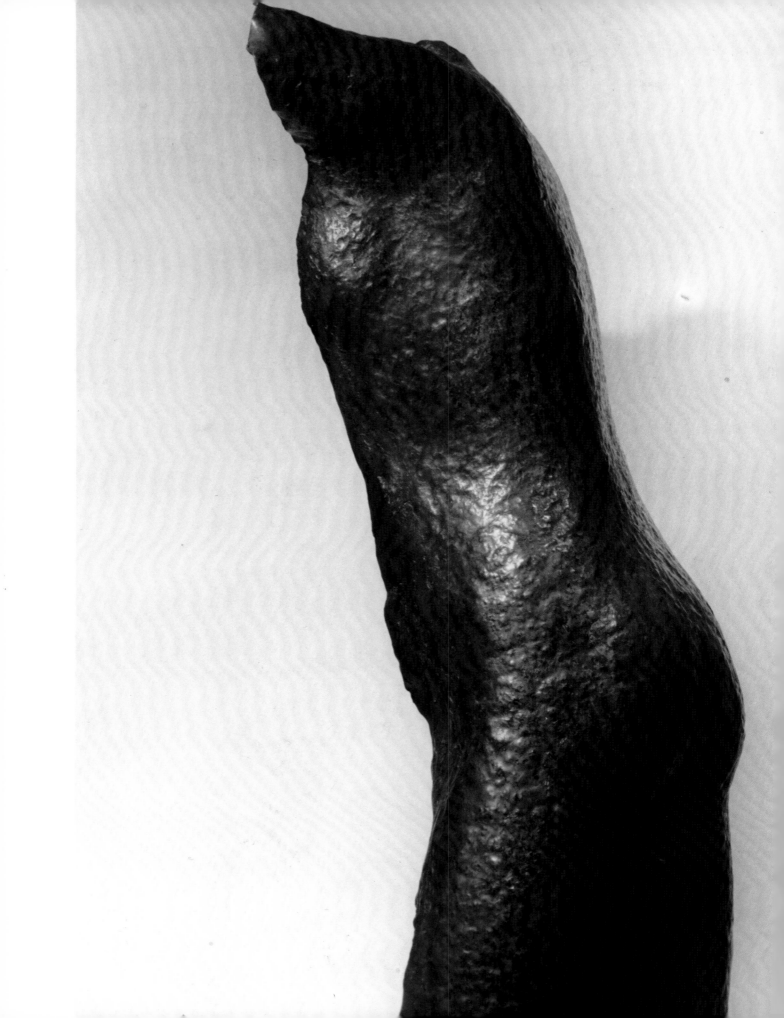

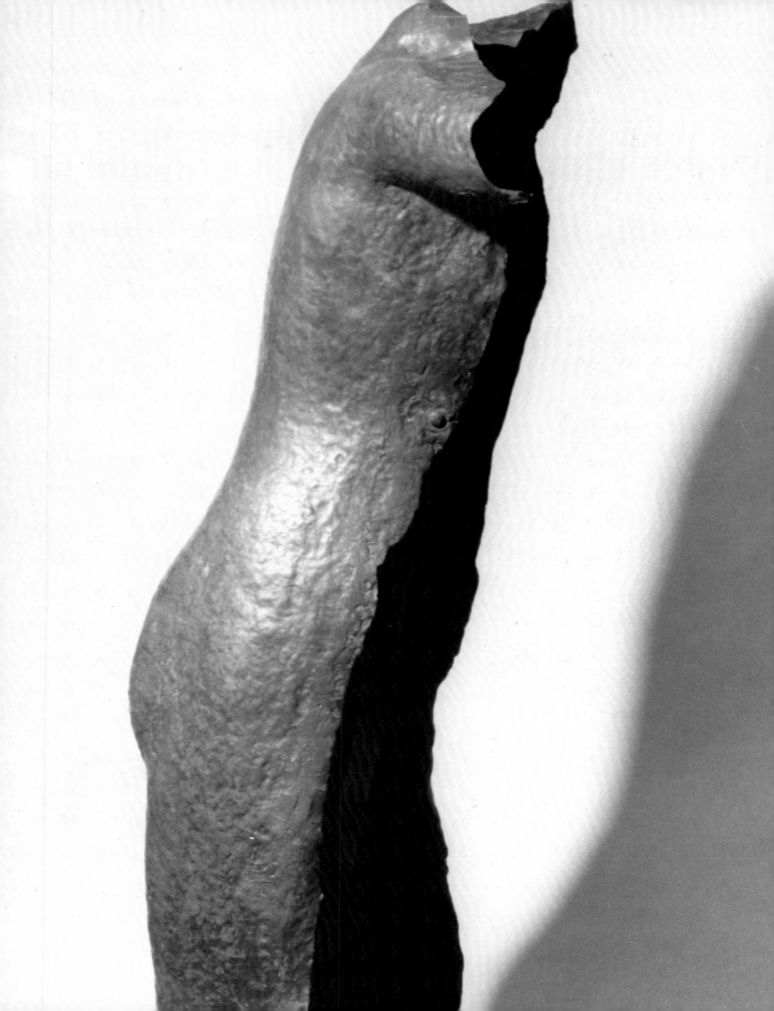

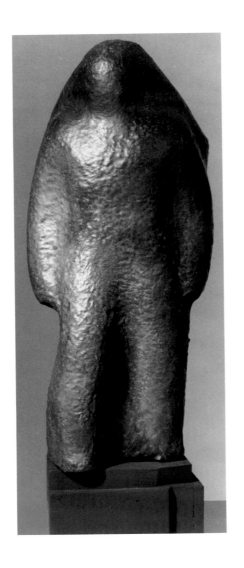

My vision of sculpture is not based on expressing ideas of illustration or the interest derived from compositions. Both elements are used as hangers upon which to compose the visions of form-harmonies which are thought, based on the same directing principle, derived from definite philosophical analysis of the present social and natural movement.

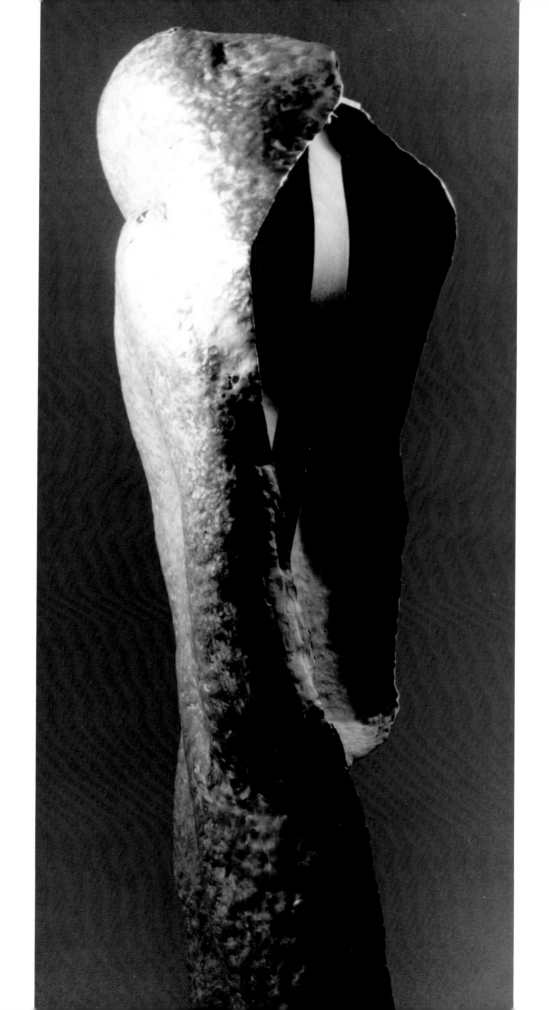

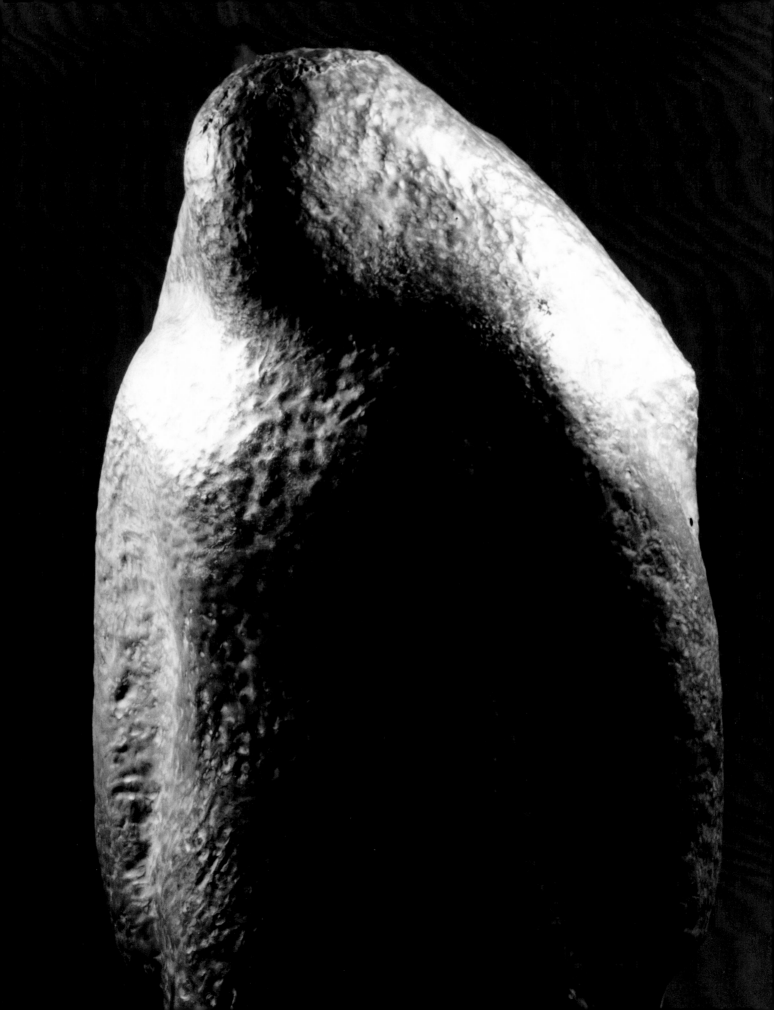

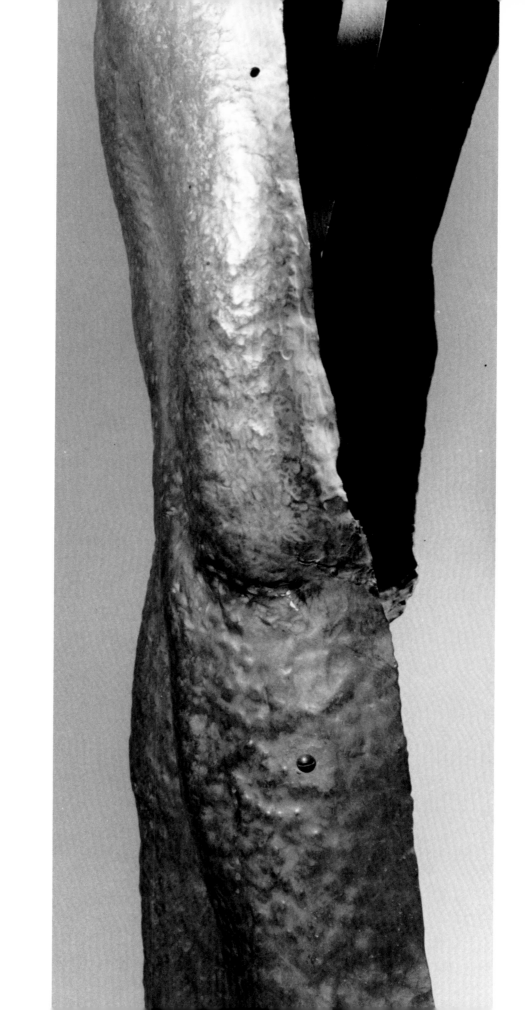

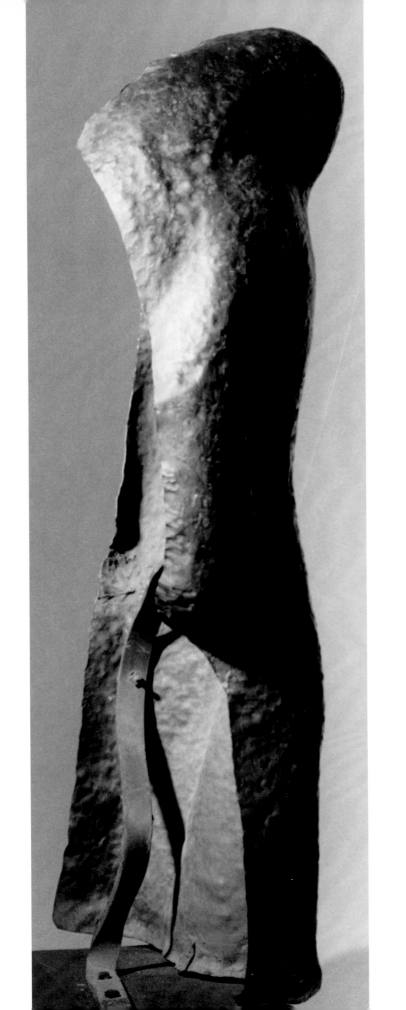

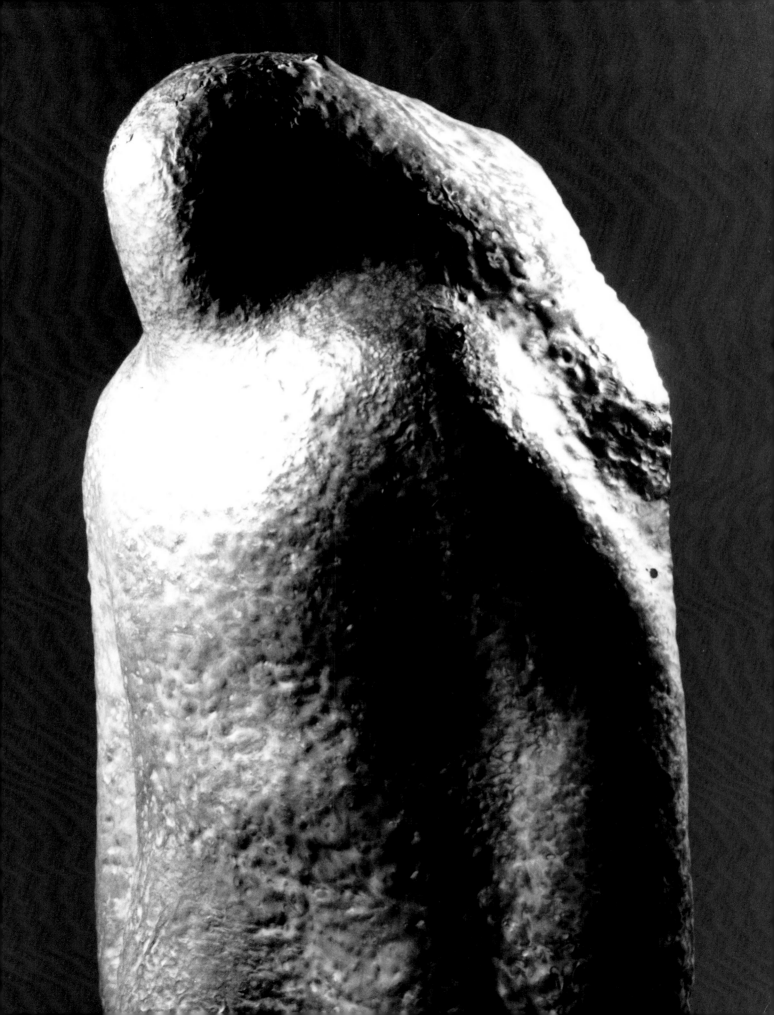

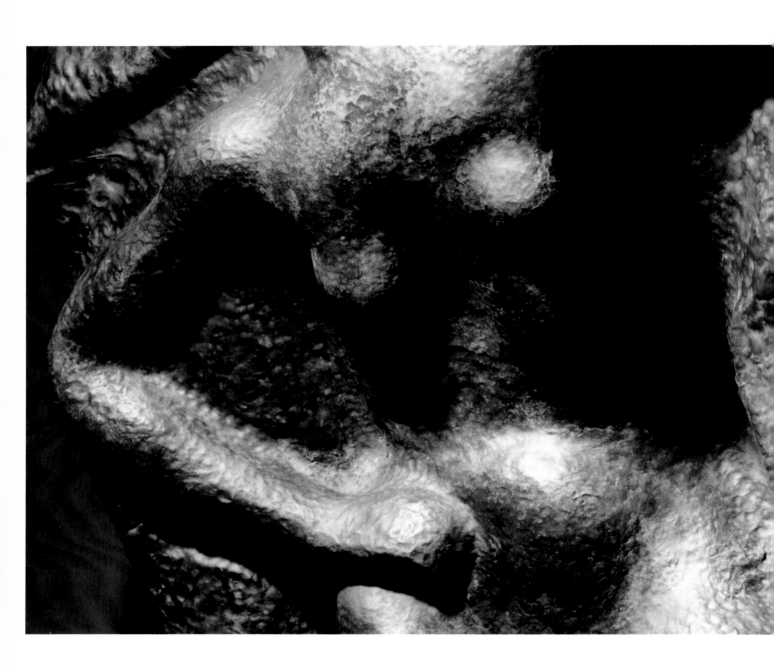

A sculptor must understand which particular impulses *can be expressed with sculptural forms. He must understand the period he lives in—that is, the* rhythm of his time. *He must understand the* language *he will use to express it.*

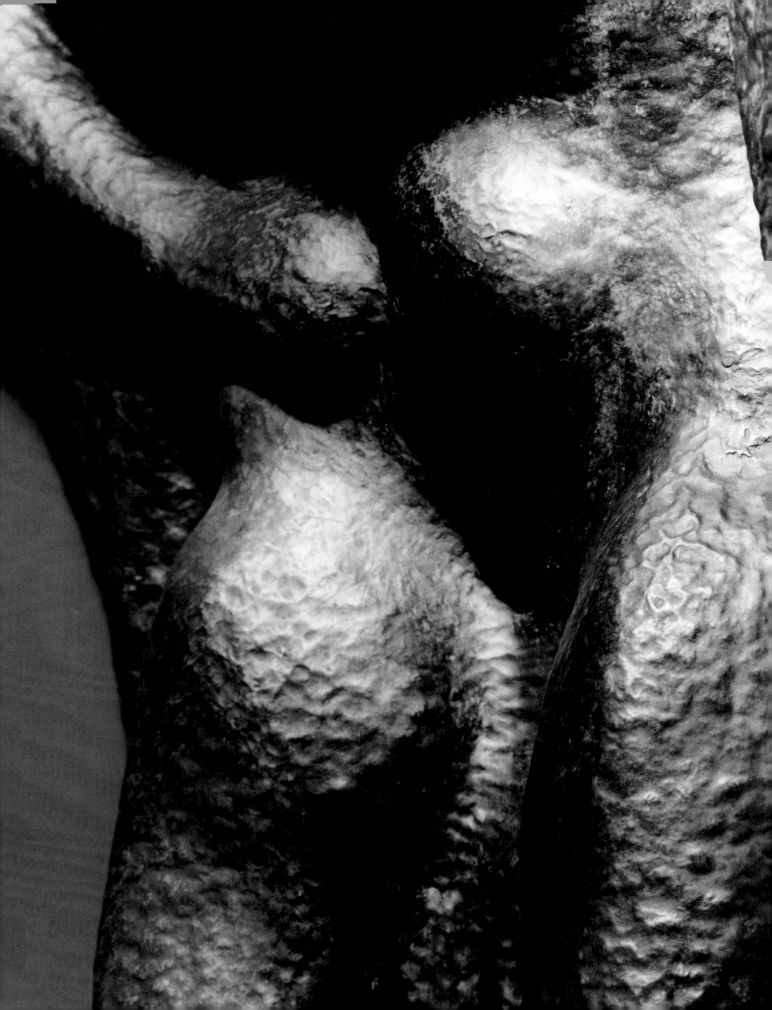

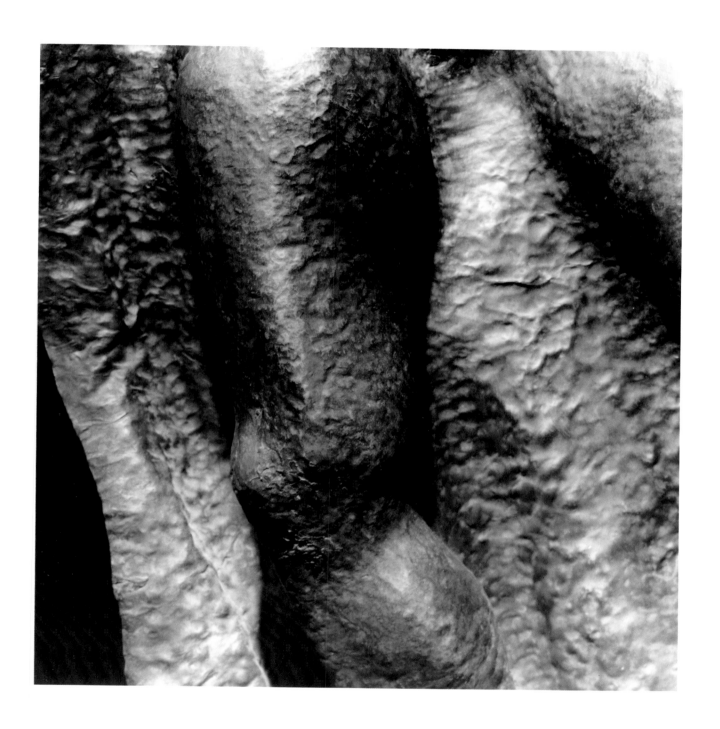

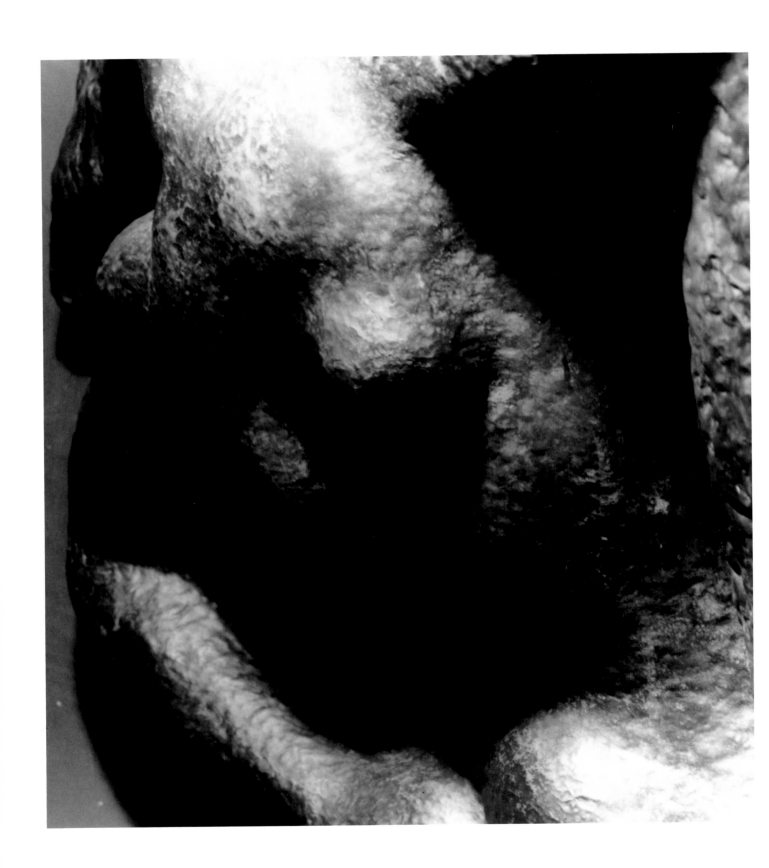

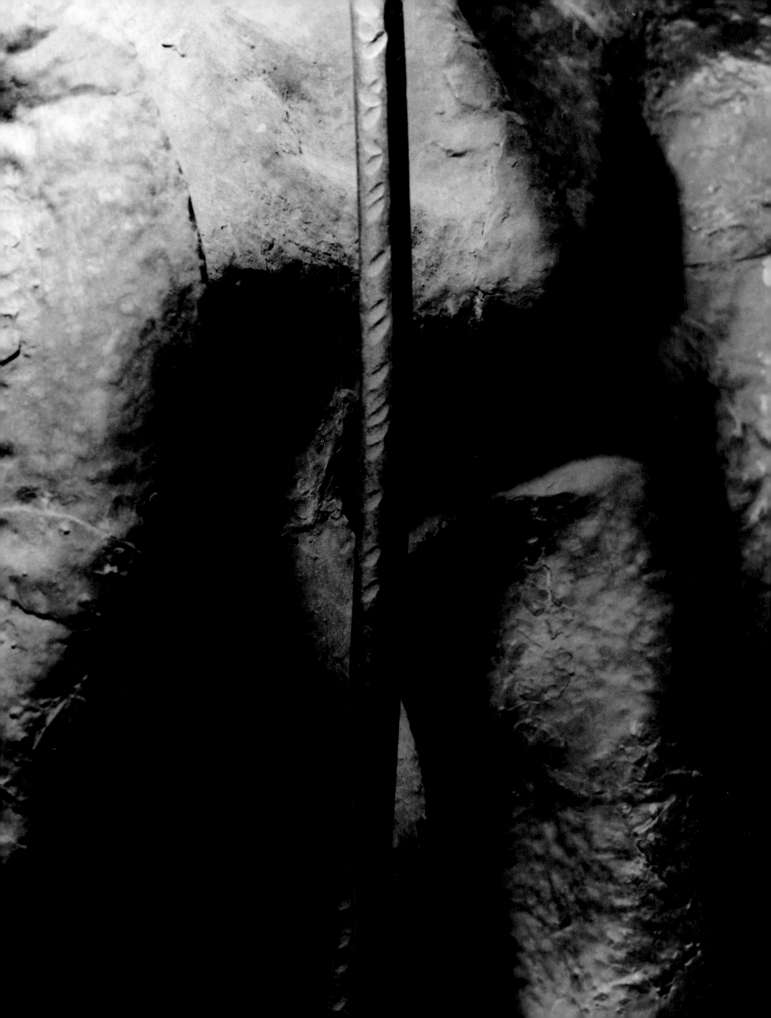

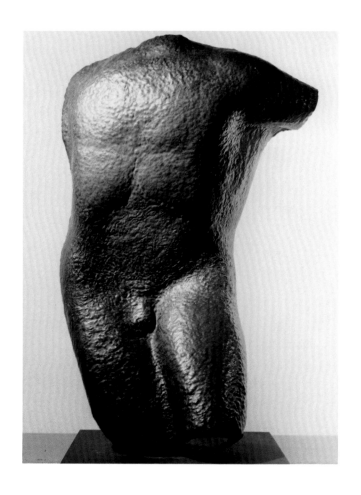

*The horizon cleared, the sun
shone brightly, the forms developed
into a harmonious order. I knew
suddenly how sculpture expressing
my inner world must look. . . .*

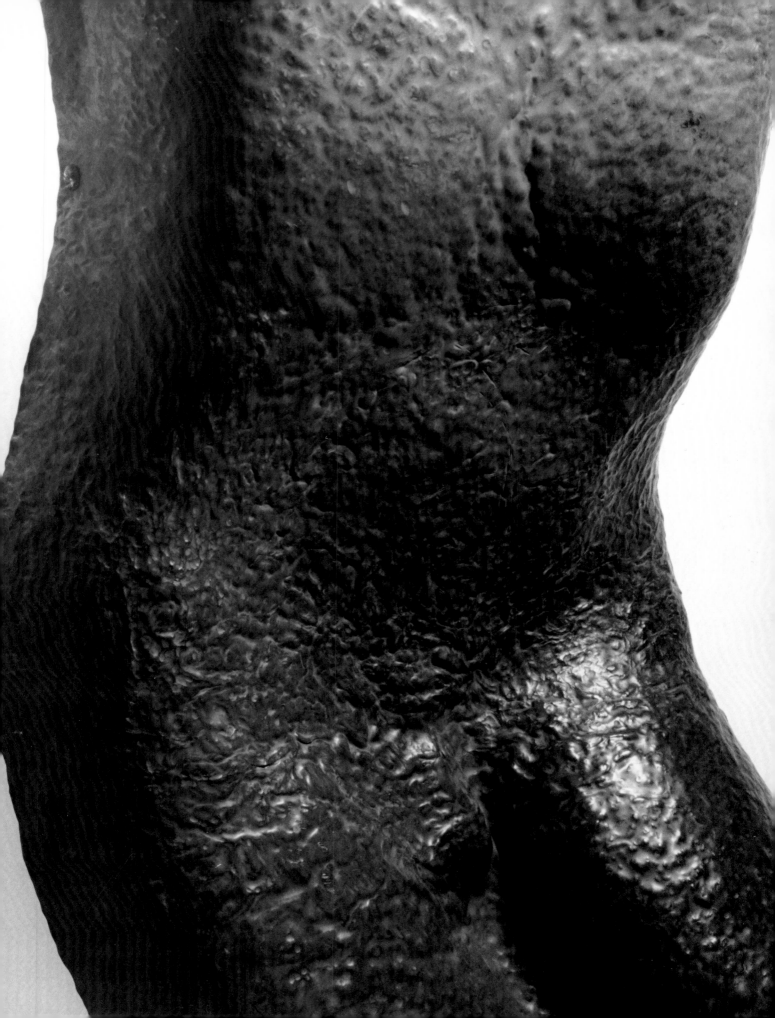

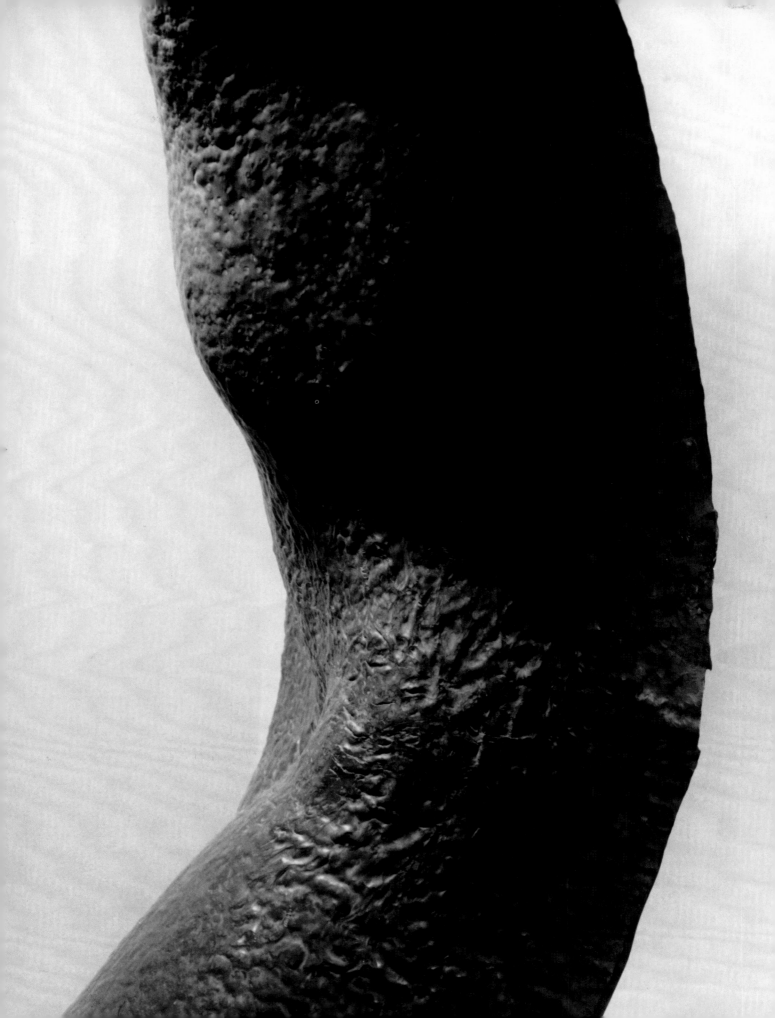

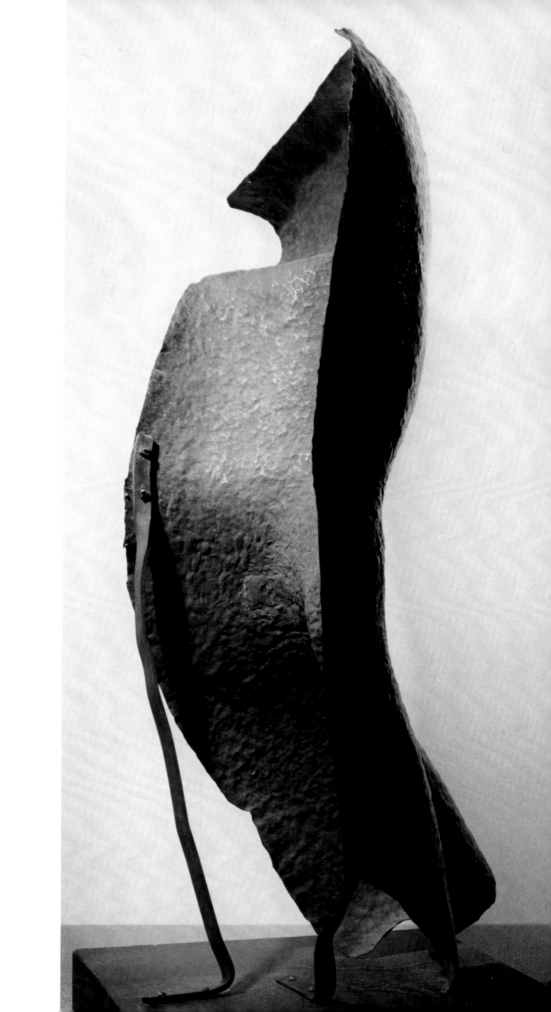

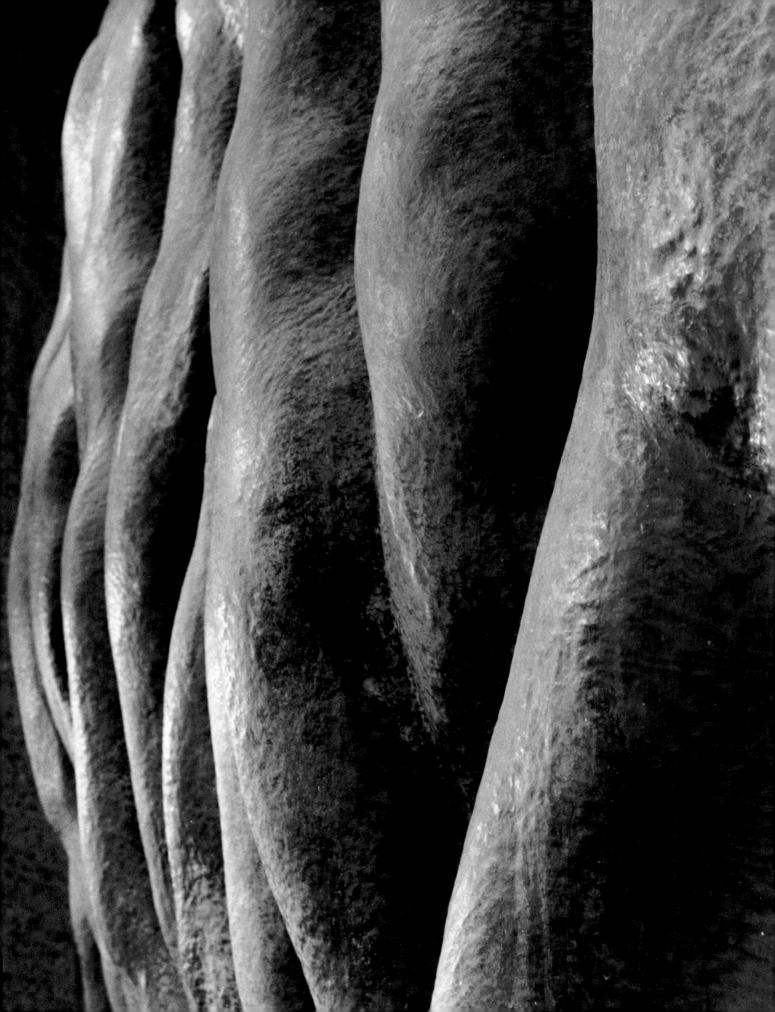

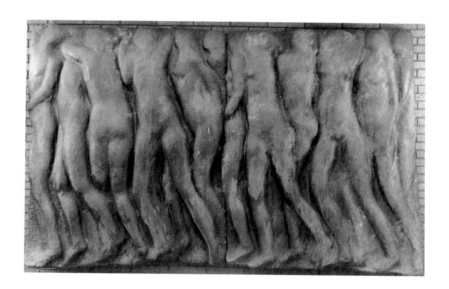

Nature's secret of endless suggestiveness, in spite of the definition of its details, is in its endless number of variations.

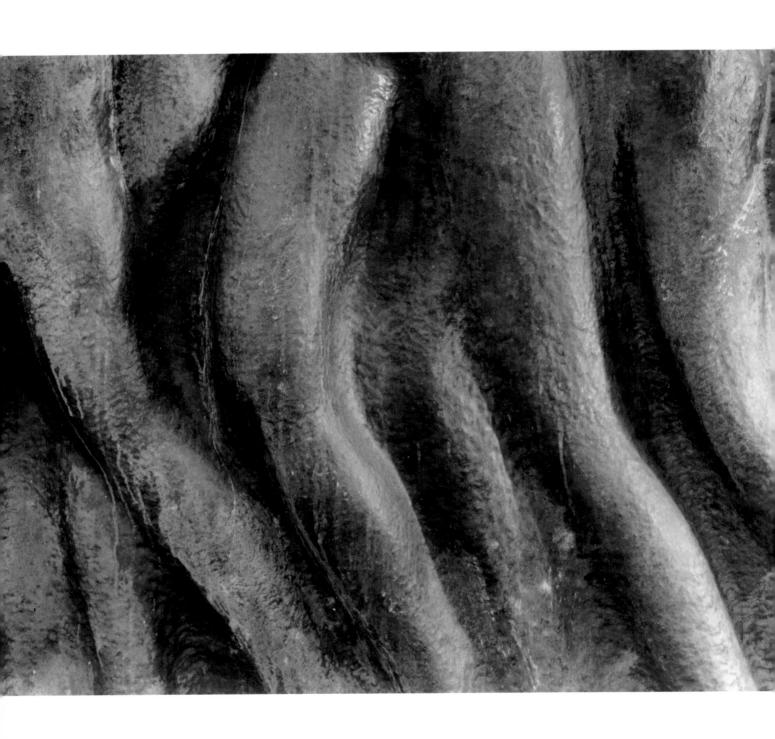

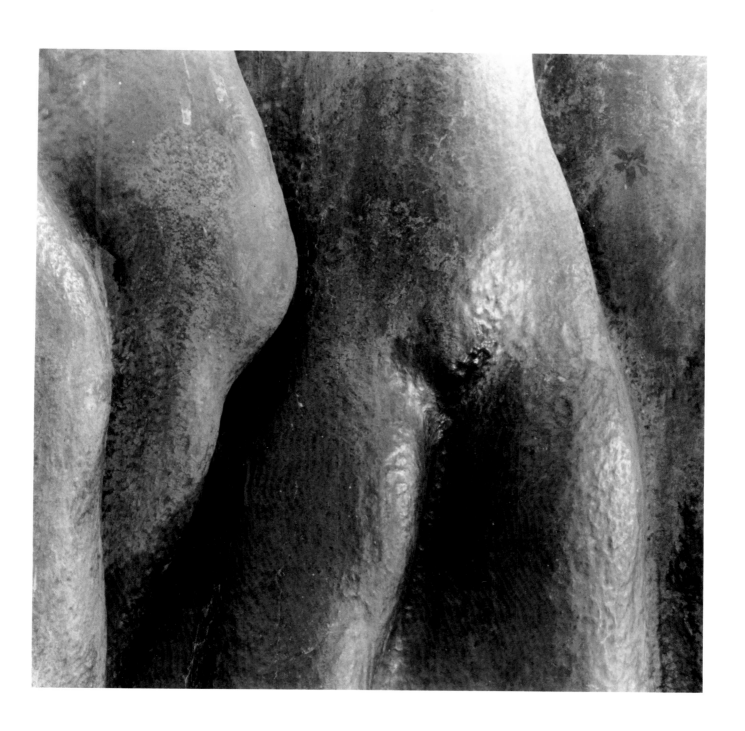

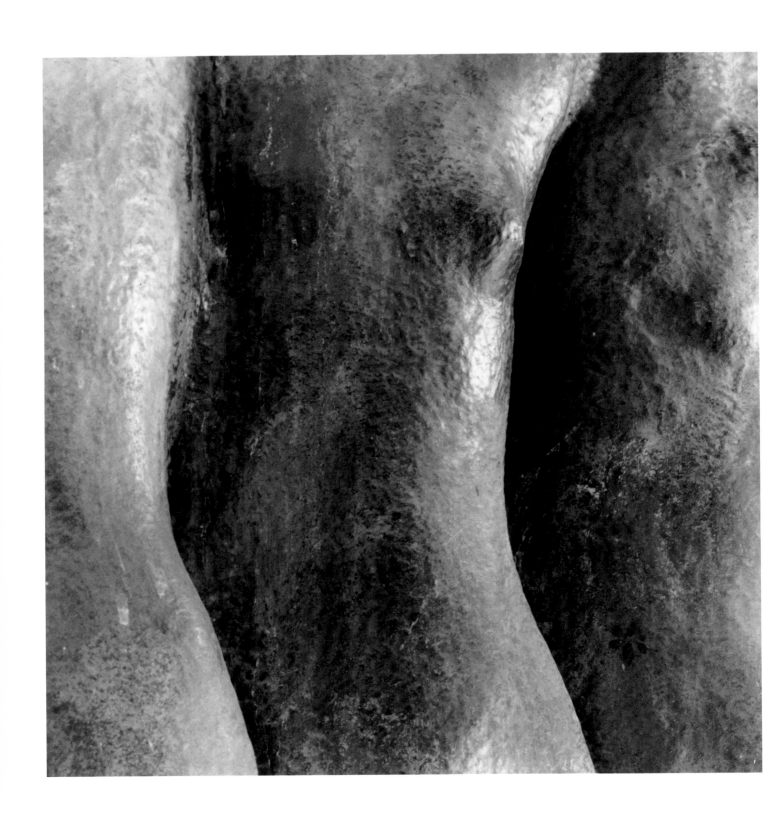

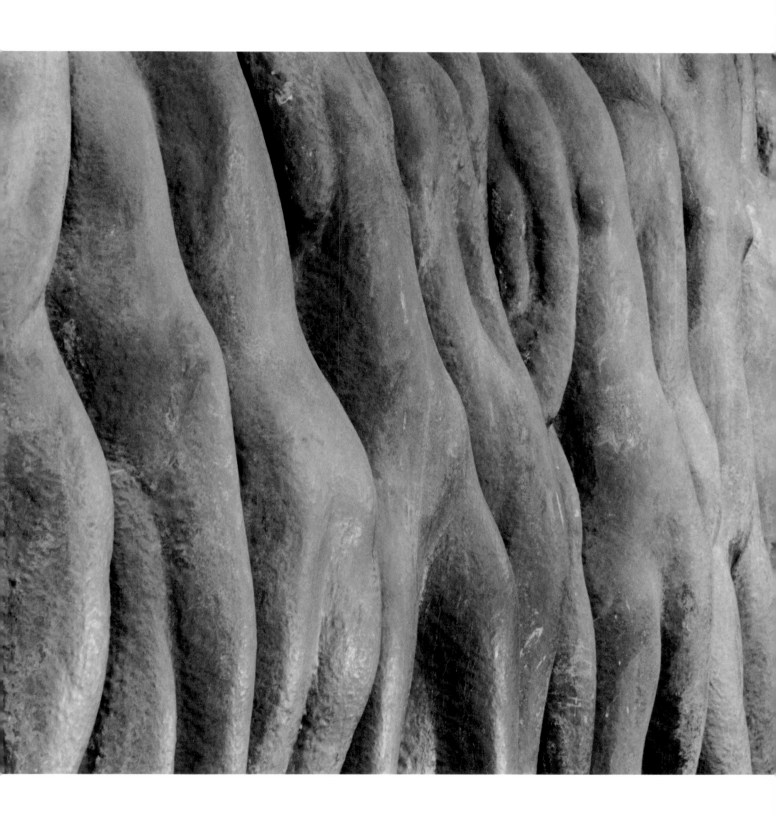

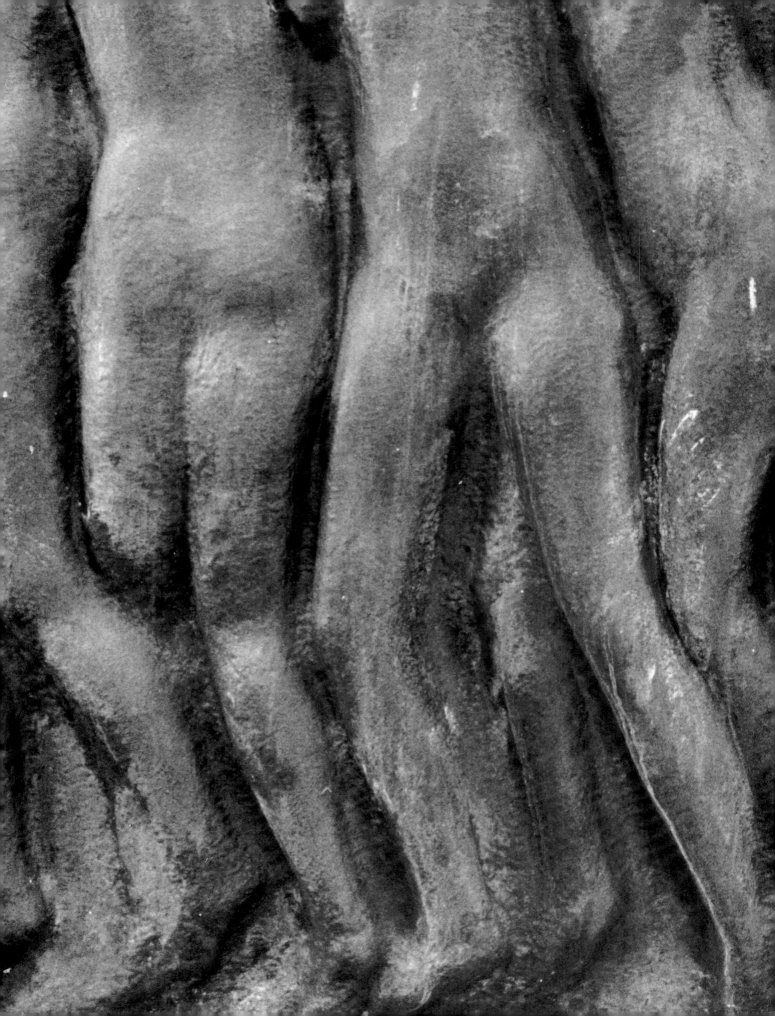

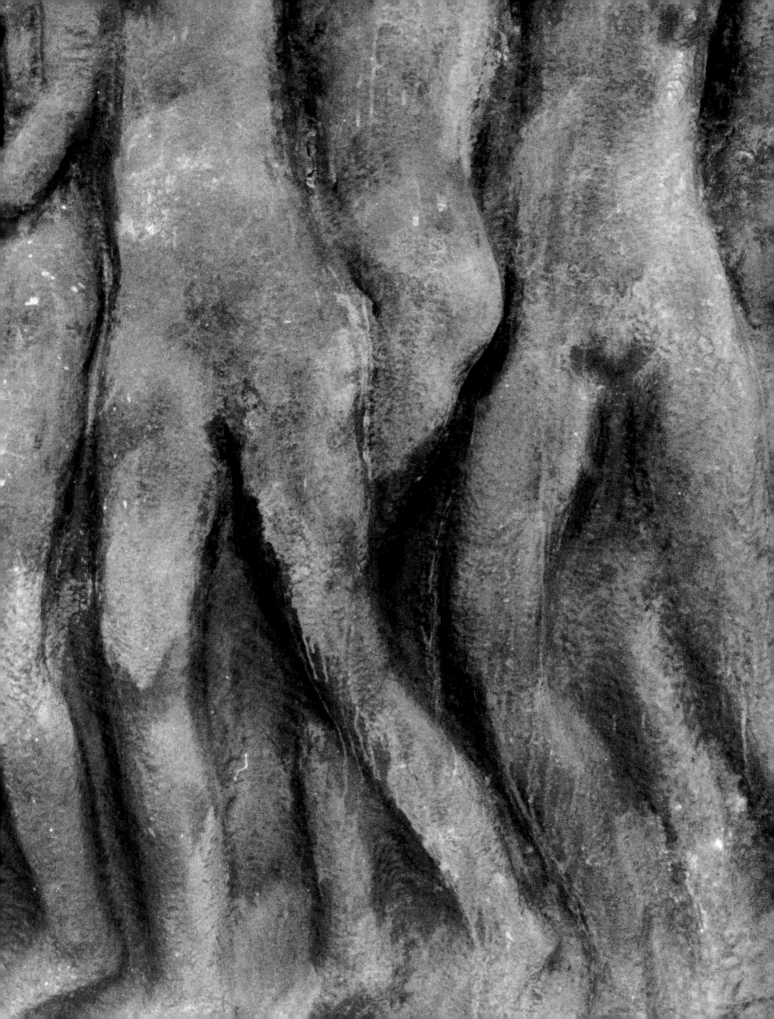

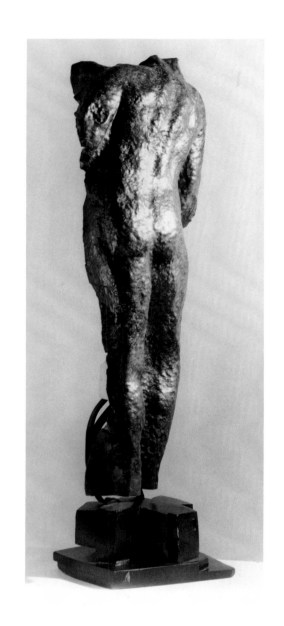

Hope and belief and joy and serenity are the dominant expressions in the world of each of us, for we are living things.

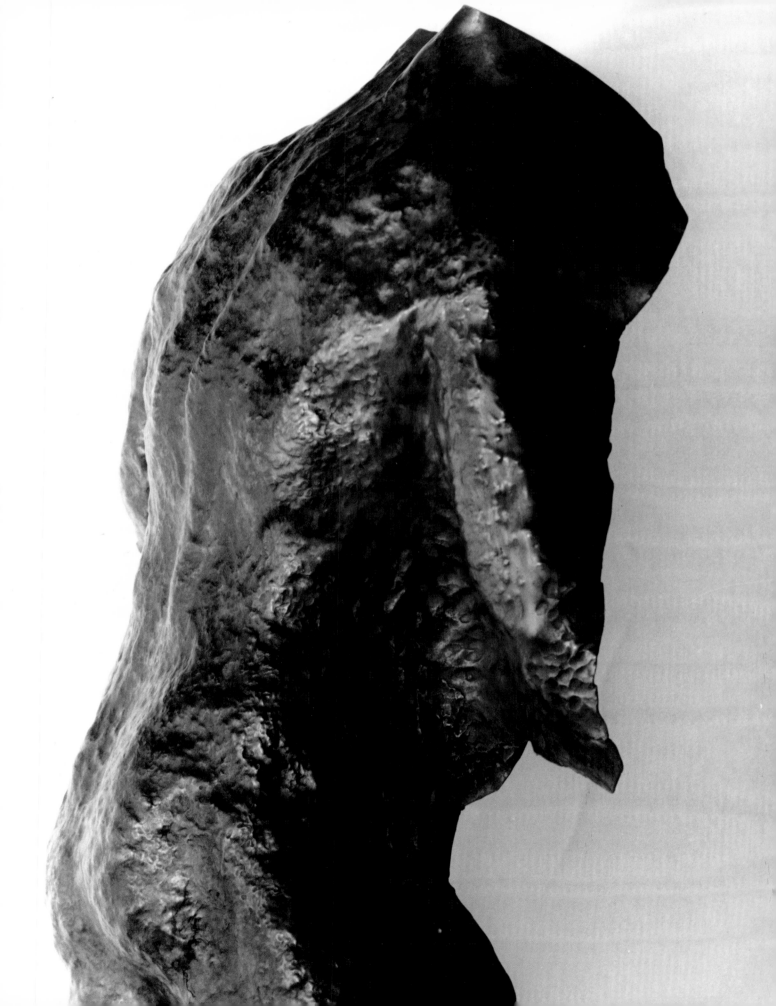

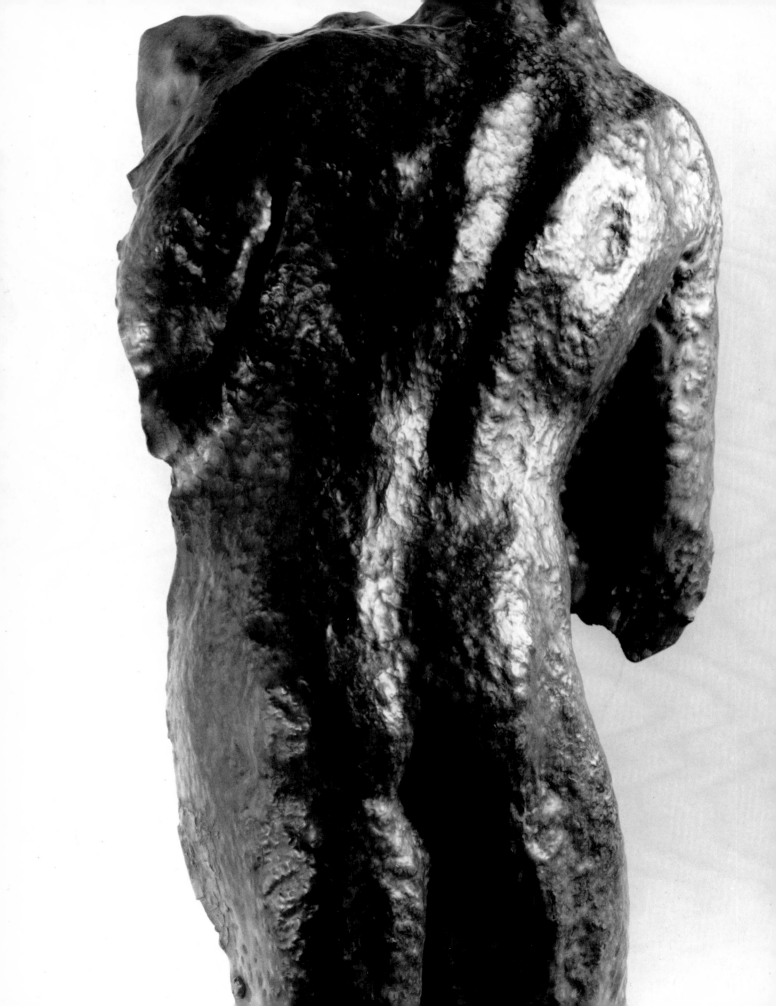

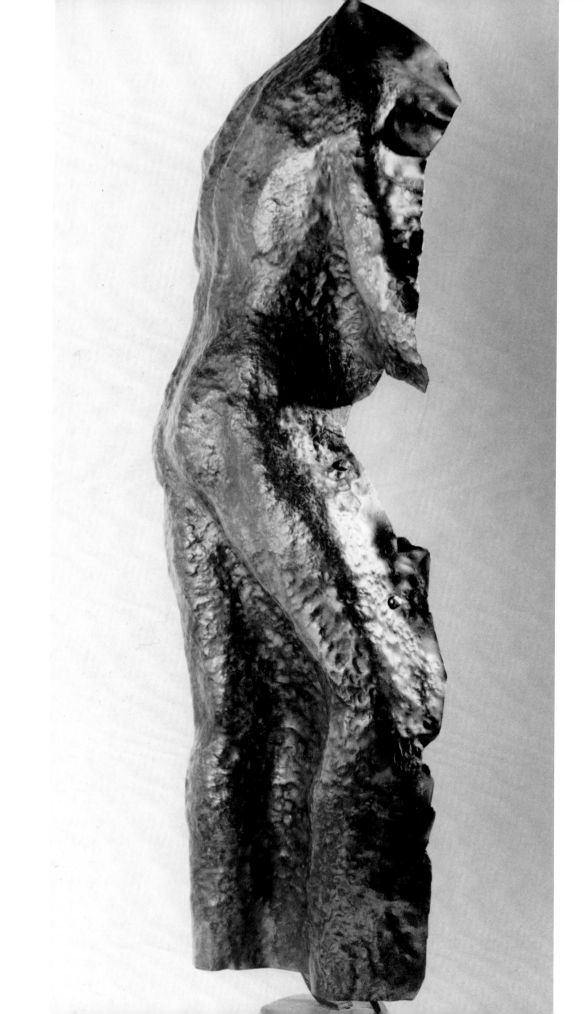

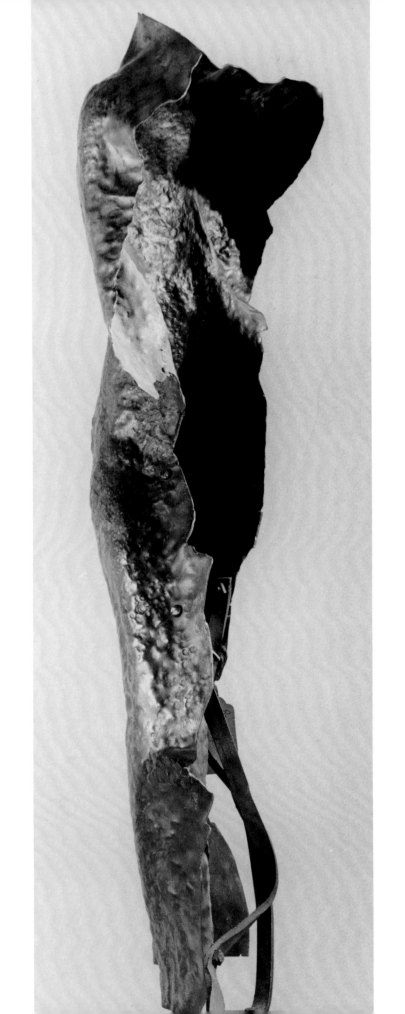

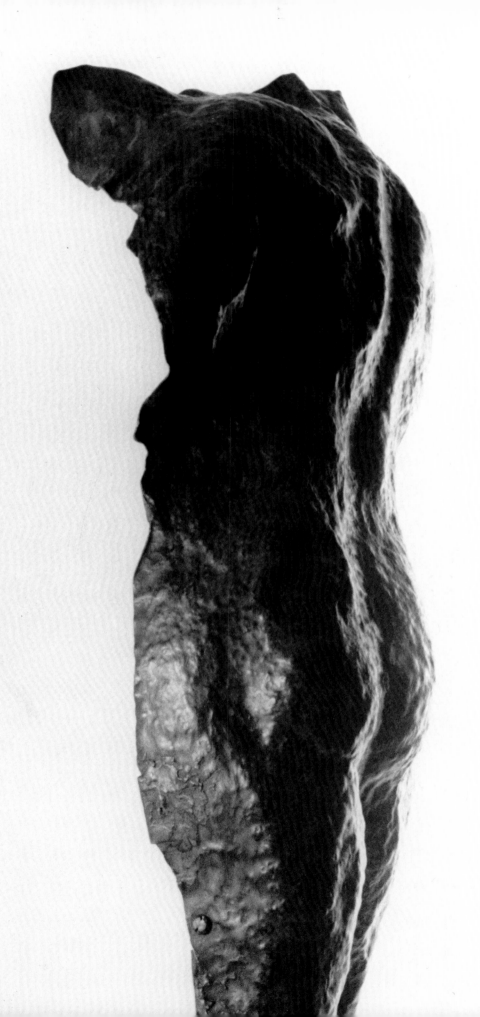

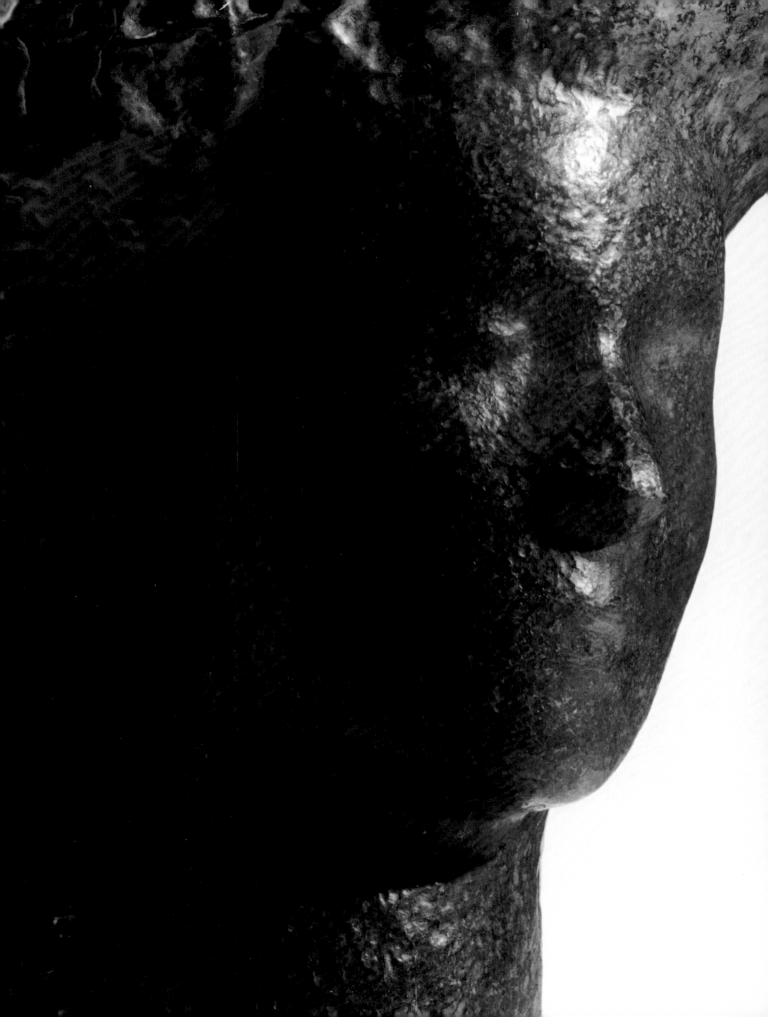

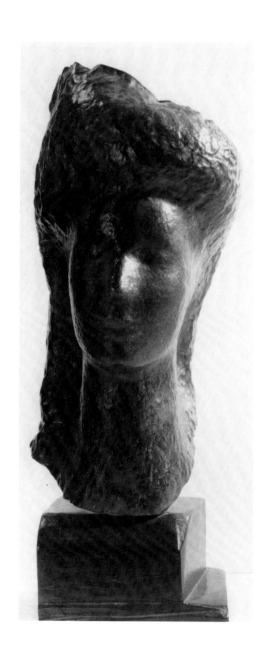

Sculpture is a conversation with symbols, with which one can speak about those deep sensations of life which trouble, or bring joy, to every human being. It awakens dreams of beauty, creates ideals, yet beyond our reach. It makes the movements of nature's forces comprehensible to us. . . .

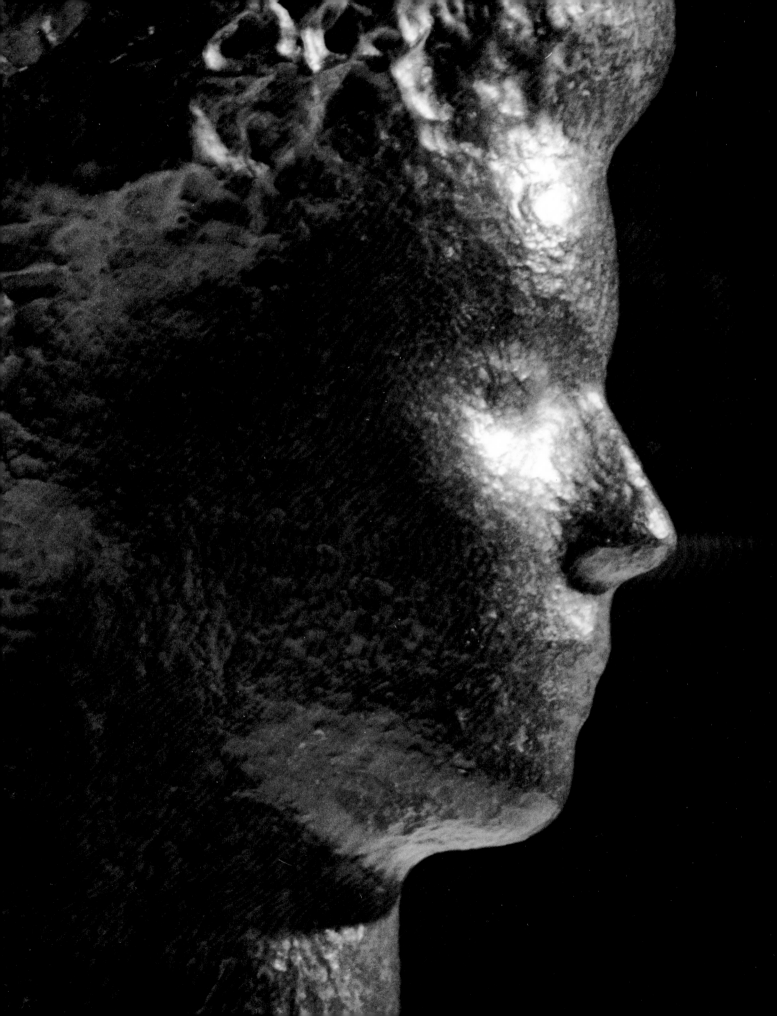

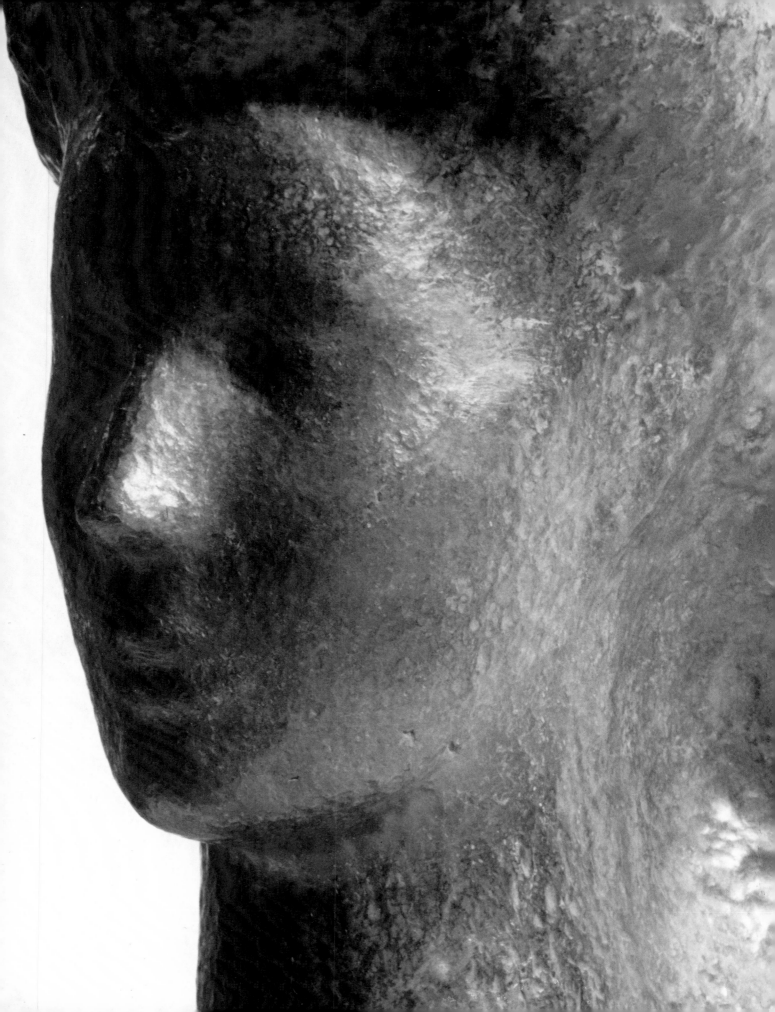

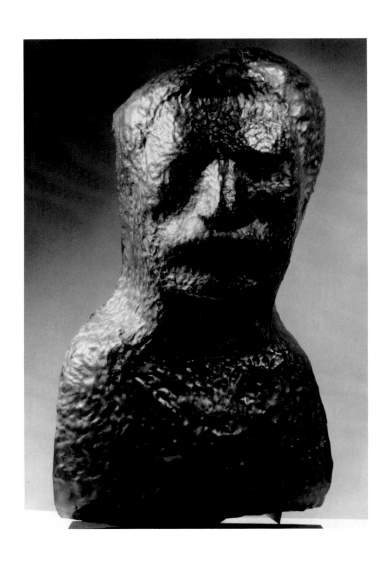

. . . many years must be spent in this search for self-understanding. For to understand yourself, you must also understand the creations of others.

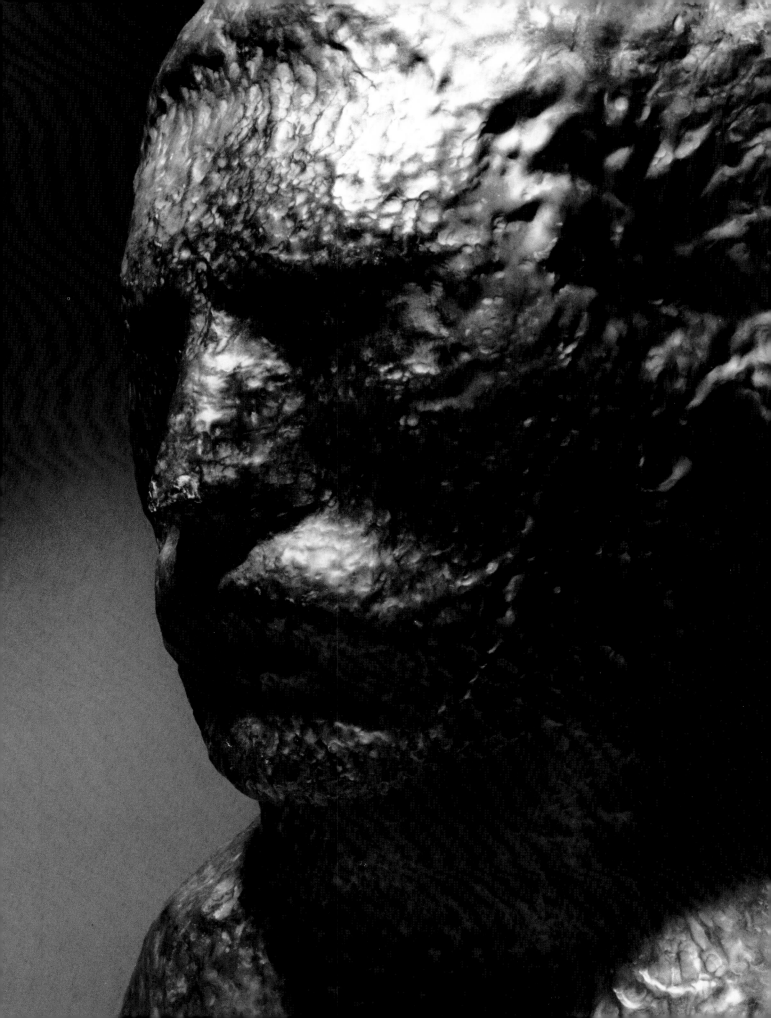

Any artist knows how difficult it is
to awaken a dormant vision....
In art the personal state is the con-
trolling influence. In fact, it is the
force that begins and ends the
creative visions.

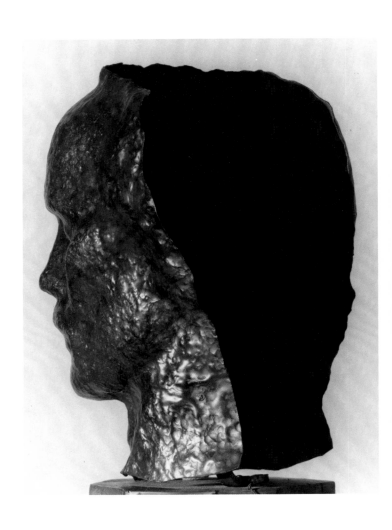

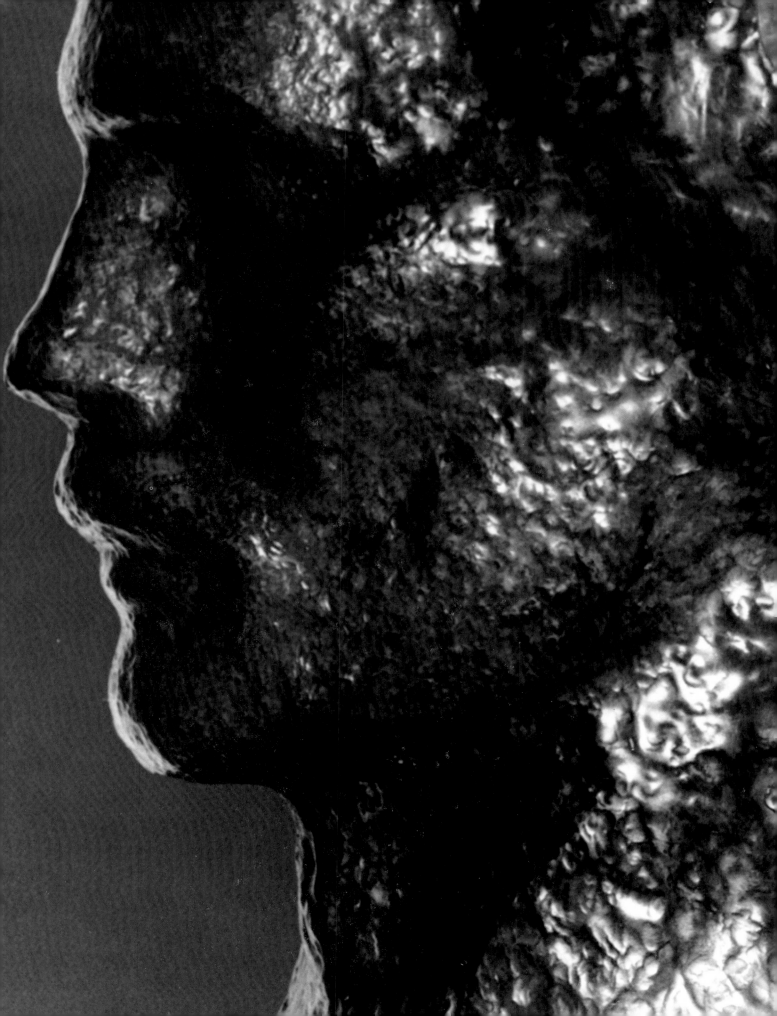

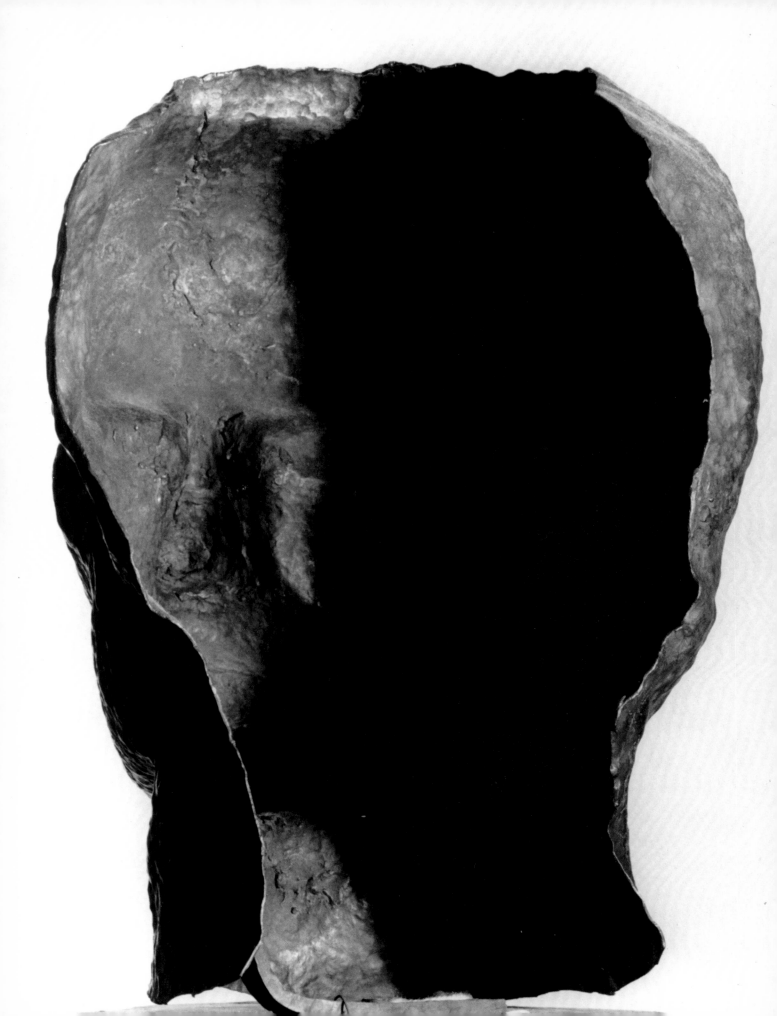

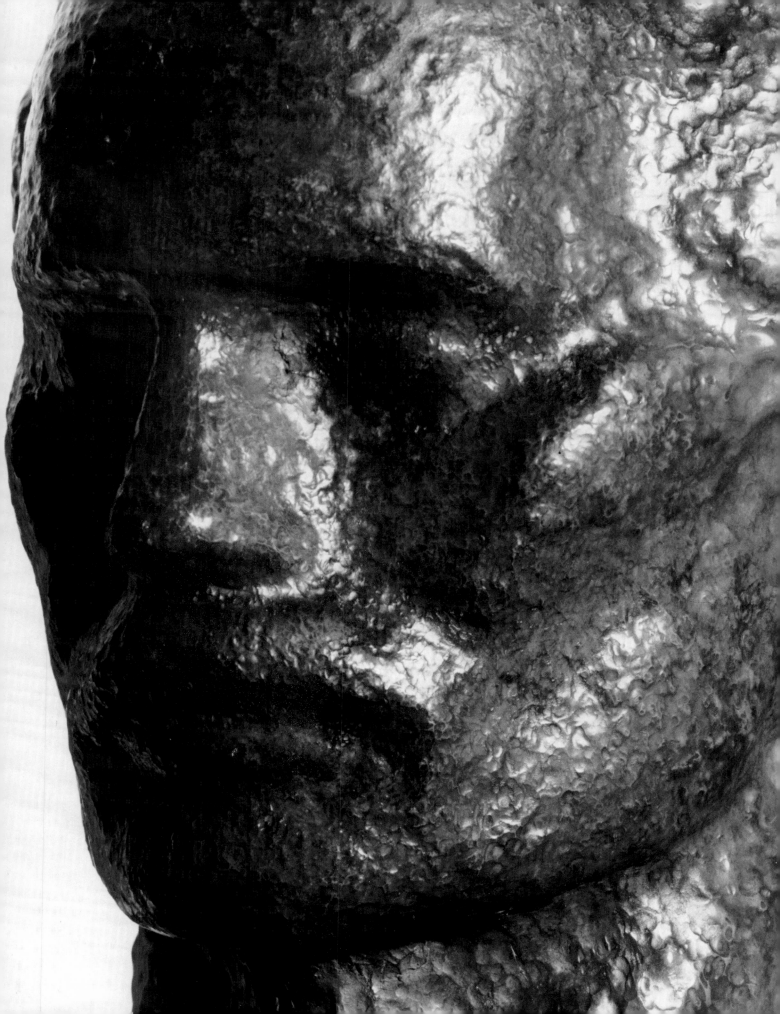

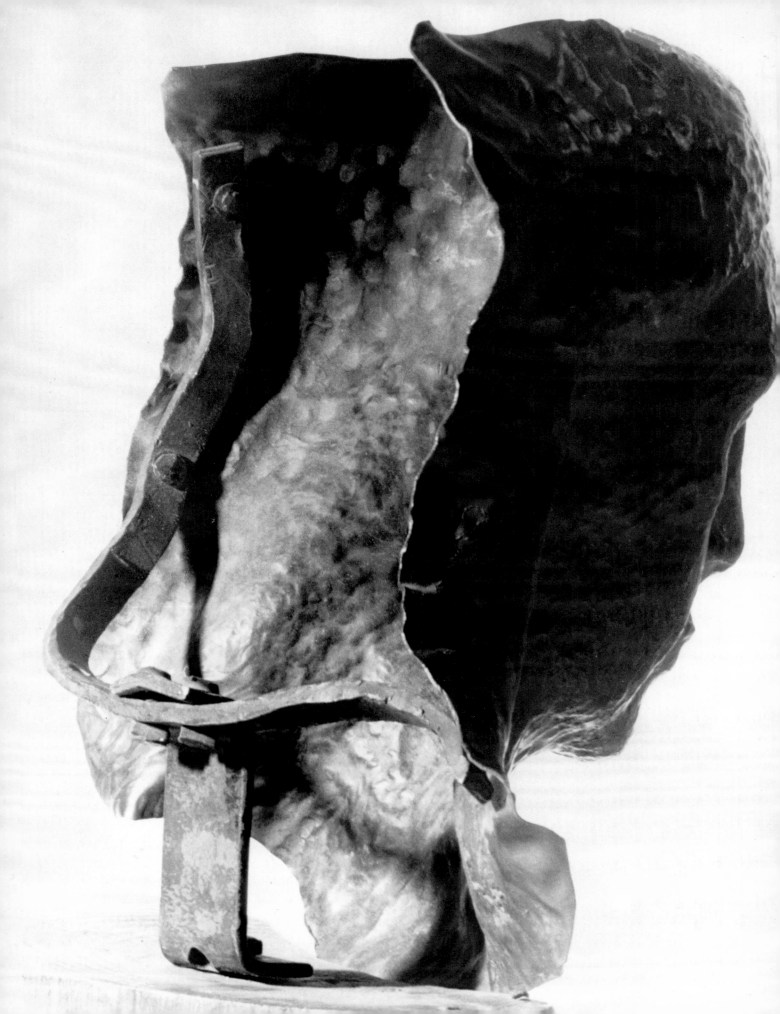

. . . the artist, during his creative
period, is similar to an open
wound which must be watched,
helped . . . even cuddled in some
way by a gentle hand.

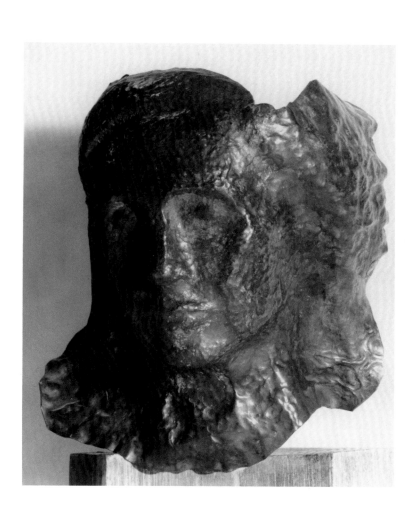

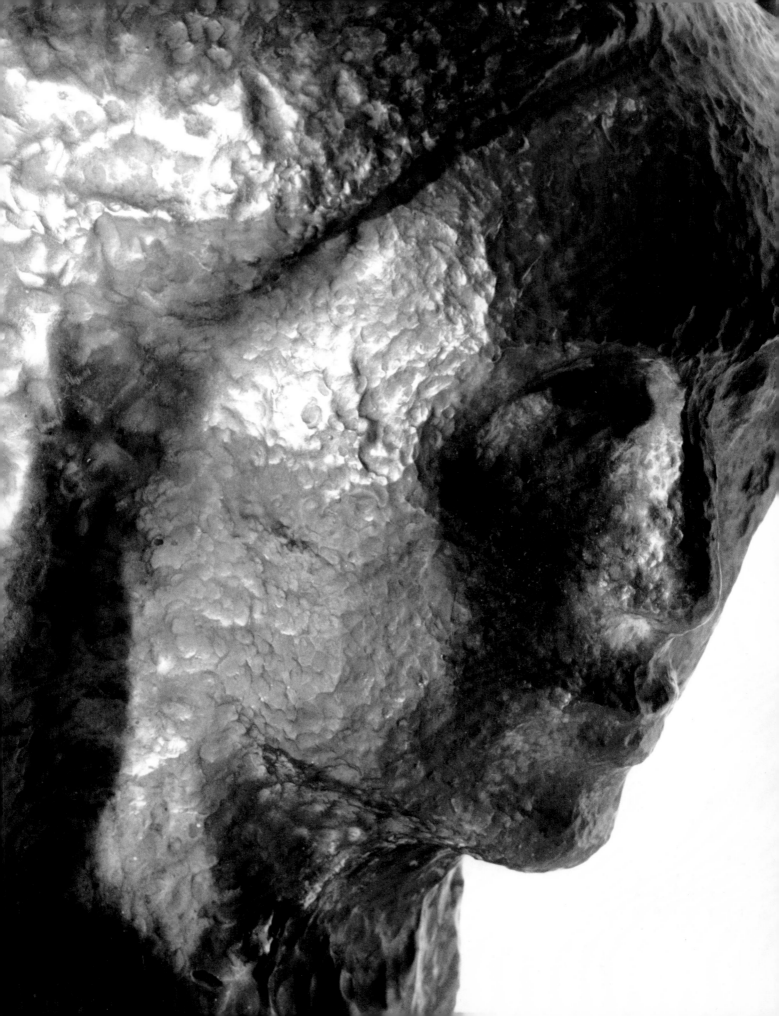

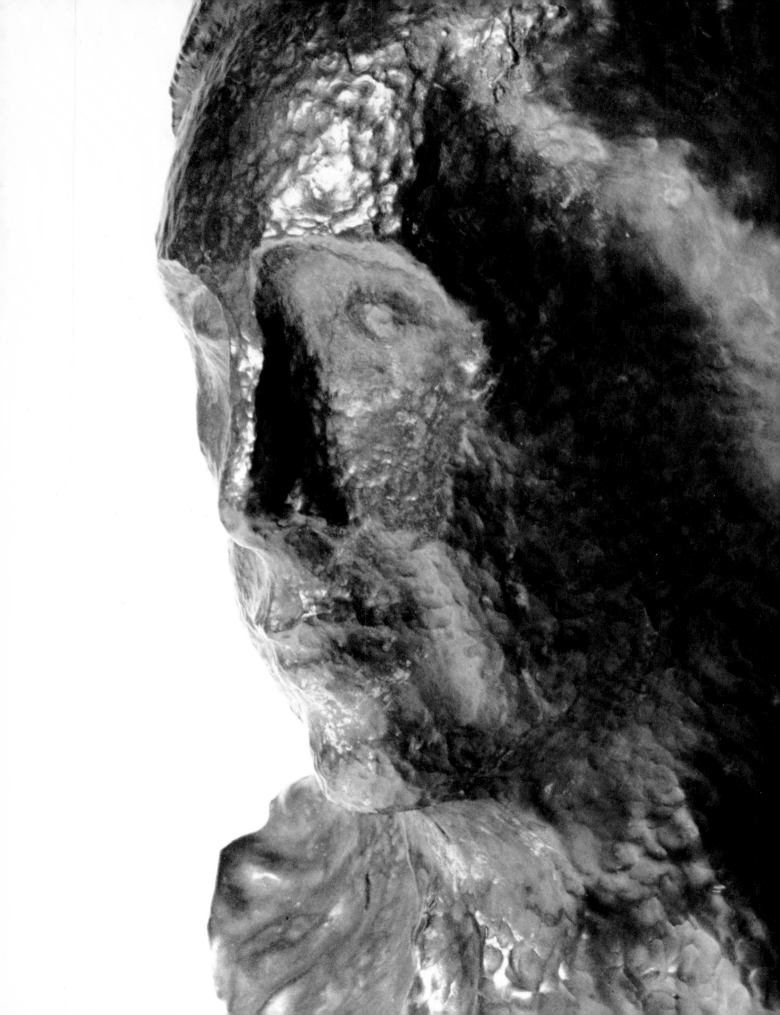

LIST OF KNOWN
HAMMERED COPPER SCULPTURES

A partial checklist prepared by the Zabriskie Gallery

ROAD BUILDER
1931–39, 2'4½" high.
The Wichita Art Museum. Purchase.

MAN OF THE FIELDS
1931–39, 3'10½" high.
Metropolitan Museum of Art. Foundation gift,
in honor of Joseph H. Hazen, 1986.

SERENITY
1932–39, 3'6" high.
University of Nebraska–Lincoln, Sheldon
Memorial Art Gallery. Purchase, F. M. Hall
Collection.

ELEGY
1933–36, 8' high.

MOTHER AND CHILD
1933–37, 2'6¼" high.
Hirshhorn Museum and Sculpture Garden,
Smithsonian Institution. Gift of Joseph H.
Hirshhorn, 1966.

JAZZ TEMPO
1933–38, 6'3" high.

LE SOLEIL
1933–38, 2'11" high.

MARTYR
1933–38, 3'3" high.

NATIVE DANCER (PEASANT DANCER)
1933–38, 2'6" high.

NANA
1933–38, 8' long.
Weatherspoon Art Gallery, University of North
Carolina, Greensboro. Gift of the Jefferson-Pilot
Corporation, Mr. and Mrs. Benjamin Cone,
North Carolina National Bank and the Blue
Bell Foundation, 1979.

COMPASSION
1933–38(9), 2'6" high.

FAMINE
c. 1933–39, 2'8" long.

LONELINESS (BEGGAR)
c. 1933–39, 3'2" high.

COAL MAN
1933–38, 3'3½" high.
Metropolitan Museum of Art. Purchase, the
Charles B. and Irene B. Jacobs Foundation gift,
in honor of Joseph H. Hazen, 1986.

NARCISSUS
c. 1933–39, 7'9" long.

UGESIE
1939–40, 6'2" high.
The Pennsylvania Academy of Fine Arts,
Philadelphia.

APHRODITE
1940–48, 8' long.
Storm King Art Center, Mountainville, NY.
Purchase.

EVE
1940–48, 4'5" high.

SLUMBER
1940–48, 3'4" long.
Whitney Museum of American Art.
Purchase.

UNKNOWN SOLDIER
1940–48, 9' long.
Hirshhorn Museum and Sculpture Garden,
Smithsonian Institution. Bequest of Joan
Baizerman, 1985.

ENCHANTMENT
1940–48, 8' high.

DANCE BACCHANAL
1940–48, 8'11" high.

LYRIC POEM
1940–48, 2'9" high.

YOUNG SCULPTOR (SELF-PORTRAIT)
1940–48, 1'8" high.

SEQUOIA (MATURITY)
c. 1940–48, 4′ high.
SLEEPING INFANT
c. 1940–48, 2′7⅞″ long.
Hirshhorn Museum and Sculpture Garden,
Smithsonian Institution. Gift of Joseph H.
Hirshhorn, 1966.
SONATA PRIMITIVE
1940–48, 5′11″ high.
San Diego Museum of Art. Gift of Mr. and Mrs.
Norton S. Walbridge.
REPOSE (MODEL AT REST)
1940–49, 2′2″ high.
CONCERTO MÉCANIQUE
1940–53, 8′ high.
MINER
c. 1944–47, 6′10½″ high.
Hirshhorn Museum and Sculpture Garden,
Smithsonian Institution. Gift of Joseph H.
Hirshhorn, 1972.
TRANSFIGURATION
1945–53, 8′ high.
Stanford University Museum of Art. Gift of The
Committee for Art at Stanford.
CRUCIFIXION
c. 1947–50, 8′ high.
OLD COURTESAN
1947–52, 3′2¼″ high.
Solomon R. Guggenheim Museum.
ASTARTE
1949–52, 19¾″ long.
SUN WORSHIP
1949–52, 3′1½″ high.
URANIA (TRANQUIL TONES)
1949–52, 2′11″ high.
JEUNE FILLE
c. 1949–52, 1′2″ high.
NIKÉ
1949–52, 5′7½″ high.
Walker Art Center. Gift of the T. B. Walker
Foundation, 1953.
ADAGIO
1950–56, 3′9⅛″ high.
Hirshhorn Museum and Sculpture Garden,
Smithsonian Institution. Gift of the Joseph H.
Hirshhorn Foundation, 1979.

MÉDITERRANÉE
1950–56, 3′ long.
SERENADE
1950–57, 3′6″ long.
AURORA
1950–57, 6′6″ high.
ADRIANA
1950–57, 2′3″ high.
CANTATA
1950–57, 3′3½″ high.
DESERT
1950–57, 2′7¾″ high.
EXTASE
1950–57, 3′6½″ high.
INFINITY
1950–57, 8′6″ high.
Rockefeller Collection, Pocantico Hills.
MIDI
1950–57, 3′1½″ high.
SIESTA
1950–57, 1′7¼″ high.
SONG OF THE EARTH
1950–57, 5′10″ high.
THERESA
1950–57, 2′2″ high.
HARVEST
1950–57, 2′9″ high.
TITAN
1950–57, 6′6″ high.
Tel Aviv Sculpture Garden,
Tel Aviv Museum.
CREATION
1950–57, 8′ high.
Hirshhorn Museum and Sculpture Garden,
Smithsonian Institution. Gift of Joan
Baizerman, 1979.
VESTAL
1951–55, 3′½″ high.
VENUS IN REPOSE
c. 1951–55, 3′ high.
YOUNG APOLLO
c. 1951–55, 3′ high.
APPASSIONATA
1951–57, 5′10″ high.

NIGHT (pendant to DAY)
c. 1952–55, 8′6″ long.
DAY
c. 1952–56, 8′4″ long.
Georgia Museum of Art, The University of
Georgia, Athens. University purchase.
NOCTURNE
c. 1954–55, 5′5″ high.
PRIMAVERA
1954–55, 8′6¼″ high.
National Museum of American Art, Smithsonian
Institution.
NEREID
1955–57, 4′7½″ high.
Hirshhorn Museum and Sculpture Garden,
Smithsonian Institution. Gift of Joseph H.
Hirshhorn, 1966.
FEMALE NUDE WITH ARMS ABOVE HEAD
(ADOLESCENCE) n.d., 8′½″ high.
Hirshhorn Museum and Sculpture Garden,
Smithsonian Institution. Gift of Joan
Baizerman, 1979.
FEMALE NUDE WITH ARMS ABOVE HEAD
(ASCENSION) n.d., 8′9″ high.
Hirshhorn Museum and Sculpture Garden,
Smithsonian Institution. Gift of Joan
Baizerman, 1979.
MALE NUDE—FLYING FIGURE (VICTORY)
n.d., 8′3″ high.
Hirshhorn Museum and Sculpture Garden,
Smithsonian Institution. Gift of Joan
Baizerman, 1979.
FEMALE TORSO
n.d., 4′ high.
MALE FIGURE
n.d., 43″ high.
STREET SINGER
n.d., 3′ high.
VANITY (DANCE ILLUSION)
n.d., ⅞″ high.

Months of the Year Series
PEON—JANUARY
1950–57, 3′ high.
LA LOIRE—FEBRUARY
1950–57, 3′ long.

FIREBIRD—MARCH
1950–57, 3′7½″ high.
The William Benton Museum of Art, University
of Connecticut, Storrs. Gift of museum
volunteers, 1976.
VIVACE—APRIL
1950–57, 3′ high.
LARGO—MAY
1950–57, 3′ high.
CERES—JUNE
1950–57, 3′ high.
JULY
1950–57, 3′ long.
TORRENT—AUGUST
1950–57, 3′ high.
SEPTEMBER
1950–57, 3′ high.
INDIAN SUMMER—OCTOBER
1950–57, 3′7″ high.
MOONLIGHT—NOVEMBER
1950–57, 3′ long.
PYRÉNÉES—DECEMBER
1950–57, 3′ high.

Heads
MY FATHER
1933–38, 1′9″ high.
SILENCE
1936, 1′2¼″ high.
University Art Museum, University of
Minnesota, Minneapolis. Purchase, John Rood
Sculpture Collection Fund.
MY MOTHER
1940–49, 1′1½″ high.
Hirshhorn Museum and Sculpture Garden,
Smithsonian Institution. Gift of Joseph H.
Hirshhorn, 1966.
ALBERT EINSTEIN
1940–49, 2′2″ high.
BERNARD SHAW
1940–49, 1′8″ high.
IMAGE
1940–49, 1′7½″ high.
LA RELIGIEUSE
1940–49, 2′1″ high.

MOUNTAINEER
1940–49, 2'1½" high.
Metropolitan Museum of Art. Foundation gift,
in honor of Joseph H. Hazen, 1986.
SOLDIER
1940–49, 1'3" high.
DREAM
1945–47, 3'8" high.
DAWN
1947–52, 2'⅛" high.
Hirshhorn Museum and Sculpture Garden,
Smithsonian Institution. Gift of the Joseph H.
Hirshhorn Foundation, 1979.
TUCSON MOUNTAIN
1949–51, 1'6½" high.
JEREMIAH (RABBI)
1949–52, 1'2½" high.
SIBYL
1949–56, 2' high.
MEXICANA
1950–57, 1'11" high.
LE PRINTEMPS
1952, 1'11" high.
Addison Gallery of American Art, Phillips
Academy, Andover, MA. Gift of the Leland
Stillman Foundation in memory of Thomas
Cochran.
SELF PORTRAIT
1952–56, 1'9½" high.
ESPÉRANCE
1953–56, 1'11" high.
Hirshhorn Museum and Sculpture Garden,
Smithsonian Institution. Gift of Joseph H.
Hirshhorn, 1966.
BLIND WARRIOR
n.d., 1'3½" high.
DAUGHTER OF ISRAEL
n.d., 1'2½" high.
OLIVE BARK
n.d., 14½" high.

Sculptural Symphonies
EXUBERANCE—FIRST SCULPTURAL SYMPHONY
1933–38, 5'9" × 6'7".
University Art Museum, The University of New
Mexico, Albuquerque.

MARCH OF THE INNOCENTS—SECOND
SCULPTURAL SYMPHONY
1933–38, 6'9" × 10'.
Health Hospitals Corporation, New York.
EROICA—FOURTH SCULPTURAL SYMPHONY
c. 1940–53, 7'9" × 4'7".
Hirshhorn Museum and Sculpture Garden,
Smithsonian Institution. Gift of Joan
Baizerman, 1985.
CRESCENDO—FIFTH SCULPTURAL SYMPHONY
c. 1940–52, 8'1" × 5'5".
Hirshhorn Museum and Sculpture Garden,
Smithsonian Institution. Gift of Joan
Baizerman, 1985.

The complete work of Saul Baizerman includes
plasters, bronzes and a collection of drawings
(The Saul Baizerman Collection, Jackson
Library, The University of North Carolina,
Greensboro). Fifty-eight bronzes from the
group known as "The City and the People"
were part of a gift by Joan Baizerman to the
Hirshhorn Museum and Sculpture Garden.

Unless otherwise noted, the aforementioned
hammered copper sculptures are in private
collections or their location is unknown.

Dedicated to Joan Hay Baizerman
whose selfless devotion to her husband's
work made this book possible.

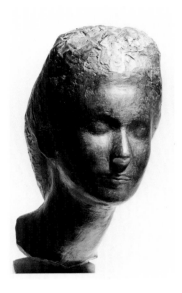

My friend's heart has quieted my own. I do not fret, as I
have done the last troubled years. The spirit of fight and pain
has left my art. It has returned to the natural state of my
nature—that of optimism. So grateful to you, my dear friend,
Joan. Little, indeed, I have to reciprocate with, except with
the warmth of feeling of my own heart.

Saul Baizerman, 1953